2002

2002

ART AND ARTIFACT
THE MUSEUM AS MEDIUM

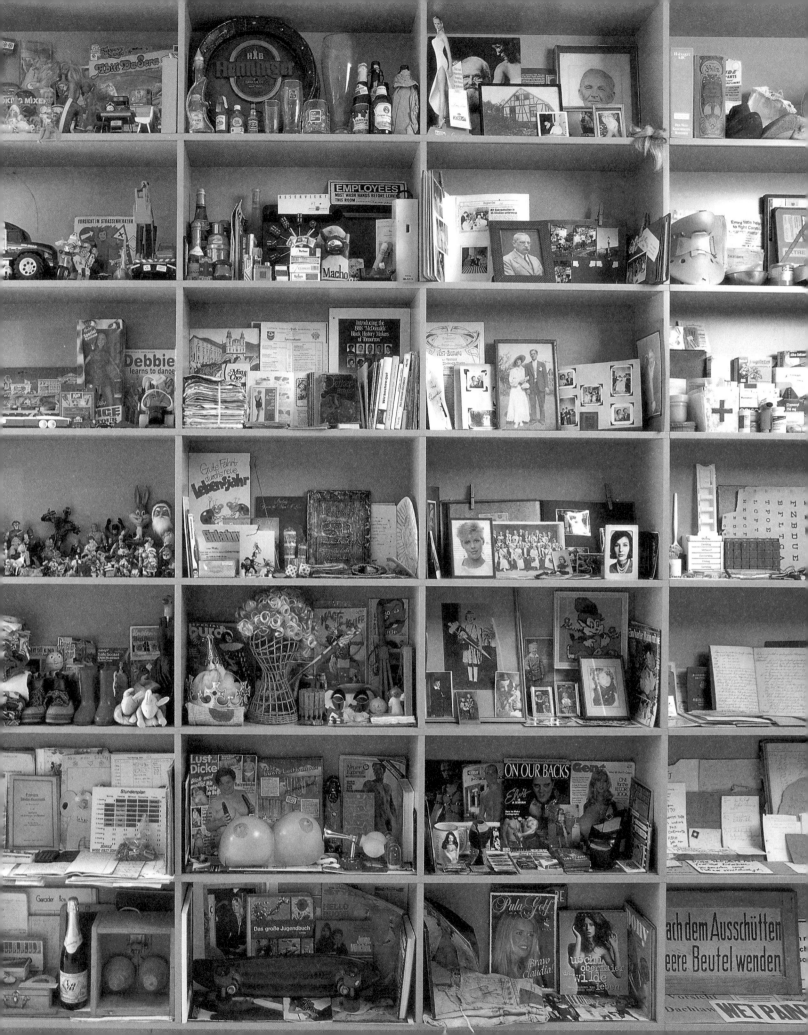

JAMES PUTNAM

ART AND ARTIFACT
THE MUSEUM AS MEDIUM

with 280 illustrations, 229 in color

Thames & Hudson

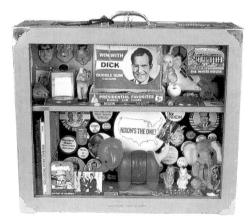

Jeffrey Vallance, *The Travelling Nixon Museum,*
1991 (see p. 71)

Title-page illustration: Karsten Bott, *One of
Each on Shelves,* 2000 (detail). Badisches
Landesmuseum, Karlsruhe. See also p. 39.

page 6: Richard Wentworth, *Rims, lips, feet,*
installation at the exhibition 'Private View',
Bowes Museum, Barnard Castle, Co. Durham,
1996

Research/photo research: Yukiko Kakuta

© 2001 James Putnam

First published in hardcover in the United States of America
in 2001 by Thames & Hudson Inc., 500 Fifth Avenue,
New York, New York 10110

Library of Congress Catalog Card Number 2001088626
ISBN 0-500-23790-5

Printed and bound in Italy by STIGE

CONTENTS

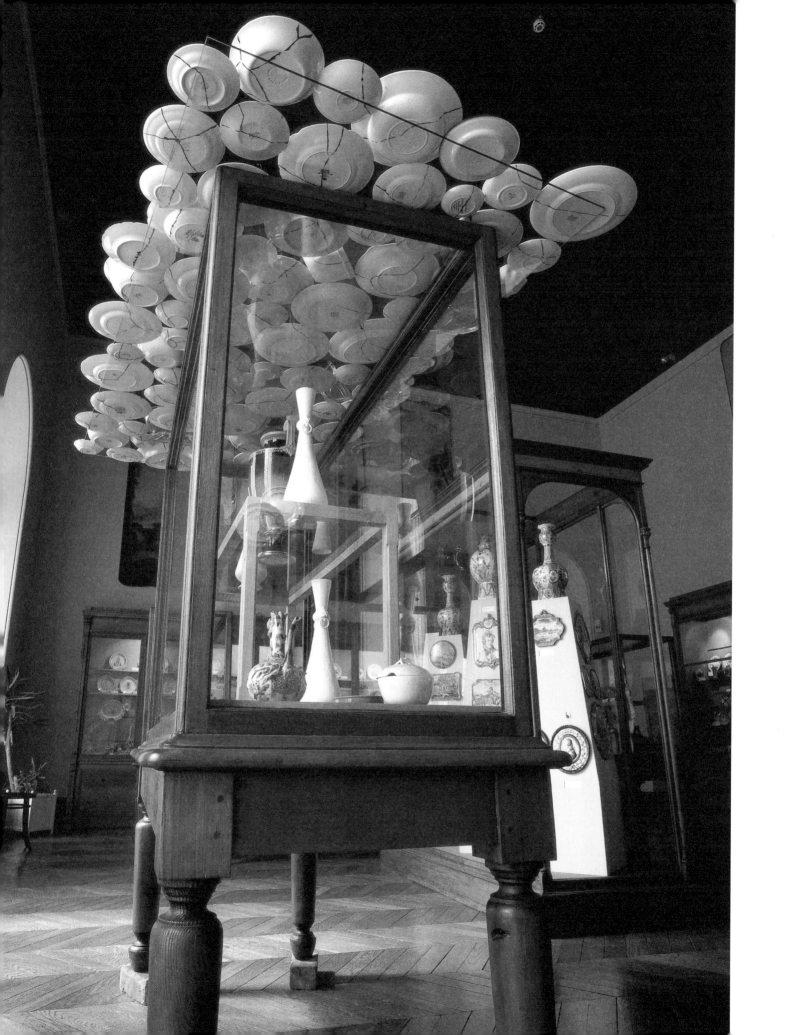

preface

As a child I was fascinated by my local museum and inspired to mimic its display methods. I gathered flower-pot fragments, bits of rusty old iron and oddly shaped stones, arranging them in the glass-fronted bookcase in my bedroom and labelling them as imaginary ancient artifacts. Besides suggesting my ambition to become a museum curator, it is perhaps significant that my instinctive, naive enthusiasm for collecting and presenting objects in such a manner was motivated more by their evocative display potential than by any historical authenticity. The museum's classification and display of its collections can have an aesthetic quality which has many parallels with and influence on art practice, and many artists are also interested in investigating methods used by museums in presenting an 'official' cultural and historical overview.

I have set out here to show an emerging museological tendency in art which is matched by the use of the traditional museum as a site for artists' interventions. Some of these contemporary art projects in non-art museums are not widely known in art circles, and are published here for the first time. By gathering together a wide range of linked material it is thus possible to evaluate its significance in the broader arena of current art practice. Certain aspects of the subject have been examined previously in the curatorial projects or critical writings of others, in particular Harald Szeemann, Jan Hoot, Kasper König, Jean-Hubert Martin, Michael Fehr and Kynaston McShine. I must thank Walter Grasskamp for supplying me with his pioneering research on artists as collectors, Massimo Valsecchi for his unique knowledge of Claudio Costa's work, and Maria Gilissen for kindly advising me on my text regarding Marcel Broodthaers so that she could set the record straight regarding specific details. In addition the excellently researched exhibition catalogue curated by the late Adalgisa Lugli entitled *Wunderkammer* for the XLII Venice Biennale (1986), was a source of much inspiration.

The absence of a publication which combined so many diverse yet related aspects of the dialogue between the museum and contemporary artists was immediately apparent. The idea of undertaking such a challenge evolved initially from discussions with Calum Storrie, and I am grateful to him for his helpful input into the introduction section of the book and giving me access to his personal library. From the outset, it was crucial to develop a system for presenting the subject visually, a difficult task which Yukiko Kakuta achieved so effectively. In addition she undertook much of the groundwork research and the demanding and often complex job of acquiring illustration material. Above all I am indebted to many artists, colleagues and friends for their enthusiasm and commitment to the project. I share with them a passion for the unique visual poetry of the museum and an interest in examining its institutional role. The traditional museum architectural façade, based on the Greek temple, conveys an impression of power, religion and permanence and it is perhaps a fitting reflection on our contemporary sensibility that it has been likened to both a cathedral and a mausoleum.

My own particular perspective on the subject is that of a curator rather than a theorist and has been shaped from years of working with both historical artifacts and living artists. Although the museum's meticulous organizing principles and unique mode of display have been a major influence on contemporary artists, I have been concerned with showing that there is an ideological exchange taking place where artists exert an equally powerful influence on museums. To present this phenomenon in a coherent form, it has been necessary to devise a classification system, a process which ironically alludes to the museum's own need for ordering systems. Nevertheless, some of the works that I have included under specific headings could as easily fit into some of the other sections. I have avoided introducing a hierarchical system in the book's layout and equal prominence is given to works by younger emerging artists and well-established figures alike. But the need to cover so much material means that in many areas artists are referred to only in the extended captions and I have not set out to provide overviews of their work. Rather than offer analytical interpretations, I have tried to allow the images to speak for themselves, and wherever it seemed appropriate have interwoven quotations by artists into the text.

When I began this project, I set out with an idealistic quest to be encyclopaedic, yet I must accept that, like a museum collection, the publication can only hope to be representative rather than definitive. I have endeavoured to illustrate how the history of modernism inevitably intersects with that of modern art museums and how increasingly the art of the present affects what they exhibit and collect. As the intermediary between the artist and the audience, the museum provides a site for the essential encounter with a work of art and I have faith in its traditional role as a philosophical institution, a place of stimulation and inspiration which serves to mirror aspects of the past, present and future.

J. P.
February 2001

INTRODUCTION

open the box

'Every image of the past that is not recognised by the present as one of its own concerns threatens to disappear irretrievably.'

Walter Benjamin , 'Thesis on the Philosophy of History'

Anyone who has ever wandered around a museum that retains a nineteenth-century display, with a dense accumulation of objects in ranks of vitrines, may wonder how it could possibly relate to the kind of clinical white space usually associated with the contemporary art museum. One notable example of the traditional approach is the Pitt Rivers in Oxford (founded in 1884), which combines its founder's quest for completeness with a continuing aura of 'curiosity' and preserving – virtually unaltered – what is in effect a time-capsule, cocooned from the ever-changing world outside. The diversity of its essentially 'non-art' collection, which lacks the tendency of modern museums to over-interpret, inspires the imagination and tends to generate questions rather than give answers. Many feel that the particular nineteenth-century display aesthetic of such institutions which have escaped modernization approaches an art form in itself. In complete contrast,

the modern art museum has created its own, purist display aesthetic, a highly self-conscious viewing space which proclaims the institutionalization of art. The resulting idealized neutrality of the white interior is thus offset by a need to re-establish the heterogeneous spirit of the traditional museum through art. What is most intriguing is the way in which the museum concept has developed into an expression of multiple commitments and roles, which have in turn become increasingly conflicting and ambiguous. Although the nineteenth-century encyclopaedic approach represents the very antithesis of methods of display in the modern art museum, the two types are in fact connected, not merely through the process of museological evolution but also because many con-temporary artists have been inspired by the wider notion of the museum which such places embody – that is to say as an institution, an idea and a practice.

A natural starting-point for examining the relationship between artists and museums is the cabinet of curiosities or *Wunderkammer*, which existed in Europe from the sixteenth to the eighteenth century.[1] This early ancestor of the museum possessed a special quality in tune with the creative imagination, a quest to explore the rational and the irrational and a capricious freedom of arrangement. It is this apparent lack of rational classifica-tion, with its bizarre sense of accumulation and juxtaposition, that makes the *Wunderkammer* concept aesthetically so appealing. But the unscientific form of these pre-Enlightenment collections even-tually led to the dispersal of their contents and to the birth of the museum as we know it today. It is possible to identify two dominant tendencies, in which the artist confronts miraculous aspects of the *Wunderkammer*. One is as a collector, who uses assemblage through the arrangement and juxtaposition of diverse collected

ROBERT FILLIOU
THE FROZEN EXHIBITION
1972

This scaled-down retrospective in a cardboard bowler hat evolved from Filliou's earlier Galerie Légitime, 1962. As a challenge to the static nature of the conventional museum, the artist would wear a real hat around Paris and present its contents to strangers and to those he met in the street.

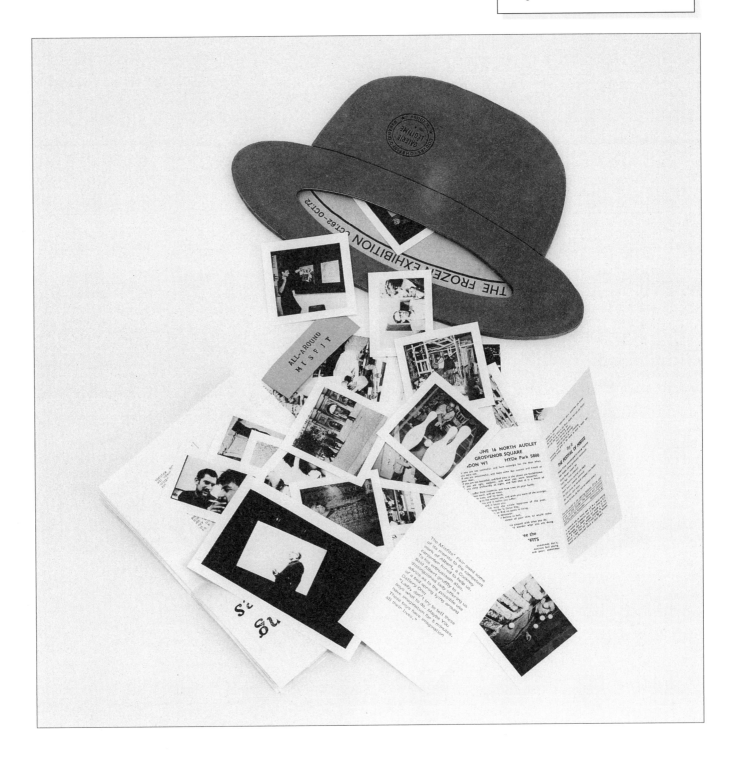

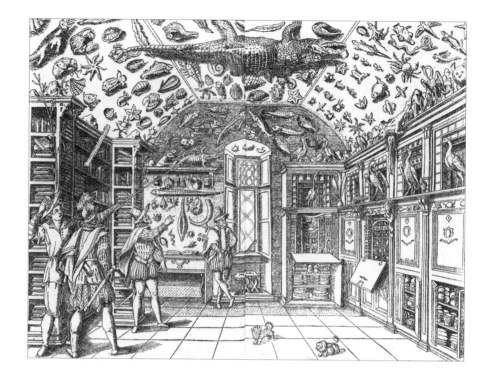

The *Wunderkammer* of Ferrante Imperato, Naples
From *Historia Naturale* by Ferrante Imperato
1599

Based on the idea that the entire cosmos could be
controlled within the confines of a private room,
the *Wunderkammer* was an expression of a particular
individual's collecting interests. Rare, precious and
bizarre objects were intended to arouse wonder in
the mind of the viewer and to provide aesthetic
pleasure. A delight in the anomalous was also in tune
with the Mannerist taste of the late sixteenth century.
The *Wunderkammer* was linked to the creative imagi-
nation and has parallels with the work of the Dadaists,
the Surrealists and some contemporary artists.

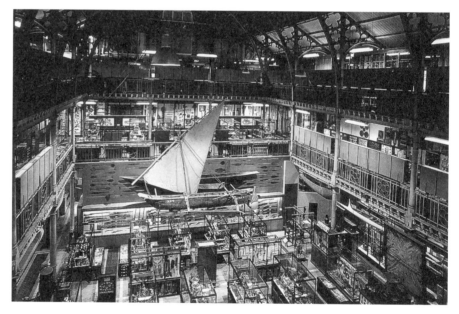

The Pitt Rivers Museum,
Oxford

The diverse collections of the noted anthropologist
General A.H.L.F. Pitt Rivers (1827–1900) form the
basis of the museum, which has been greatly expanded
since its foundation in 1884. They include ethno-
graphical, prehistoric and natural history material.
The museum's original closely packed style of display,
with its selective taxonomies, remains unchanged and
continues to provide artistic inspiration.

objects. The other is by exploring the
parameters between natural and artificial
materials, by imaginative manipulation and
transformation, as illustrated in the work of
the Surrealists. The *Wunderkammer* was a
very private and devotional place specially
created with the profound belief that
nature was linked with art.

The collections were usually displayed in
multi-compartmented cabinets and vitrines
and arranged in such a way as to inspire
wonder and stimulate creative thought.
They included exotic natural objects that
crossed the rational boundaries of animal,
vegetable and mineral, such as fossils,
coral formations and composite creatures,

basilisks and mermen. Particularly desir-
able were anomalies or freaks of nature
and optical wonders like special mirrors
and lenses capable of distorting reality.
It is possible to apply the '*Wunderkammer*
principle' to the invention of the miracu-
lous in art. Many artists have shared this
fascination with the subversion of natural

order, as illustrated in the paintings of Hieronymus Bosch and Giuseppe Arcimboldo which include fanciful composite creations derived from animal, vegetable and mineral sources. A thread of continuity extends into the twentieth century and it is possible to see similar mechanisms at work particularly in the case of the Dadaists and Surrealists, and of the Post-Modern avant-garde artists in the 1970s and 1980s.[2] The *Wunderkammer* also embraced the notion that the world exists to be containable in one room or cabinet, a pre-programmable personal environment. A parallel process exists in the way some artists create and orchestrate their own aesthetic spaces, in isolation from the outside world. Kurt Schwitters used his own house in Hanover as a vehicle for his spatial experiments with his *Merzbau* (begun in 1919), which became a microcosm of his artistic practice. In his poetic assemblages, created from ephemera and small found objects, Joseph Cornell also constructed very personal microcosms in the form of narrative assemblages. The earlier versions in 1932

KURT SCHWITTERS
HANOVER MERZBAU: VIEW WITH BLUE WINDOW
1933

Throughout the 1920s and up to 1936, Schwitters obsessively transformed a number of rooms in his home into a unique spatial environment. The *Merzbau* functioned as a sort of container for a variety of objects having personal significance for the artist, a synthesis between Constructivist and Dada elements. Schwitters went on to develop various 'caves' and 'grottoes', some of which were left visible through glass fronts, while others became completely hidden. At its most developed stage the *Merzbau* contained 40 grottoes, variously dedicated either to people or to symbolic or topographical subjects.

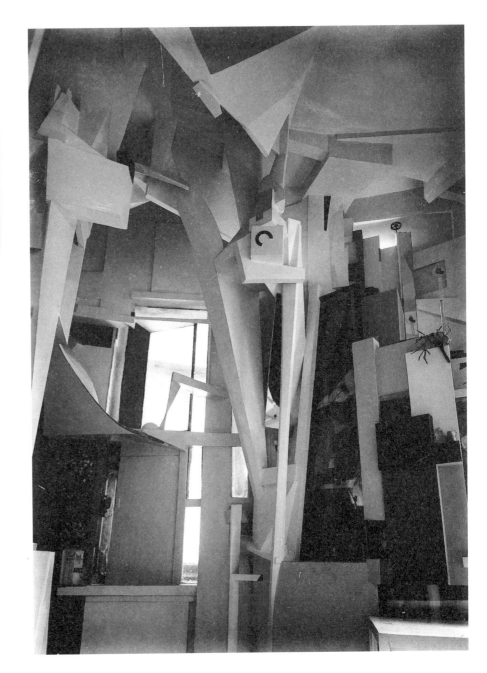

were contained in bell-jars of the type
used for the display of stuffed birds, but
small glass-fronted containers – 'shadow
boxes' – became his most familiar mode of
presentation during the 1940s and 1950s.

The Surrealists made unusual accumula-
tions of disparate objects. André Breton's
collection included a mandrake root in
the shape of a person, embalmed animals,
shells, ethnographic objects from Africa
and Oceania, incised bones and stones
and a mirror that multiplied the image.
Surrealism practises on a wide scale the
Wunderkammer principle, with its mixture

or fusion of diverse elements and materials,
because of its resistance to their separation
by specialized classification in the real
world. Many twentieth-century artists have
followed a collecting principle, akin to the
Wunderkammer, which embodied an
element of free association where the mind
could roam at will. The subject matter of
such a collection might be both eclectic
and personal, bound up with memory and
imagination, accumulation rather than
sheer calculated order and selection. The
artist frequently has an attitude of mind
similar to that of the *bricoleur,* motivated
by an instinctive and mysterious love of
things which have no known relationship
to one another. This is the result of a *Sam-
meltrieb* or primal urge to collect, or as
Walter Benjamin put it: 'Animals (birds,
ants), children, and old men as collectors.'
According to Benjamin, collecting is also a
form of memory: 'Every passion borders on

the chaotic, but the collector's passion
borders on the chaos of memories.'[3]

The artist's urge to accumulate objects
in the studio is part of the age-old human
impulse to gather and hoard. But artistic
collecting is very different from that of
the hobbyist or the 'serious' collector
and it has a distinct character which links
it to the creative process. Historically,
paintings have shown artists at work in
their studios surrounded by diverse
collected objects which they might depict
as still-life studies to enhance the back-
ground of formal portraits. In the twentieth
century artists may actually use the things
they collect as an integral part of a work.
With the early modernists, collage became
an offshoot of artists' collections where cut-
out images, ephemera and even small
found objects were applied directly to the
canvas support. Max Ernst used printed
illustrations, Kurt Schwitters used dis-
carded tram tickets and Hannah Höch
made assemblages from photographs.
The increasing assimilation of the found
object into a work of art of course owes
much to Marcel Duchamp.

Through his principle of the 'Readymade'
Duchamp was able to demonstrate in 1917
that something as ordinary as a standard
urinal could be accorded the title *Fountain*
and transformed at will into an art object.
He claimed to have chosen mass-produced
objects like the urinal, bottle-rack and snow
shovel in moments of 'aesthetic amnesia'
and to have displayed them, alone and
empty of aesthetic presumption, precisely
to ridicule the 'aura' of value and prestige
that traditionally accrues to the art object.

Through his Readymades Duchamp had indirectly mocked the museum concept and challenged the uniqueness of genuine works of art – an idea that has continued to inspire succeeding generations of artists. The artistic tendency to gather together large quantities of society's cast-offs and the extension of the notion of the *objet trouvé* coincides with the vast post-World War II growth in consumer goods. In the early 1960s, flea-markets, rubbish tips and the streets provided endless supplies of working materials for artists like Robert Rauschenberg, Allan Kaprow and Ed Kienholz, just as they had for the Surrealists in the 1930s.

During this period Claes Oldenburg created a series of works that broke through the boundaries of performance, installation and display. His installations 'The Street' of 1960 and 'The Store' of 1961 were sites for exhibition, live art and the selling of work. In his notebook written during the year-long life of 'The Store', he wrote: 'I am for art that is political-erotical-mystical, that does something other than sit on its ass in a museum.'[4] In this installation Oldenburg used found and altered objects as display and as consumable art. The inventory for 'The Store' of December 1961 lists

107 items which he referred to as 'charged objects'; these were things which had been transformed, not only through the artist's intercession but also through actual change via their 'participation' in the installation and 'The Store'. Oldenburg's position was to shift later in the decade, when Pop art became a runaway success and much of the work made by the Pop artists, including that by Oldenburg himself, did indeed sit 'on its ass in museums'. A similar idea was explored by Daniel Spoerri, who created a grocery store stocked with all sorts of packages stamped 'Attention – work of Art'. Here each item was offered for sale at the same price as the genuine article when sold in a normal store. Of course,

much of this work depends for its historical legitimacy on the foundations laid by Duchamp with his 'Readymades'.

Daniel Spoerri, along with Yves Klein, Jean Tinguely and Arman, was a member of the French movement Nouveau Réalisme, which was formed in 1960. In common with a number of prominent artists based in New York at the time, they used collections of discarded materials which were presented in the form of assemblages, tableaux, happenings and environments. Perhaps the most notorious example of mass-accumulation was Arman's exhibition 'Le Plein', where an art gallery was crammed from floor to ceiling with detritus

ARMAN
LE PLEIN ('FULL-UP')
Detail of installation at the Iris Clert Gallery, Paris
1960

With the help of his artist friend Martial Raysse, Arman spent an intensive week collecting enough rubbish from streets and dustbins in Paris to fill the entire gallery and kept an inventory of everything he included. Although the original intention had been to exhibit only household cast-offs, he also included a quantity of organic material, but after thirteen days the resulting smell had become so unpleasant that the exhibition had to be closed.

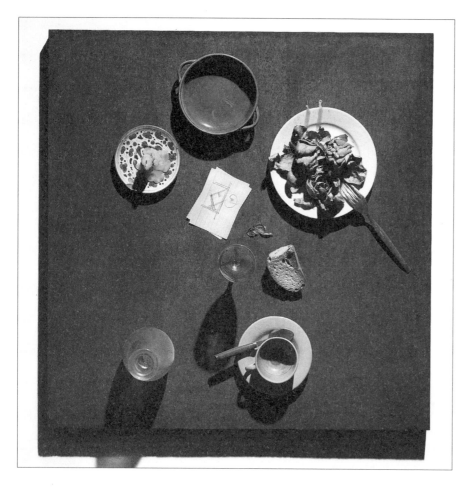

PIERO MANZONI
MERDA D'ARTISTA NO. 58
1961

Manzoni challenged many traditional notions of
artistic value by designating what he chose to sign
as a work of art, whether it be a person or a
potentially worthless artifact derived from his own
body. In 1959, Manzoni had proposed the idea of
displaying living people as art and encapsulating
human bodies in transparent plastic. In the same
year he preserved a series of 45 'pneumatic
sculptures', inflated by means of his own breath.
Two years later, he went on to produce 90 sealed
cans containing his own faeces; the contents
weighed 30 grams and each can was individually
signed and numbered.

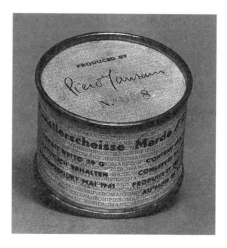

DANIEL SPOERRI
SNARE PICTURE
1972

From the early 1960s, Spoerri produced a series of
tableaux pièges (literally 'snare pictures'), trapping
random groupings of objects at a given moment,
frozen in time. In each of these assemblages cutlery
and crockery, together with plates and dishes,
complete with meal leftovers, were fixed down to
a table-top which was then mounted on the wall
as a vertical display.

collected from the streets of Paris. This was
the perfect foil to Yves Klein's 'Le Vide',
held two years earlier in the same gallery,
which involved an entirely empty interior
painted white.[5] These artists wanted to
identify themselves with tangible objects in
reaction to the Abstract Expressionism that
had previously dominated the art scene,
and what is significant here is the mode
of display adopted by both Arman and
Spoerri. They frequently presented
arrangements of objects either in
see-through containers or mounted on
a hard support. Arman showed his
'Poubelles' (dustbins) consisting of clear
acrylic containers full of discarded waste
items. He also set multiples of any type
of object, from door-handles to watch
parts, into clear resin. The containers
had the effect of framing the subject,
drawing the observer's attention to
recognize the strange beauty of cast-off
materials, which thus become endowed
with a whole new aesthetic structure.
A similar principle is employed by Daniel
Spoerri in his 'snare pictures', which
consist of table-tops with objects and

meal leftovers fixed to the surface and then
displayed vertically on the wall.

Since the late 1960s artists have increas-
ingly made use of the display case or the
vitrine to present their work, and this prac-
tice has become a familiar one in galleries
devoted to contemporary art. The vitrine
was originally adopted by the Church for
preserving and venerating the relics of
saints – a practice which helped to enhance
the powerful presence of the holy and
sacred. It embodies a very particular display
aesthetic which has a singular ability to
transform magically the most humble
object into something special, unique and
generally more attractive or fascinating.
Once placed in a vitrine, an object is

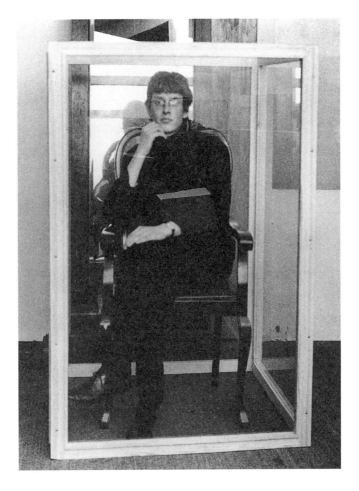

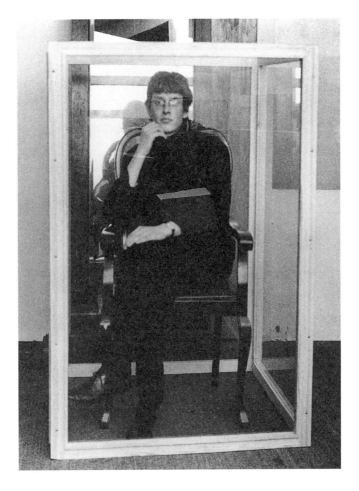

TIMM ULRICHS ⟲

**TIMM ULRICHS ⟲
THE FIRST LIVING WORK
OF ART**
1961

Ulrichs' work was probably the earliest example of
an artist using a vitrine to exhibit himself; based on
the principle of 'art is life and life is art', the
performance was recorded in a photowork shown
at the Juryfreie Kunstausstellung Berlin in 1965. A
later version was staged at the Karl Ernst Osthaus-
Museum, Hagen, Germany, in 1991.

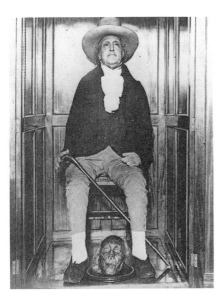

⟲ The *Auto-Icon* of Jeremy Bentham (1745–1832)
University College, London

Bentham's *Auto-Icon* or self-image – his clothed
skeleton with lifelike wax head displayed in a vitrine in
the college entrance lobby – has parallels with the more
recent notion of displaying live models as works of art.
The presentation of Bentham's skeleton and
mummified head (seen in the foreground) was in
keeping with the wishes of this eccentric English
philosopher and jurist. In 1974, Bentham's *Auto-Icon*
was featured in a film entitled *Figures of Wax* made by
the Belgian artist Marcel Broodthaers.

perceived in a completely different way by
the viewer, as compared with when it is
viewed in its original context. The vitrine
functions as a means of protection both
from the elements and the spectator, who
is thus physically separated from its con-
tents. Almost like a peep-show it seduces,
concentrating, looking, staring at the
untouchable and the unattainable. The

vitrine shares with the shop window and
commercial display case the power to catch
the attention of the passer-by. The albums
of photographs of shopfronts and window
displays in Paris, taken in the 1920s by
Eugène Atget, who influenced the Surreal-
ists, explore the possibilities of the vitrine
without the mediation of authority inher-
ent in the museum display.

The use of the vitrine in science and
medicine is linked to the need to keep a
specimen in a still viewable, arrested state
of being. The practice of preservation of
museum exhibits by taxidermy, pickling,
dehydration etc. illustrates the desire to
suspend time and stabilize objects against
decomposition. It also keeps the viewer at

a comfortable, voyeuristic distance, so
avoiding direct contact with something
perhaps distasteful yet fascinating, such
as an anatomical dissection. The vitrine's
associations with both science and the
Church relate to its role as bodily con-
tainer, and a number of artists have even
exhibited living people or themselves in
vitrines as part of a wider fascination with
their exploration of the material self or
the body. This idea has an intriguing
precedent in the philosopher Jeremy
Bentham's *Auto-Icon*, and in recent years
living people have been exhibited in vit-
rines as a form of performance art.[6] Artists
might also create works from intimate
personal possessions, keepsakes or even
body fluids which, like both reliquaries

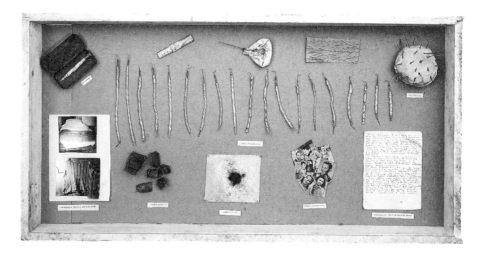

and museum artifacts, serve as tangible evidence of their existence. Thus Piero Manzoni's works *c.* 1960 are effectively personal relics which also relate to the authentication and value of art.[7]

In some of the works of Christian Boltanski and Joseph Beuys the vitrine has connections with both the melancholic funereal quality of the church reliquary and the use of the glass-sided incubator for premature babies. Beuys often used vitrines to contain a diverse range of materials that have references to his own life and include relics of his 'actions' or performances. The vitrine came to form part of the language with which Beuys made his art works, providing a 'neutral' protected space for elements that otherwise might be seen as fugitive. This is, of course, the *raison d'être* of the museum showcase and, in this, Beuys's position in relation to the museum is made clear. He used the elements available as a vehicle for his ideas and so the museum and its component parts came to be another set of tools to be used in his argument. His use of this language is shown most clearly in the installation which he organized as a permanent suite of galleries at the

Hessisches Landesmuseum in Darmstadt in 1970. This is situated directly above the museum's old natural history displays, a fact which appropriately echoes Beuys's own emphasis on the link between art and science, past and future and the personal and universal. In terms of its presentation of curious objects in vitrines, the *Beuys Block* is, in effect, a museum created by the artist which stealthily usurps the conventional museum to his own ends. It is both a concentration of Beuys's work and his vision of his relationship with the world using personally symbolic collected objects.

The activities taking place behind the scenes in museums have been as important as the modes of display in public areas. There is the interesting contrast between revealing and concealing, as illustrated in the common museum process of choosing to exhibit one object while keeping others in reserve storage. The establishment of systems of organization is as instinctive to human nature as is the accumulation and collecting, and artists frequently imitate the institutional practice of creating inventories and archives as part of a working process. Joseph Cornell carefully

preserved all kinds of material that was surplus but related in some way to his main body of work, keeping it in shoe-boxes and other improvised archive boxes. In 1946 he presented an exhibition called 'Romantic Museum: Portraits of Women', which was derived from a body of his works that he referred to as 'dossiers'.[8] These were unfinished works, housed inside document boxes which were intended to be added to and subtracted from as part of his working research process. The basement of the Cornell family home served as the storeroom for these dossiers and constructions, all carefully filed into the relevant categories. He had wanted his house to become a permanent museum after his death, but although the accumulated stores were kept together, they were transported to Washington to become an archive within the Smithsonian Institution. One of Cornell's archive boxes which recently came to light reveals that he assisted Marcel Duchamp in making the various elements of his portable museum, the *Boîte-en-valise*.[9]

From 1974 Andy Warhol created 'Time Capsules', obsessively packing and storing

ANNETTE MESSAGER
ALBUM COLLECTIONS
Installation at the Städtische Galerie im
Lenbachhaus, Munich
1973

Assembling collections in the form of scrapbooks,
Messager compiled a numbered sequence of 56
albums between about 1971 and 1974. Her first
collection was taken directly from the commem-
orative tradition of marriage albums, and she
substituted her own face and name for those of
the real brides. Subsequent albums chronicle
fictional events in her life, frequently using
illustrations from magazines. Her entire album
collections have been displayed as a form of
archive in vitrines at a number of contemporary
art venues.

JOSEPH BEUYS
BEUYS BLOCK:
VIEW OF ROOM 3
Hessisches Landesmuseum, Darmstadt
1970

This, the largest group of Beuys's vitrine sculptures,
is regarded as the most definitive example since
the works were installed personally by the artist. He
once suggested that his fascination with glass
began at birth when as a premature baby he was
placed in a glass-sided incubator. The vitrines serve
as displays of relics of Beuys's life and contain a
diverse selection of objects used in his Actions of
the 1960s and early 1970s, brought together in
what he called a 'constellation of ideas'.

all kinds of ordinary objects which he accumulated from day to day. These were standard-size cardboard cartons which, when full, were labelled, sealed and sent into storage in New Jersey. They were filled with everything that passed across Warhol's desk, including magazines, invitations, photographs, unopened letters and, occasionally, clothes. The 'Time Capsules' now form the core of the archive housed at the Andy Warhol Museum in Pittsburgh. Warhol used the 'Time Capsules' as a kind of repository for his own past; in his diary entry of 24 May 1984 the artist notes: 'I opened a Time Capsule and every time I do it's a mistake, because I drag it back and start looking through it …'.[10] Warhol expressed

and extended this fascination for things hidden and stored when, in 1969, he was invited by the Rhode Island School of Design to curate an exhibition of work selected from the collection of its own Museum of Art in Providence. Called 'Raid the Icebox', the show was part of a series conceived by John and Dominique de Menil, 'who wanted to bring out into the open some of the unfamiliar and often unsuspected treasures moldering in museum basements, inaccessible to the general public'.[11] Instead of selecting individual examples for display, Warhol chose to exhibit complete groups of related objects exactly as he had found them in the storeroom, for example by bringing all the chairs out of storage. When it came to the shoe collection, the Museum curator pointed out that this process would result in duplication of some pairs or in showing inferior examples of particular types of shoe, but Warhol insisted on including the complete collection. 'There were exasperating moments when we felt that Andy Warhol was exhibiting "storage" rather than works of art, that a series of labels could mean as much to him as the paintings to which they refer. And perhaps they do, for in his vision, all things become part of the whole and we know what is being exhibited is Andy Warhol.'[12] This exhibition has become historically significant as having set a precedent for other museums to follow, by inviting artists to act as guest curators.

While the idea of the artist's museum is essentially a tendency in twentieth-century art, it has some parallels with the extra-

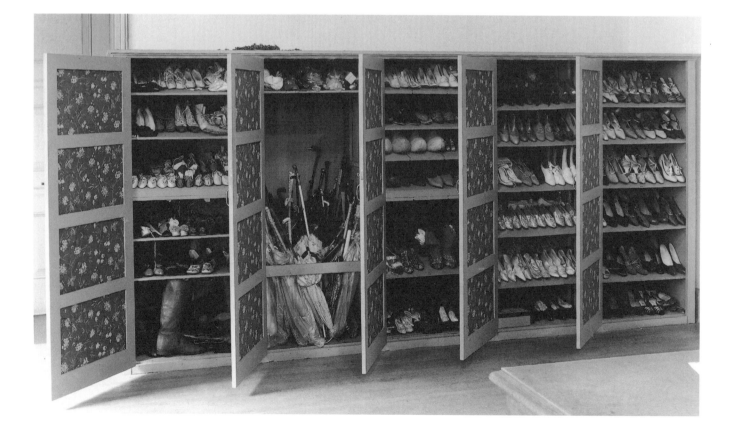

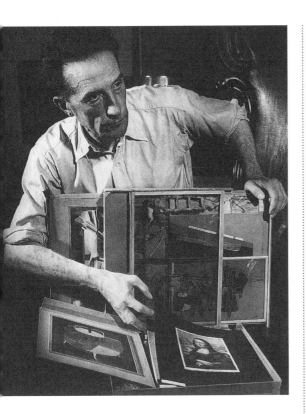

ordinary personal museums created in England, over a hundred years earlier, by the architect Sir John Soane and in America by the painter Charles Willson Peale. In his London house Sir John Soane designed a special rotunda, crammed from floor to ceiling with three storeys of sculptures and architectural fragments, at the centre of which he placed a bust of himself. On the other side of the Atlantic in Pennsylvania, Charles Willson Peale, the painter of Revolutionary heroes, created the first American Museum. This included vitrines containing his large collection of natural history specimens arranged in a hierarchical display which conformed to his knowledge of the Linnaean system.[13] Artists are inevitably collectors of their own works in finished and preparatory form, which they might periodically reappraise and modify. By necessity their studios might even need

to be organized in a way similar to museum storerooms. Perhaps the most immediate artist's museum involves the presentation of an individual's own work: thus Duchamp's *Boîte-en-valise* is effectively a portable museum of his works in miniature enclosed in a custom-made suitcase. He decided to develop a retrospective of his existing art, which involved making miniature representations of paintings, graphics and Readymades to fit inside an attaché case. Between 1935 and 1940 he created a deluxe edition of twenty boxes, all in brown-leather carrying cases but with slight variations in design and content. During the 1950s and 1960s, he released an edition consisting of six different series in archive box form. Each box unfolds to reveal various works displayed on pull-out and standing frames. Since the content was rearrangeable, both the artist himself and the individual collector could assume the role of curator.

Duchamp's artistic use of the anonymous-looking attaché case was appropriated by the Fluxus artists for housing their numerous *Fluxkit* editions. These were described as 'miniature Fluxus museums' by the movement's founder, George Maciunas. Between 1975 and 1977, Maciunas assembled what was to be the last Fluxus anthology: the *Fluxcabinet*. This was a wooden cabinet with twenty drawers containing objects by fourteen Fluxus artists. For drawer 12 he contributed his *Excreta Fluxorum*, a taxonomic presentation of insect and mammalian faeces, arranged hierarchically according to their evolutionary order. Other participants created alternatives to the static museum,

and Robert Filliou made what was, in effect, a museum in a hat (with the objects tucked into the band) which became *The Frozen Exhibition* (1972).

For his 'Museum of Drawers', Herbert Distel conceived the idea of creating an entire museum of modern art in a multi-drawer cabinet. He invited artists to contribute works in miniature scale mostly dating from the 1960s and 1970s. Each work was contained in one of the 500 compartments of a cotton-reel cabinet,

Sir John Soane's Museum, London
The rotunda, looking east, with the bust of Sir John Soane in the middle

In 1833, Sir John Soane directed that his house in Lincoln's Inn Fields should be bequeathed to the nation and preserved 'as nearly as possible in the state' in which it was left at the time of his death (which occurred four years later). Although Soane is noted mainly for major architectural projects such as the Bank of England, his house and museum have come to be widely regarded as being close to an art form.

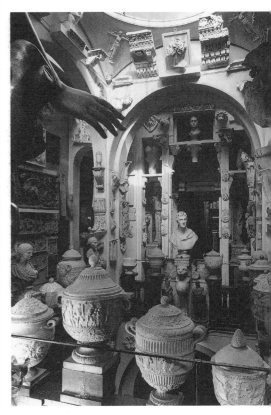

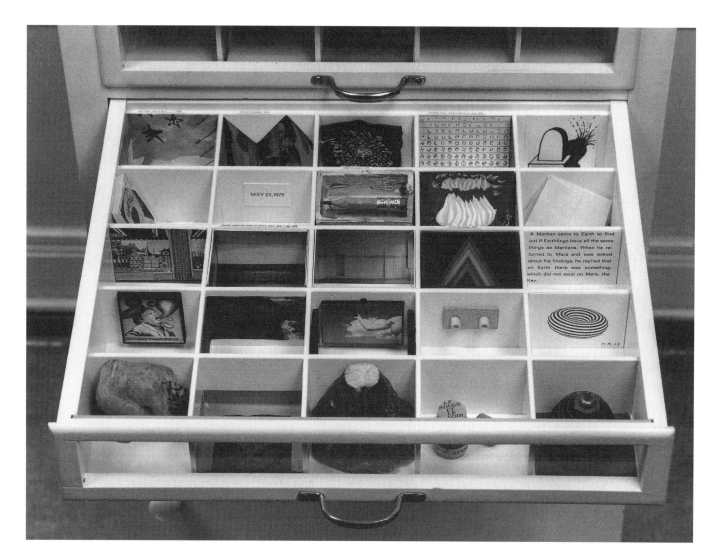

in which each compartment represented a 'room' of the museum. In 1972, the 'Museum of Drawers' was included in the exhibition Documenta V in Kassel, an event which represented a watershed in the relationship between the institution of the museum and contemporary art. This exhibition attempted to show the strands in contemporary art, including land art, film as art and the artist's museum which, along with Distel's creation, included examples of works by Marcel Duchamp, Claes Oldenburg, Ben Vautier and Marcel Broodthaers. Though a relatively small proportion of a massive summary of

current practice, this exhibition marked an acknowledgment of a significant tendency. It provided the opportunity for Oldenburg to show his 'Mouse Museum', a collection of found and fabricated material which he had built up and displayed in his studios during the mid-1960s. The 385 miniature consumer objects and toys which were retrieved from Oldenburg's studio were displayed in linear form in a continuous vitrine, and the plan of this building within a building takes its shape from a distinctive cartoon mouse. Although this shape may be unreadable from the ground, the museum structure is used as a logo and thus

HERBERT DISTEL ↻
MUSEUM OF DRAWERS
1970–77

Distel invited artists to contribute a miniature work of art to the museum he was both creating and curating. This was housed in a former cotton-reel cabinet with a total of 500 compartments in twenty drawers set on a base made by Ed Kienholz. The artists represented included many well-known names, such as Picasso, but some of them have since sunk into relative obscurity.

⊕ DETAIL OF DRAWER NO. 8
An open drawer reveals 25 individual partitions, each containing a miniature work by a different artist. Those featured here are (from left to right): Paul Thek, Larry Rivers, Richard Estes, Peter Nagel, Alfred Hrdlicka; Billy Al Bengston, On Kawara, De Wain Valentain, Mark Tobey, Moshe Gershuni; Annette Messager, Stephen Posen, Giuseppe Penone, Christian Vogt, Philip King; Manfred Mohr, Jacques Hérold, Lucio Sel Pezzo, A.R. Penck, Eugenio Miccini; Dieter Roth, John Latham, Nam June Paik, Markus Raetz, Franz Eggenschwiler.

integrated with the collection, so becoming, in effect, another exhibit. There is no hierarchy to the display of found, bought or modified objects and maquettes, and they are all preserved just as if they were still in use as the artist's 'notebook' of forms. The installation, though by no means portable, refers back inevitably to the *Boîte-en-valise*. It was subsequently shown in its final form in Chicago in 1977 and then in Cologne and Otterlo in 1979. After Documenta V a second element was added to the ensemble: the *Ray Gun Wing*. Again the form of the structure is dictated by its contents and here the objects are selected for their similarity in form to that of a pistol. The *Ray Gun Wing* adds an ironic comment on the scholarly approach to museum making and to the expansion of museum buildings. Neither the objects on display in the 'Mouse Museum' nor the *Ray Gun Wing* are 'new' work made for exhibition; instead these installations are more properly seen as yet another view of Oldenburg's output.

'Fiction enables us to grasp reality and at the same time that which is veiled by reality', wrote Marcel Broodthaers, who in 1968 first developed his critical concept for the *Musée d'Art Moderne, Département des Aigles* ('Museum of Modern Art, Department of Eagles').[14] Using the device of the heraldic eagle to symbolize the authority of the museum and the tendency for it to be divided into various departments, he went on to make a series of twelve sections, in each of which he acted as its director, curator, designer and publicist. This earliest section of the museum was a kind of installation –

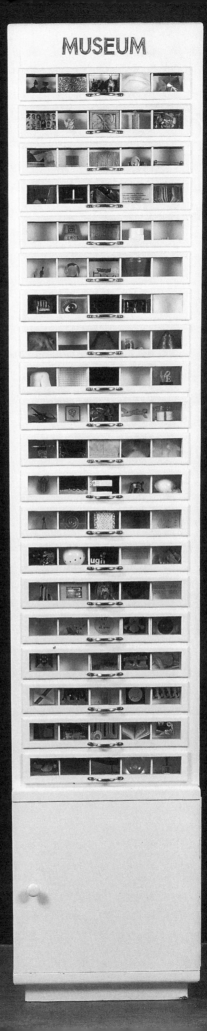

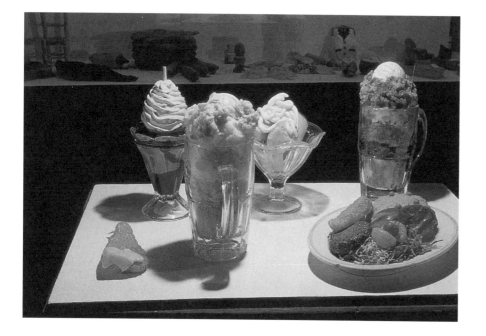

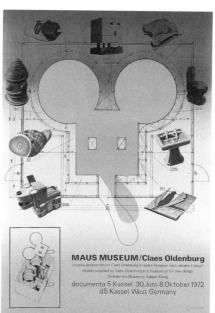

CLAES OLDENBURG
MOUSE MUSEUM
Installation; detail
1965–77

The artist's notebooks of 1965–66 contain plans to found a 'museum of popular objects'. The museum is housed within a series of display cases made from wood, corrugated aluminium and Plexiglas. This microcosm of objects, a few of which are shown here, is intended to reflect not only Oldenburg's working process, but also his percep-tion of stereotypes in American society. Although somewhat diverse in their classification, the groups of objects exhibited are unified through their form, colour, texture and proportion.

CLAES OLDENBURG
POSTER FOR THE MOUSE MUSEUM
1972

The floor-plan of Oldenburg's museum is based on both the form of an early movie camera and a cartoon mouse-head. The poster, measuring 78.4 x 55.9 cm (31 x 22 in.), was designed by Oldenburg himself and printed as a lithograph to advertise the first showing of the museum at Documenta V in Kassel, Germany. The artist decided to exhibit his collection in display cases after seeing Joseph Beuys's vitrines at Darmstadt Museum earlier in the same year. It consists of 385 found and modified everyday objects and toys which he had accumulated in his studio since the mid-1960s; 367 items were selected for display in 1972.

which he staged at his own house in Brussels – consisting of empty packing crates, postcards of French nineteenth-century paintings fixed to the wall, a slide projection of prints by Grandville, and even a turtle living in his garden. On the opening and closing days of the nineteenth-century section, exactly one year apart, an empty transport container was parked outside the building, suggesting the recent arrival/imminent removal of the collection on display. On the night of the closure invited guests were taken by coach to Antwerp to attend the opening there of the seventeenth-century section of the *Musée*. This new stage repeated the style of the first section, but contained a different set of reproductions, all but one being works by Rubens. These events marked the beginning of a continuous, itinerant project and along the way the *Musée d'Art Moderne, Département des Aigles* covered various subjects: literature, folklore, cinema, finance, publicity and modern art.

Broodthaers also created a more informed and ephemeral section of the museum on the beach at Le Coq in 1970, assisted by Herman Daled. Both men donned canvas hats daubed with the word 'Museum' and drew a notional museum plan in the sand. This was a form of archaeological invention and, when the dig was complete, bilingual (French and Flemish) signs were erected saying 'Touching the objects is absolutely forbidden'. A year later, at the Cologne Art Fair, he presented the *Musée d'Art Moderne, Département des Aigles, Section Financière*, which was an announcement of the bankruptcy of this fictional museum. The museum was put up for sale and, in order to publicize the idea, he intended to offer for sale 'an unlimited edition' gold ingot, stamped with an eagle motif.

In 1972 Broodthaers was invited by the director of the Kunsthalle in Düsseldorf to make what was to be the most extensive manifestation of the museum. 'La Section des Figures' ('Figures Section') – *The Eagle from the Oligocene to the Present*, comprised

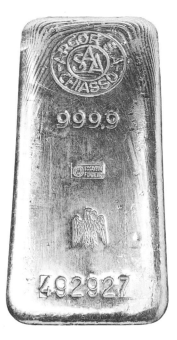

over 300 objects in a wide variety of media, all representing eagles, borrowed from various museum and private collections. They were displayed in vitrines, each with an engraved plastic label declaring in French, German or English 'This is not a work of art!'. The installation looked like a 'normal' museum exhibition, but at the point of the visitor's encounter with each object, the arbitrarily placed eagle and its label revealed the subversive quality of the display. Like most thematic exhibitions, it was didactic in content, although there was no explanation of development or origin. Formal links between objects, though established by the choice of the subject 'eagle', were not elaborated. This was an exhibition which existed in its own dialectical sphere, calling into question the museum processes of selection and ordering as applied to the presentation of contemporary art.

Language is an essential factor in all of Broodthaers' work, which is not surprising given his background as a poet, and he maintained that 'the language of forms must be united with that of words'.[15] He recognized the significance of the relationship between the museum label and the object it describes and his work conveys an urge to free the written word from this traditional subordinate role. In the Düsseldorf exhibition he made particular play on the gulf that exists between word and image and the fact that the museum seeks to deny this reality in its attempt at a unification of word and object. A label which reads 'This is not a work of art!' refers to the object, to the ensemble of label and object, to the exhibition and, in the manner of the joke enacted by children, to the label itself. There is, of course, also an in-built homage to René Magritte's labelled depiction of a pipe: 'Ceci n'est pas une pipe.' Magritte labelled objects in such a way that they were not described; his labels address the viewer, rather than describe the object, in terms such as 'here is …' or 'this is …'. Broodthaers draws attention to the complexity of the relationship between

object and label in three dimensions. As
Duchamp's 'Readymades' made clear, the
function of an art museum, as of the artist
working within its discursive authority, is
to declare, in regard to each of the objects
housed there: 'This is a work of art.'.
Broodthaers' labels reverse this proposition
through the application of Magritte's
formula, and his museum thus becomes the
location of the 'non-artwork'. In the Düs-
seldorf exhibition catalogue, he specifies
that in fact the meaning of these labels is to
be construed as 'Public, how blind you are',
and that they 'illustrate an idea of Marcel
Duchamp and of René Magritte'.[16]

In the same year, the final manifestation
of his *Musée d'Art Moderne* was shown
in Kassel in two parts at Documenta V.
The 'Section Publicité' was installed on
the ground floor of the Neue Galerie; this
included catalogues and photographs from
previous sections and a few vestigial, empty
frames containing references to non-
existent figures. In the upper gallery, the

'Section d'Art Moderne' ('Modern Art
Section') now comprised only a series of
signs and labels, with lettering and direc-
tional arrows applied to the walls, pointing
the way to non-existent cloakrooms and
offices. On the window, and visible from
outside, was painted 'Museum/Musée', and
on the inside 'Fig. 0'. On the floor, in the
centre of the gallery, the words 'private
property' (in German, English and French)
appeared in gold on a black-painted square
protected by stanchions. Halfway through
the installation's life, Broodthaers replaced
these words with 'to Write, to Paint, to
Copy, to Represent, to Speak, to Form, to
Dream, to Exchange, to Make, to Inform,
to Be Able To' (in French). He also
amended the lettering on the walls to read
'Museum of Ancient Art, Department of
Eagles, 20th-century Gallery' (in French).

Daniel Spoerri's fictional museum,
the 'Musée Sentimental', like that of
Broodthaers, had no permanent collection
or home and was staged in four different

permutations and locations between 1977
and 1989.[17] Inspired by a museum of the
same name he had discovered in Barcelona
in the mid-1960s, Spoerri suggested that
his idea of the 'Musée Sentimental' had
most in common with the *Wunderkammer*.
In Spoerri's museum the traditional
categories and hierarchies were abolished
and history, memory, science and myth
are reunited. The exhibitions' significance
lay not in their presentation, which con-
formed to a conservative museological
style, but in the curator/artist's choice of
objects, the criterion for which was their
importance relative to their urban contexts;
and while the objects did not constitute
the most important historical or artistic
artifacts from the various cities, their selec-
tion represented an attempt to compile
an inventory of what was significant.
'Key words' were matched up to exhibits
and the display was then arranged alpha-
betically using these words as the basic
point of departure. The correspondences
and relationships thus built up resemble

the interconnecting networks of the city. Like so much of significance, these items displayed aspects of the everyday or have a particular resonance by association.

Spoerri's museum was first presented in 1977 in Paris at the Centre Georges Pompidou, where he also created a museum shop called the 'aberrant boutique' within the frame of an enormous welded metal sculpture by Jean Tinguely. The shop offered for sale all manner of objects donated by artists at Spoerri's request; they included old tools, brushes, palettes and unfinished works, and all proceeds were used to benefit Amnesty International. The 'Musée Sentimental' itself was installed in a long dark corridor with different configurations of vitrines inset into the walls. Most of the objects on display related to French culture, and included relics like Vincent van Gogh's furniture, René Magritte's bowler hat, toy horses owned by Marcel Duchamp and Ingres' violin. The second 'Musée Sentimental' was designed on a much larger scale in the Kunstverein in Cologne in 1979. Since he had been invited to teach at the art school there, Spoerri involved his students in the project. They divided the museum into 120 sections, each containing several objects. These included items as diverse as a piece of lead from the roof of the cathedral damaged during World War II, a football used in an important league fixture and a pair of muddy boots found after the city's carnival weekend.

Beyond appropriating and applying museological principles to their work, artists have in practical terms become increasingly interested in exploring the museum's wider institutional framework. This phenomenon needs to be examined against the historical background rooted in the avant-garde and in the prevailing social and political climate of the 1960s. Since the beginning of the twentieth century some artists have continued to question, deny or proclaim the ideas and values of art within museum culture. Each new movement and manifesto declared its opposition to the stultifying effect of the museum, which was seen as an outmoded institution to be swept away along with orthodoxy of the academy and the salons. The history of Modernism is strewn with the ruins of the museum, yet ironically while avant-garde artists criticized museums for collecting 'dead' art, their work has been continually acquired and displayed by them. Modernism emerged amid a complex political climate of continual reinvention, since its most significant feature has been rejection of the past and complete confidence in the process of change and belief in the supremacy of the new and novel. This trend naturally led artists to challenge the cosy illusion of the museum's cultural immortality and, as Marinetti proclaimed, 'We want no part of it, the past, we the young and strong Futurists!'[18]

The museum, with its custodial view of history, was seen as either irrelevant or destructive. The Supremacist painter Kasimir Malevich proclaimed that the art of the past should be burned to make way for the art of the present. In his short essay 'On the Museum', he challenged the role of the museum in acquiring the art and artifacts of the past: 'contemporary life needs nothing other than what belongs to it.'[19] The Russian Constructivists, who had started as Futurists, did not concern themselves explicitly with the abolition of the museum. Their main priority was to by-pass the institutions of the imperial state and of wealth and to move their operations straight to the street. Museums and galleries were for them laboratories in which experiments could be carried out and there was also a belief that the artist should have an active role in their management. Alexander Rodchenko, in his 'Declaration on the Museum Management' (1919), maintained that 'artists, as the only people with a grasp of the problems of contemporary art and as the creators of artistic values, are the only ones capable of directing the acquisition of modern works of art and of establishing how a country should be educated in artistic matters'.[20] El Lissitzky applied his Constructivist principles to the organization of space with his *Prouns* (Projects for the affirmation of the new in art). These were seen as a hybrid between painting and architecture and took a number of forms, including exhibitions of large-scale photographic environments. He developed a theory for museum display which he was able to put into practice in two 'Demonstration Rooms', one in Dresden in 1926, the other in Hanover in 1928. These explored the possibility of creating a space which he believed was most suitable for presenting modern art – a space where the specifically designed surroundings were further controlled by colour and lighting. This was a museum environment which was in direct opposition to the still predominant belief in the 'neutral' space of the museum object.

The avant-garde artists in Paris during the same period also resented the museum's traditional conservatism. The work of Marcel Duchamp expressed both the Dadaists' and Surrealists' disregard of institutional authority. By adding a moustache and beard to a reproduction of the *Mona Lisa*, in his provocative work *L.H.O.O.Q.* of 1919, he was also contesting the reverence usually accorded to this most celebrated museum masterpiece in the Louvre. The Dada artists made their most controversial statement against the art establishment in 1920 at the First International Dada Fair in Berlin. This employed an authoritative style of display by the juxtaposition of text and image, a style which was to be echoed by the Nazi regime's counterattack on avant-garde art at the 'Degenerate Art' exhibition held in Munich in 1937. The Surrealists were to make their own definitive exhibition statement with the International Exposition of Surrealism held in Paris in 1938 and the 'First Papers of Surrealism' in New York in 1942. Although he himself was neither a major exhibitor nor even a completely committed Surrealist, Marcel Duchamp cleverly orchestrated both these shows, and his ideas on the manipulation of space anticipate aspects of later museum interventions. For the Paris exhibition he created a special ambience with the aid of 1,200 coal-sacks suspended from the ceiling; and, because the lighting of the gallery was deliberately subdued, visitors were issued with torches in order to view exhibits. In the 'First Papers of Surrealism', after the works had been installed, Duchamp covered the room in a web of string extending across the walls and ceilings and over the paintings. Rather than challenge museums directly, the Surrealists suggested that they imprisoned the fertile imagination. As André Breton stated in *Surrealism and Painting* in 1927: 'Now I confess that I have passed like a madman through the slippery halls of museums … Passing by all those religious compositions, all those rustic allegories, I irresistibly lost the sense of my own role. Outside, the street prepared a thousand more real enchantments for me …'.[21] The first Surrealist challenge was that of looking at reality in very different terms, a battle continually fought against the banality of the everyday. The Surrealists wanted to disinter the unconscious workings of the mind and share with the early creators of the *Wunderkammer* a desire to construct a specific, personal order and anarchic juxtaposition of collected elements, thereby resisting the kind of separation imposed by the museum through specialized classification.

A line of continuity exists between the questioning of the museum's autonomous role undertaken by the early avant-garde movements and the activities of those artists who began to create work around a critique of the institutions of art in the 1960s. As Hal Foster wrote, 'First artists like Flavin, André, Judd and Morris in the early 1960s, and then artists like Broodthaers, Buren, Asher and Haacke in the late 1960s, develop the critique of the conventions of the traditional mediums, as performed by Dada, Constructivism, and other historical avant-gardes, into an investigation of the institution of art, its perceptual and cognitive, structural and discursive parameters.'[22] By the late 1960s, worldwide student unrest, anti-Vietnam War demonstrations and civil rights and peace movements gave rise to the questioning of many long-established values and the concept of institutional authority, which included museum administrations. In France there were the activities of the Situationists led by Guy Debord and influential new ideas expressed in the works of theorists like Roland Barthes, Michel Foucault and, slightly later, Jean Baudrillard. Their writings stimulated a critical examination of existing cultural institutions and recognized art as being interwoven with a system of socio-economic exchange.

In 1967 Daniel Buren and other artists made a demonstration at the Salon de la Jeune Peinture, Musée National d'Art Moderne, Paris, where each artist exhibited a painting in the form of a simple motif, as a 'signature' of their objection against the institution, and distributed a text on a flier.[23] During the following year Buren continued to paint the 'same' painting of vertical, alternating coloured and white stripes and posted 200 of these panels on hoardings around Paris, an action which suggested the idea that displays of art no longer needed to be restricted to the confines of the museum. Meanwhile, parallel protests to the celebrated Paris student demonstrations of 1968 included the temporary occupation of the Palais des Beaux-Arts in Brussels, in which Marcel Broodthaers took part and also acted as a negotiator. Among the objectives of the demonstrators was the need

to draw attention to the lack of provision for contemporary art exhibition spaces in Brussels, and such debates undoubtedly helped to stimulate Broodthaers' use of the museum as a focus for a wider critique of the art establishment. In common with a number of other artists at the time, he had become disillusioned with the legacy of Pop art since, while it had blurred the boundaries between mass culture and high *culture*, it had sold out to the very commercialism that it was seeking to ridicule. As a result art was in danger of losing its 'true' value, becoming a mere commodity or decoration, accumulated in museums without offering critical reflection. Artists therefore began to challenge the idea of art as an avant-garde invention, and there was a new awareness that despite Marcel Duchamp's earlier claim, via his creation of the Readymade, that it is the artist who accords an object its status as a work of

art, in reality power still rests with the framing institution.

In the USA the development of 'land art' presented a direct challenge to containing art in the museum. Robert Smithson, who created his famous *Spiral Jetty* (1970) in the Great Salt Lake in Utah, took a critical stance against museums in his writings. He reinvented place as a kind of post-industrial spectacle and attempted to shift the emphasis of art away from the institutions of the gallery and museum. In his 1987 article 'Some Void Thoughts on Museums' he wrote: '... Museums are tombs, and it looks like everything is turning into a museum. Art settles into stupendous inertia. Silence supplies the dominant chord. Bright colors conceal the abyss that holds the museum together. Every solid is a bit of clogged air or space. Things flatten and fade. The museum

spreads its surfaces everywhere, and becomes an untitled collection of generalizations that immobilize the eye.'[24] In a pencil drawing of 1969 he proposed an alternative museum – *The Museum of the Void* – which was 'devoted to different kinds of emptiness'. Minimalism and Conceptual Art also presented a challenge to institutional conventions in what was described as 'The dematerialization of the

DANIEL BUREN
PHOTO-SOUVENIR: 'UP AND DOWN, IN AND OUT, STEP BY STEP', WORK IN SITU
The Art Institute of Chicago
1977

Buren's characteristic striped works *in situ*, instead of being confined to the museum's galleries where paintings are conventionally hung, are displayed on the steps of the grand entrance staircase. The visitor could thus experience the work while using the stairway, which takes on a sculptural presence and serves to connect the inside and outside of the exhibition space. The work was subsequently acquired by the museum to form part of its permanent collection.

art object'.[25] Artists like Lawrence Weiner and Joseph Kosuth had by the 1970s reached the radical conclusion that words by themselves could serve as the very material out of which art is created. Their language-based work often takes the form of large wall texts which, just like museum labels, became authoritative statements, but instead of trying to be unconfrontational they address the viewer more directly.

The growing acceptance of Conceptual and Installation Art was to provide the ideal climate to allow artists to critique the museum, both from the outside and from within, through site-specific interventions from the mid-1980s onwards.

The museum as the institution of art has of course changed almost beyond recognition since the time of the historical avant-garde, and the particular tendency for its critique by artists in the USA is linked with that country's role as the power base for the contemporary art market and the modern art museum. The twentieth century saw a rapid increase in museums of modern and contemporary art and, compared to the older-established art museums of the eighteenth and nineteenth centuries, they are a fairly recent and growing phenomenon. Since the 1960s there has been a boom in museum building without precedent since the nineteenth century, while what were previously 'alternative' venues devoted to contemporary art have since become part of the mainstream. By 1999 half of the 1,240 art museums in the USA were less than 25 years old and many of them are devoted purely to modern and contemporary art.[26] The Museum of Modern Art (MoMA),

New York, founded in 1929, is regarded as the archetypal museum of its kind which became a model for others. Contrary to popular belief, it was not the first museum intended to display only contemporary art, since as early as 1815 the Musée du Luxembourg in Paris was organized to show only the work of living artists.[27] Nevertheless, when MoMA was founded, it was the first to be exclusively concerned with Modern art and it houses one of the most comprehensive collections. It was able to shape modernism into an ideology and its strategy was conceived on business lines in terms of 'Production' and 'Distribution'. Alfred Barr, MoMA's first Director, made this clear in an early confidential report to the trustees: 'Basically, the Museum "produces" art knowledge, criticism, scholarship, understanding, taste.... Once a product is made, the next job is distribution. An exhibition in the galleries is distribution. Circulation of exhibition catalogues, memberships, publicity, radio, are all distribution.'[28]

Museums are naturally careful to play down such parallels with industry or any commercial affiliations, but some artists have become interested in examining the growing corporate involvement in the arts, both through direct collecting and through museum sponsorship. Hans Haacke has investigated the museum's complex interconnection with commerce and politics, as well as with the personalities who serve in the governing bodies of institutions. In his seminal writing on Museums he claimed: 'Every museum is perforce a political institution, no matter whether it is privately run or maintained and supervised by govern-

mental agencies'.[29] In 1970, as part of an exhibition at MoMA, entitled 'Information', he installed ballot-boxes for audience participation. Visitors were invited to vote in favour of or against the re-election of Nelson Rockefeller as Republican governor of New York in the light of the Nixon administration's Indochina (Vietnam) policy. Rockefeller had previously held posts as both president and chairman of MoMA's board of trustees, while members of the Rockefeller family had been instrumental in the original founding of the museum. A total of 37,129 visitors voted, and Haacke was thus able to link their views to external political issues that were indirectly connected to the museum's own administrative affairs. In a number of his projects, Haacke has carefully investigated a particular painting's provenance, tracing its unbroken line of ownership since it left the artist's studio. He adopts the procedure of an art historian but, instead of using his research to add to a painting's pedigree, he exposes the work's hidden financial and political background. This approach tends to present these works of art as mere symbols of corporate investment and institutional authority. His controversial *Manet – PROJECT '74* was excluded from an exhibition at the Guggenheim Museum and its Director referred to Haacke's work as an 'alien substance that had entered the art museum organism'.[30]

Daniel Buren first expressed his theory about the 'frame' the museum imposes on art in his 'Function of the Museum' written in 1970: 'The aesthetic role of the Museum is thus enhanced since it becomes a single viewpoint (cultural and visual) from which

works can be considered, an enclosure where art is born and buried, crushed by the very frame which presents and constitutes it.'[31] Buren asserted that the artist rather than the institution creates the frame, and he developed this concept further by actually deconstructing the museum space in a number of *'in-situ'*, site-specific works in the late 1970s and early 1980s. During the same period Michael Asher also created a number of subtle installations, all located within museum exhibition spaces, which critically contemplate the institutional framing of art and disrupt the museum's linear scheme of history. His best-known work of this nature was in the context of the Art Institute of Chicago's 73rd American Exhibition in 1979, when he removed the bronze replica of the life-size statue of George Washington by Houdon from its permanent site outside the main entrance and had it transferred to an internal museum gallery. Through this simple act of displacement he was able to draw attention to the different aspects of the museum's presentation of the sculpture. He showed how our aesthetic appreciation of the work changed according to its physical context, when transferred from its

familiar public decorative and commemorative role to an essentially art-historical situation. Once removed from its original site as a permanent feature of the museum façade, the statue now had to be viewed as part of an eighteenth-century collection. A historical interior thus became part of the present time-frame, since Asher effectively created his own installation by using the

other eighteenth-century works as part of the contemporary art exhibition in which he had been invited to participate.

Through being invited to create site-specific works for exhibitions in museums, artists have thus been able to intervene simultaneously in the day-to-day function and activities of institutions. In a perform-

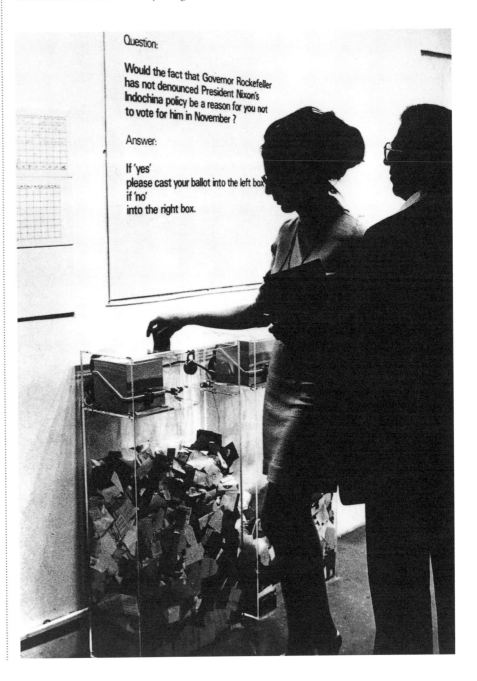

HANS HAACKE
MOMA POLL
1970

As part of the group exhibition entitled 'Information' at the Museum of Modern Art, New York, Haacke installed two transparent acrylic ballot-boxes. The museum visitor was invited to vote for or against the U.S. government's policy for involvement in the Vietnam War and the results were recorded by a photoelectrically triggered counting device. More specifically the work related to the impending election for the governorship of New York state, in which the incumbent, Nelson Rockefeller, was a candidate, since both he and his family had historic and ongoing links with MoMA.

↩ MICHAEL ASHER
THE ART INSTITUTE OF
CHICAGO, GALLERY 219
Installation view
1979

For the 73rd American Exhibition, Asher resited the bronze statue of George Washington, transferring it from its usual position outside the museum entrance to a low plinth on the floor of a gallery containing 18th-century paintings and furniture. By this action he was able to reconfigure the role of the statue from a monumental, commemorative piece to feature in an art historical context. His conceptual statement as a participant in an exhibition of contemporary art was to illustrate how museological presentation of sculpture could be varied according to different historical criteria.

LOUISE LAWLER ↪
ZEUS AND DAVID
1984

The less formal arrangements of objects in museum basements have proved fascination subject matter for artists to photograph. Lawler's intentionally cropped images capture an almost playful aspect of these *ad hoc* juxtapositions which would inevitably be absent in the consciously posed context of an exhibition gallery.

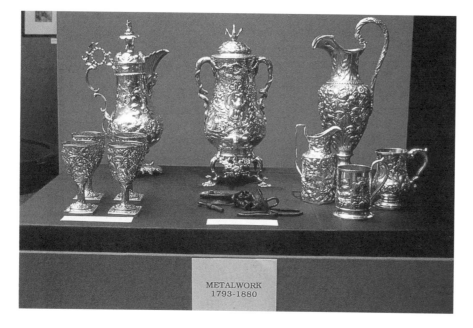

METALWORK
1793-1880

↩ FRED WILSON
METALWORK 1793-1880
Installation from the exhibition 'Mining the Museum'
Maryland Historical Society, Baltimore
1992

As part of his exhibition Wilson juxtaposed all kinds of unlikely objects in order to illustrate the 'hidden' history of the museum's collection. In this group the two labels read: 'Silver vessels in Baltimore repoussé style 1830' and 'Slave Shackles, maker unknown, made in Baltimore, *c.*1793–1872'. This combination was intended to make the point that the affluent 19th-century lifestyle of Baltimore high society had been built on slavery.

ance work called *Service Area*, Vito Acconci forwarded his mail to a display case situated in the exhibition 'Information' at MoMA in 1970. By this action both the museum and the postal service were used by the artist, and the confines of the exhibition space were deconstructed or extended to include Acconci's daily journey from home to the museum to collect his mail. His loft studio was thereby temporarily relocated to the museum.

The growth in museological studies has also been a significant catalyst in the museums' investigation of their social and cultural function. By the early 1990s a number of art museums were staging exhibitions in which artists were invited to create work that would interact with the permanent collections or be instrumental in examining aspects of the

museum's institutional role. The Carnegie International, Pittsburgh (1991), and 'The End(s) of the Museum' at the Fundacio Antoni Tápies, Barcelona (1995), were among a number of significant exhibitions involving internationally known artists whose work addressed specific museum themes. Many artists have found a particular affinity with natural history, archaeology and ethnography collections, especially those with displays that have escaped refurbishment. They have continued to use the medium of photography and gone beyond documenting the museum collection to reveal the peculiarities of its space and visitor dialogue. In the mid-1980s, a number of artists, such as Fred Wilson, Louise Lawler and Mark Dion, have been concerned with exploring the social and political agendas concealed behind the museum's supposedly neutral façade. They have gone on to use the museum as a critical vantage point for reviewing questions of wealth, privilege, gender and cultural prejudices. Most significantly, artists have been given the opportunity to work directly with these 'non-art' collections, a phenomenon that is linked to the museum's growing tendency to self-evaluation in the wake of an increasing emphasis on considerations of political correctness.

This need for museums to review their conventional presentation and interpretation methods and to develop fresh initiatives has led to active collaborations where practising artists have been invited to curate exhibitions and advise on matters of display. A number of ground-breaking exhibitions have resulted, such as Joseph Kosuth's 'The Play of the Unmentionable' at the Brooklyn Museum of Art (1991) and Fred Wilson's 'Mining the Museum', held at the Maryland Historical Society in Baltimore (1992). In these exhibitions the artist acted both as guest curator and as creator of a site-specific installation. This approach is a two-way process in which museums offer contemporary artists challenging alternative venues and contexts to the 'white-cube' environment, while artists provide museums with a means of reanimating

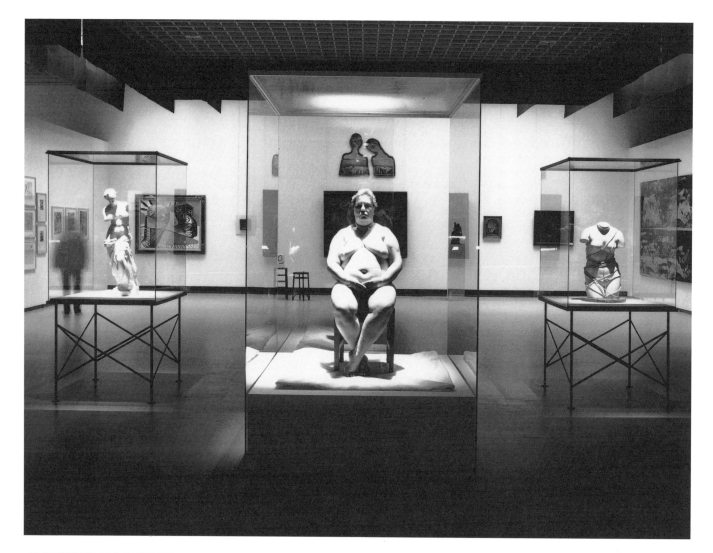

PETER GREENAWAY
THE PHYSICAL SELF

Installation view at the exhibition of the same name
Museum Boijmans-Van Beuningen, Rotterdam
1991

As a guest curator Greenaway chose as his theme
the human body, depicted at different stages from
birth to old age, in an exhibition built around
the museum's collection of old master paintings,
drawings and prints. This historic material was
interspersed with a number of vitrines in which
nude models were exhibited standing, sitting
of reclining in traditional studio poses, thus
producing a striking juxtaposition of living
people with inanimate museum objects.

their collections and attracting new audiences. The involvement of major public museums with living artists has evolved naturally from a tradition of the artist-in-residence, and artists might be commissioned to create a work inspired by a specific painting or invited to select and comment on their favourite works in a particular collection.[32] The activities of artists and institutions are becoming increasingly interwoven with the development and expansion of museums of modern art which are having to reckon with the potential long-term outcome of this dialogue with the art of the present.

Artists might be specially commissioned to make large works which become part of museums' rapidly growing collections, but are subject to the limitations of their storage facilities. Contemporary art forms, such as video, performance, site-specific installation and digital media have joined with photography to challenge the very mission of the museum as collector and preserver of the unique and tangible.

Duchamp has already theoretically out-manœuvred the traditional concept of the museum, since to accept unquestioningly one of his Readymades as a work of art

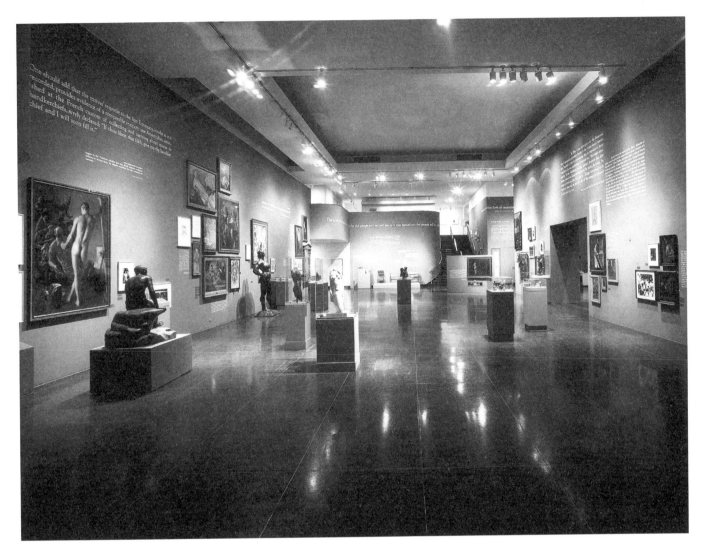

JOSEPH KOSUTH
THE PLAY OF
THE UNMENTIONABLE

Installation view, The Brooklyn Museum, New York
1990

Kosuth's installation for the Grand Lobby comprised his selection and display of works from the Brooklyn Museum's collection. This was based largely around the theme of censorship as illustrated by works from various cultures throughout history. His large and prominent wall texts included many provocative quotations from well-known philosophers, writers and other historical figures, including Adolf Hitler.

is to enjoy the very irony of its preservation by an institution, and his concept of the *Boîte-en-valise* also represents a challenge to the confinement of art within the walls of the museum. Although the rigid and autonomous nature of the museum was criticized by both the early avant-garde movements and their successors, by the 1990s many artists recognized the more positive evolutionary role that some museums can play when their curators are more receptive to new ideas. Criticized for having a rigid structure and for being out of touch with the real world, traditional museums can, by adopting an enlightened approach, become more of a laboratory for experimentation. Using its institutional power, the museum forms the ultimate arena for artistic discourse with the recognition that art is a dynamic force, continually in a state of flux.

CHAPTER I *the museum effect*

The principles followed by museums for ordering their collections, in terms of both exhibition and storage, have had a strong aesthetic and conceptual influence on contemporary art practice; this may be either direct or subliminal. In using systems of classification, display, archiving and storage, artists have been able to apply museological methods to both the production and the presentation of their work. They are inspired not only by these practical methods but also by their broader institutional context, since the fact of being exhibited in a museum confers on objects an aura of importance and authenticity, endowing whatever is presented with a sense of significance. There has been an increasing tendency to employ typical museum display devices such as vitrines, archive boxes, specimen jars, descriptive labels, drawer cabinets and even packing crates used for the shipping and storage of works of art. Some artists have been specially attracted to the use of the display case or vitrine, and this has become a familiar mode of presentation in contemporary art, coinciding with a shift towards working more with mixed media and with the ever-present need to protect delicate materials.

DAMIEN HIRST
DEAD ENDS DIED OUT,
EXPLORED
1993

Cigarettes have been a recurring theme in Hirst's work, and in this taxonomic display he exploited the infinite variety of forms resulting from stubbing them out. The stark severity of the design of the vitrines, coupled with Hirst's use of metaphorical and often playful, ironic titles, conveys an acute sense of the here and now which transports the display cases beyond basic museological associations.

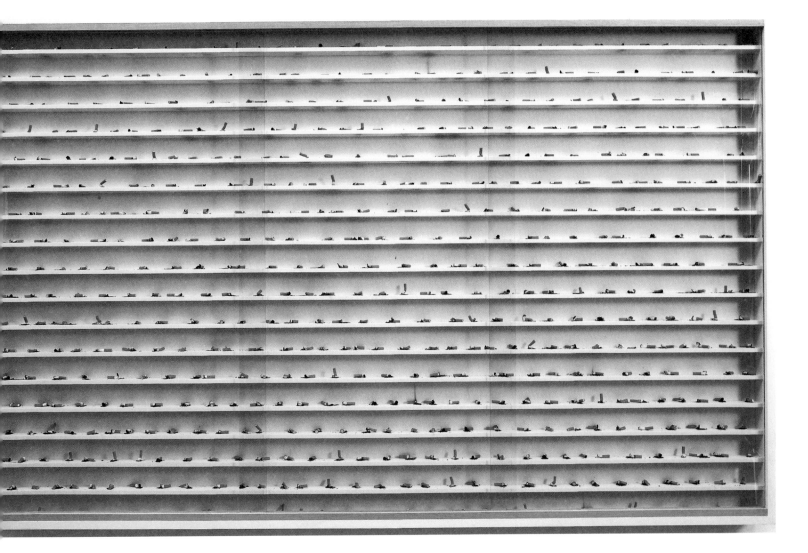

Essentially a giant container for exhibits, the museum can offer a more aesthetically pleasing presentation merely by isolating an object from its original context and reframing it for more considered viewing. In *Unsettled Objects* (1968–69), Lothar Baumgarten has commented on the significance of this re-presentation of artifacts: 'The display of powerful objects in vitrines and the desire to make use of their energy for a didactic exhibition displaces them and makes them enigmatic.'[1] Baumgarten's work was presented in the form of a slide projection showing eighty images of the closely packed display of exhibits in the Pitt Rivers Museum, Oxford. All museums, through their chosen mode of display, using the traditional devices of plinth, vitrine and label, have the potential to transform almost anything they exhibit into a work of art. Every museum display and exhibition involves some form of visual construction with which artists have found an affinity, as has been acknowledged by Mark Dion: '... I love museums, I think the design of museum exhibitions is an art form in and of itself, on par with novels, paintings, sculptures and films.'[2] The

JEFF KOONS
NEW SHELTON WET / DRY
TRIPLEDECKER
1981

Between 1980 and 1986 Koons produced a series of works called *The New* which create a fascinating parallel between high art and mass culture. He recontextualized domestic vacuum cleaners as examples of contemporary art, encased them in Plexiglas and illuminated from within by fluorescent lighting. This ironical suggestion of a link between department store and museum display also represents a celebration of the newness and undiminished commodity value of banal consumer objects. Koons' statement, illustrating the fetishistic aspect of the art object by denial of its intended use, was viewed by many critics as a Post-Modern version of Marcel Duchamp's Readymades of 1913–17.

vitrine is the primary museum display device which, from the standpoint of artists, suggests a number of significant practical, formal and conceptual possibilities. The most remarkable feature of the vitrine is its ability to transport its carefully ordered and labelled contents beyond the triviality and ephemerality of the everyday. At the outset the vitrine is intended to protect its contents both from dust and damage and from theft. It therefore provides artists with a convenient means of presenting works in less conventional, less durable media, and in this respect it is related to the box frame used for displaying assemblages and collages. However, the vitrine proper is usually much larger and can have a more assertive, 'sculptural' presence within an exhibition gallery. The act of placing an object in a vitrine immediately focuses attention on it and suggests that it might also be both precious and vulnerable. The vitrine reinforces the notion of the unique, untouchable and unattainable and, perhaps significantly, has its roots in the medieval church reliquary. It therefore enhances the inherent visual power of an object to catch a viewer's attention and to stimulate contemplation.

The effect of placing something in a vitrine is to 'museumize' it: the glass creates not just a physical barrier but establishes an 'official distance' between object and viewer. By rendering untouchable the contained object or work of art, the more important and precious it becomes; it thus shares with the shop window and commercial display case the power to seduce the passer-by. In his presentation of pristine, brand-new

products, Jeff Koons' series *The New* (1980–86) employs this commercial device of making the most banal objects appear special. Thus Koons' domestic vacuum cleaners cease to be everyday items once they are displayed inside an acrylic box. Although the vitrine is essentially a frame, it also provides a carefully controlled and articulated environment. Its appropriation by contemporary artists coincides with their growing preference for delicate materials or potentially confrontational mixed media, the results of which need protective containment. While Joseph Cornell's 'shadow boxes' have an affinity with the more 'poetic', hand-crafted nature of nineteenth-century museum displays, the type of vitrine favoured by many contemporary artists tends to be rather industrial in appearance, often conveying the impression of being intentionally neutral, even clinical.

The practice of preserving specimens in liquids, as employed by natural history and anatomical museums, offers an unusual visual dimension which has appealed to some contemporary artists. On a conceptual level, such displays present life-forms in a suspended, inanimate state, as if 'frozen' in time. In *Isolated Elements Swimming in the Same Direction for the Purpose of Understanding* (1991), Damien Hirst exhibited around forty fish of various species, separately suspended in formaldehyde and encased in Perspex. Neatly arranged on shelves in a vitrine, they all faced in the same direction as if swimming in a shoal. Similarly, he has also used glass-fronted cabinets to display ordered arrangements of objects

and specimens such as medicines, shells and cigarette-ends. The formal groups of objects have the authoritative look of a museum display in which each is presented as a document of 'truth', but rather than having interpretative labels the objects provoke thought through their ironical and metaphorical titles. While some of Hirst's vitrine works contain preserved and dissected animals and thus have obvious parallels with displays in anatomical museums, they lose such 'dusty' associations, thanks to their pristine presentation in the white space typical of the contemporary art gallery. In works like *Self* (1991) and *Eternal Spring* (1998), both of which employ refrigerated vitrines, Marc Quinn also evokes the atmosphere of a laboratory, while the design of his 'scientific' vitrines, with their LED displays and immaculate plinths made of stainless steel, suggest integral sculptural forms.

When a group of objects is exhibited together in a vitrine, a kind of visual construction or statement is involved, suggesting that they have some formal or cultural relationship one with another. This principle has inspired artists to imitate museological classification, arrangement and labelling according to type. The immediate appeal of this form of display is that the result conveys the impression of careful evaluation and deduction. Artists have created works that involve the arrangement of objects in regimented displays as if following a scientific ordering process like 'Taxonomy', the universal system of classification originally applied to natural history specimens.[3] Ann Hamilton's

MARC QUINN
ETERNAL SPRING
(SUNFLOWERS) I
1998

Quinn has frequently made use of stainless-steel refrigeration units in his work in order to preserve various forms of organic matter. The viewer can thus marvel at and contemplate the fascinating state of suspended equilibrium seen through the glass of the sealed vitrine. Although the cut sunflowers are technically no longer living, their physical reality is preserved, and their immortality as a work of art has obvious parallels with Van Gogh's famous painting of 1888. Yet in contrast the work by Quinn also alludes to the fragile, temporal nature of the flowers and their dependence on an electrically controlled life-support system. (Another version of the same work is installed in the Wellcome Wing of the Science Museum, London.)

installation *Between Taxonomy and Communion* (1990), at the San Diego Museum of Contemporary Art, included systematic groupings of thousands of human and animal teeth laid out on a flat surface. Arranged in meticulous rows, they had the appearance of a vast museological display.

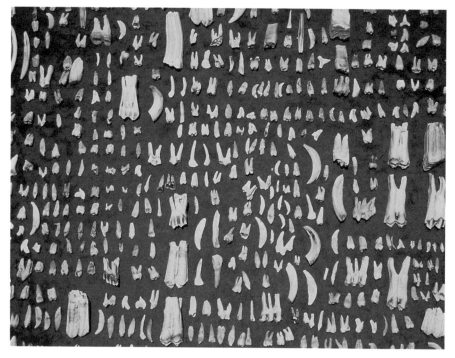

ANN HAMILTON 🌱
BETWEEN TAXONOMY
AND COMMUNION

Installation view (detail)

San Diego Museum of Contemporary Art

1990

This display of some 16,000 human and animal teeth, presented in taxonomical style is concerned with the idea that the life-force can still be present in inanimate dead objects. Removed from their bodily context, these teeth acquire an almost precious quality and significance, like museological exhibits. The beautifully polished specimens presented on a vast steel table covered with iron oxide seem to invite the spectator to touch them. However, visitors are discouraged from doing this for fear of staining their fingers with the red liquid resulting from water dripping onto the table and from there onto the floor; the blood-like liquid evoked a sense of ritual.

↩ Detail of table surface with display of teeth

The growing tendency manifested in much contemporary art to address the materialistic culture of the present has led to work that involves the classification and display of consumer cast-offs. Karsten Bott's installation *One of Each* (1993) at the Offenes Kulturhaus, Linz, consisted of an extensive collection of mass-produced utilitarian objects of varied material, colour and form, divided into various groups. Even the most obsolete, broken and trivial everyday items are meticulously ordered in rows. The assemblage, which could be viewed in its entirety from a boardwalk platform, is no doubt inspired by either the modern phenomenon of the car-boot sale or the flea-market where diverse objects are presented for sale laid out either on tables or on the ground. Bott's installations are selections from a massive ongoing collection of similar material; thus his 'Archive of Contemporary History' is carefully

KARSTEN BOTT
ONE OF EACH

Offenes Kulturhaus, Linz
1993

Spread like a carpet over the gallery floor, Bott's installation (entitled 'Von Jedem Eins') consists of a vast accumulation of used artifacts chosen from his 'Archive of Contemporary History', founded in 1986. In preparation, he first makes a meticulous inventory on a computer of all the objects selected, which he classifies under various sections. His intention is in part to forge emotional links between people's individual life histories and the history of their surroundings and environment. When not exhibited, the archive is kept in banana crates stacked on shelves in a vast storeroom.

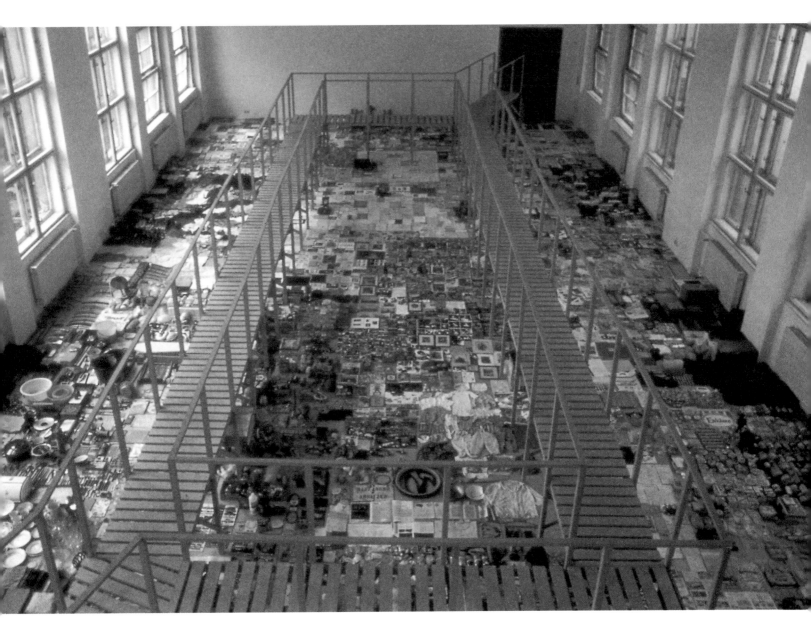

MARK DION
TATE THAMES DIG
1999–2000

This work consisted of two phases: an archaeological process and museological presentation. Dion and a team of volunteers combed the foreshore of the Thames at low tide close to the two Tate Gallery locations on Millbank and at Bankside in London. The finds were carefully cleaned and classified by archaeologists working in tents set up outside Tate Britain on Millbank, so allowing interested members of the public to observe the proceedings. A fascinating spectrum of artifacts dating from all periods was displayed, contemporary consumer objects being juxtaposed with old bones, potsherds etc. A selection of the finds was finally put on display in the Tate Gallery, in a vitrine with drawers, old-fashioned in appearance, but specially constructed to Dion's specification.

↩ [1] Site II – Bankside dig team

[4–6] The vitrine and installation details ↪

inventoried and stored as if belonging to an institution. Mark Dion's artistic practice often follows a sequence of gathering, sorting, classification and display. Some of his works have involved a kind of archaeological process which leads to the material culture of the present being exhibited alongside that of the past.

In 1997, for his site-specific installation *Raiding Neptune's Vault* seen in the Nordic Pavilion at the Venice Biennale, Dion displayed a fascinating collection of artifacts retrieved by him from the silt of a local canal. Two years later, in a more extensive project for the Tate Gallery, London, *Tate Thames Dig*, he and a team of helpers gathered material from the foreshore of the River Thames. The resulting collection, which revealed an ongoing history of the city, included items as diverse as ancient potsherds and contemporary plastic telephone cards; it was eventually exhibited at the Tate Gallery in a traditional museum-style vitrine.

[2] Foreshore detail

[3] Sorting the specimens

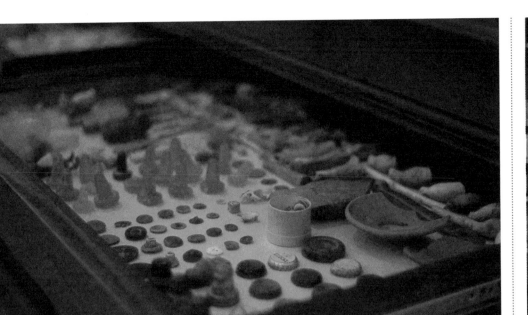

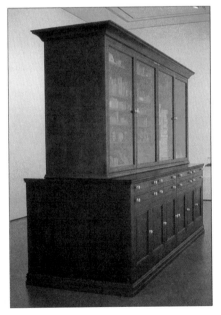

Reserve collections often hold a greater fascination for artists than do the exhibition galleries of museums. On this point Dion observed that 'The museum needs to be turned inside out – the back rooms put on exhibition and the displays put into storage.'[4] The extraordinary visual potential of museum reserve collections was realized by Andy Warhol as early as 1970 with his exhibition 'Raid the Icebox' at the Museum of Art, Rhode Island School of Design. While the exhibition galleries represent the public face of a museum, its storerooms and basements remain its concealed, private zones; in most major museums the relative proportion of exhibited material compared to the reserve is staggeringly small. This discrepancy has become even more apparent due to a more minimalist display aesthetic, the need to accommodate more extensive interpretative object labels and the ongoing acquisition of contemporary works, often of larger dimensions. The artist's interest has therefore extended to museum storage facilities, akin to vast warehouses, in which major works of art sit on industrial racking covered by polythene dust sheets or remain encased in anonymous packing crates.

In 1968, Marcel Broodthaers displayed empty crates, formerly used to transport paintings, in the first version of his *Musée d'Art Moderne, Département des Aigles, Section XIXe Siècle*. The boom in international art shipping linked with the regular practice of inter-museum loans for large-scale exhibitions has led to the packing case becoming a familiar sight in museum back rooms. However, the humble crate has emerged from storage to take centre stage in exhibition galleries and a number of artists have transformed it into a sculptural form. Richard Artschwager and Martin Kippenberger have both made sculptures imitating the type of crate used in fine art shipping; with their heavy-duty construction with fronts and corners reinforced to resist rough handling, they command an authoritative presence when seen in the gallery space. They also make a Duchampian gesture, teasing the viewer with the idea that there are sculptures

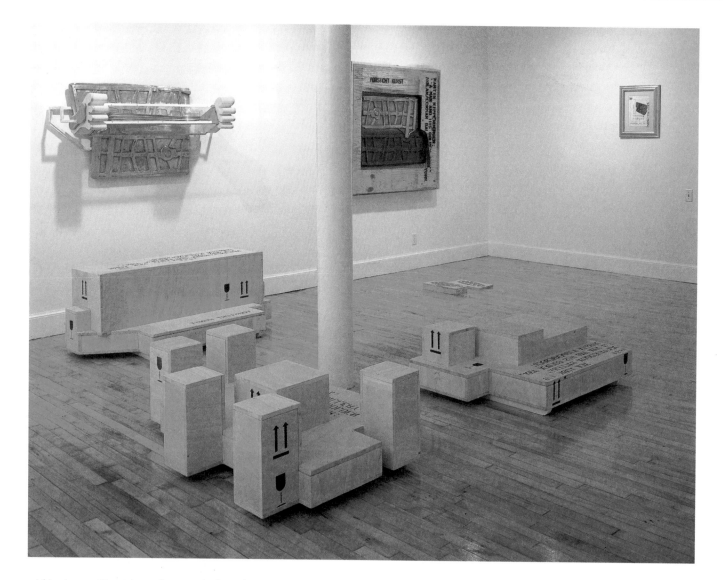

within them, still waiting to be unpacked. Ironically, in order to protect its soft pine surfaces, each crate sculpture in turn has its own packing case, fabricated from the same materials and to similar specifications.

The institutional practice of making archives and inventories has inspired artists to create their own. Archiving evokes the idea of important, official records which, even if hidden from view or forgotten, may be preserved for posterity. Christian Boltanski's series of works called *Archives* consist of row upon row of metal or cardboard archive boxes stacked one on top of another. They can also include hundreds of photographic portraits, haunting, anonymous, dimly lit images suspended on wire-mesh grills in a manner suggestive of museum reserve storage areas. The solemn style of presentation and lighting seems to conjure up associations with religious icons, where the repeated pattern of the images themselves is suggestive of ritual. By 1972, Boltanski had already begun to compile his photographic archive using found photos, amateur snapshots borrowed from various friends, portraits acquired

**MARTIN KIPPENBERGER
A MAN AND HIS ART**
Frank Sinatra Series
1994

Museums often allow works of art to be kept indefinitely in shipping and storage crates, which may be unpacked only rarely. Kippenberger presented such crates as intricate sculptures in their own right to be exhibited alongside his other works on display in the gallery.

from schools and clubs, as well as crime story images culled from newspapers. In another work, *Children's Museum Storage Area* (1989), he has incorporated shelving systems suggestive of the museum's reserve

store; these are crammed full of used clothing, with its inevitable reminders of Jewish victims of the Holocaust. His work is often concerned with collections of other peoples' memories, once lost and forgotten but now reunited with their original context in the museum space. Boltanski has described his artistic practice as being concerned with 'telling stories known to all' and presenting a 'universal history' of memories.

The inventory or itemized list has also served as the basis for a major series of Boltanski's works. In January 1973, he sent handwritten proposals to 62 museum curators specializing in art, history and ethnology, asking that each of them should buy, borrow or otherwise acquire the complete belongings of a single deceased individual, objects 'which after his or her death gave witness to that person's existence.'[5] He further requested that each group of objects be exhibited together in a museum gallery. Five of the institutions approached by him agreed to participate in the project, and in most cases the personal effects consisted mainly

of household furniture, domestic appliances and ephemera. In these catalogues of individuals' property no attempt is made to point out the particular personality or character of the former owners. The objects might therefore be seen as material evidence of social trends. In this respect, the museological framing – with its methodical documented detail – makes ordinary objects appear extraordinary,

like a collection of ethnographic artifacts. These 'Inventory' works seem to proclaim the idea that absolutely anything may be considered worthy of being collected and exhibited and furthermore that any diverse material is, in its particular context, as culturally relevant as so-called 'high art' designated as such by museums in accordance with their established hierarchical systems.

**CHRISTIAN BOLTANSKI
THE ARCHIVE OF THE
CARNEGIE INTERNATIONAL
1896–1991**
Installation at the Mattress Factory, Pittsburgh
1991

As part of his contribution to the exhibition, Boltanski created a fictional archive of the Carnegie International dating back to its inception in 1895. Within the narrow installation space the over-powering effect of racks filled with labelled cardboard boxes served to convey to the spectator a sense of historical transience. Boltanski's works frequently play on the contrast between the fallibility of human memory and official institutional archives which convey a stark, objective record of the past.

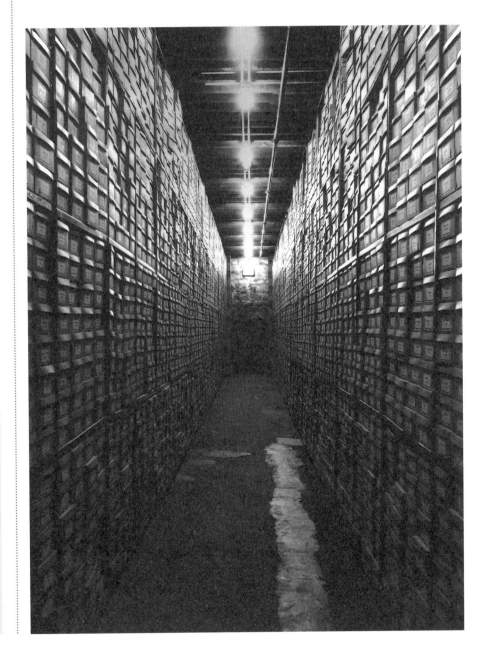

WALTERCIO CALDAS
VENETIAN SERIES
1997

The illusion of panes of glass in a display case is suggested in a series of sculptures made by Caldas for the Brazilian Pavilion of the XLVII Venice Biennale. These works investigate the act of looking, exploring the intermediate state between what the object on display and what surrounds it. They also reveal the precarious nature of the perceived surface and the ambiguous space between transparency and physical reality. Perspex tags attached to the vessel shapes bear the names of famous artists as a means of conveying the continuity of art history.

REINHARD MUCHA
TREYSA
1993

Mucha's work often relates to museum shelves and vitrines, exploring them as sculptural forms. He plays with the irony of the empty showcase and the interior shelf which exhibits only itself – a container without content. The protective pane of glass draws the viewer to peer at the empty space within, while providing a simultaneous reflection of exterior surroundings. Commenting on the fundamental act of looking, the vitrine allows reflection in a contemplative sense. Entirely covered with grey felt, the interior of the showcase suggests warmth, insulation and absorption, thus creating a repository for memory. The title of the work is taken from the name of a small town in Hesse (south-west of Kassel), one of a number of German place names consisting of six letters which Mucha has used as titles for a series of works.

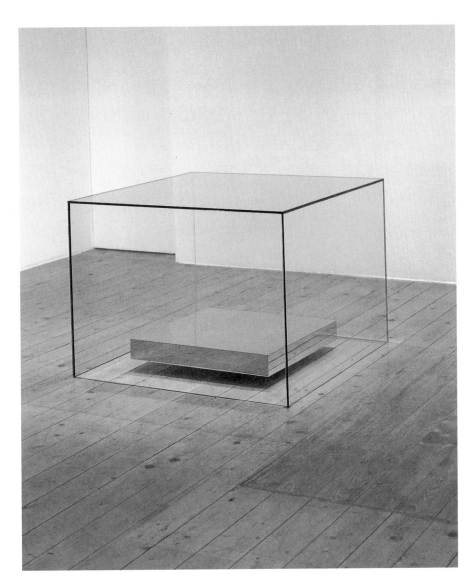

YUJI TAKEOKA
FLOATING PEDESTAL
1992

Takeoka explores the form of display devices by presenting his specially created plinths, pedestals and bases as sculptures in their own right. His first series was begun in 1984, and an entire exhibition of these works was shown first in Belgium at the Museum van Hedendaagse Kunst, Ghent, in 1989 and then in Germany as public outdoor sculpture at Documenta IX, Kassel, in 1992.

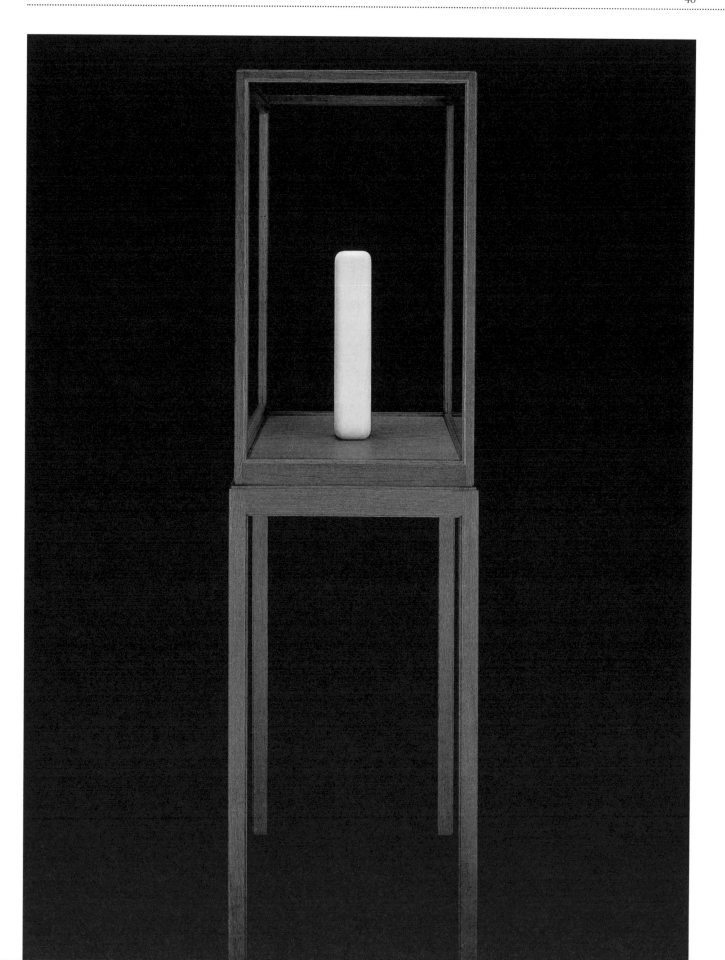

⟳ JAMES LEE BYARS
THE FIGURE OF QUESTION
1989

Aesthetic appreciation of a questioning approach to looking is a characteristic feature of the work of Byars, who often created pristine geometric forms from marble or gilded metal displayed in elegant vitrines. Through this mode of presentation he is able to stimulate in the viewer a sense of the intrinsic perfection and mystery residing within certain primal forms and precious materials. The open-endedness suggested by the provocative titles of his works invites a questioning attitude rather than simple acceptance in relation to the conventional authoritative stance presented by the museum exhibit.

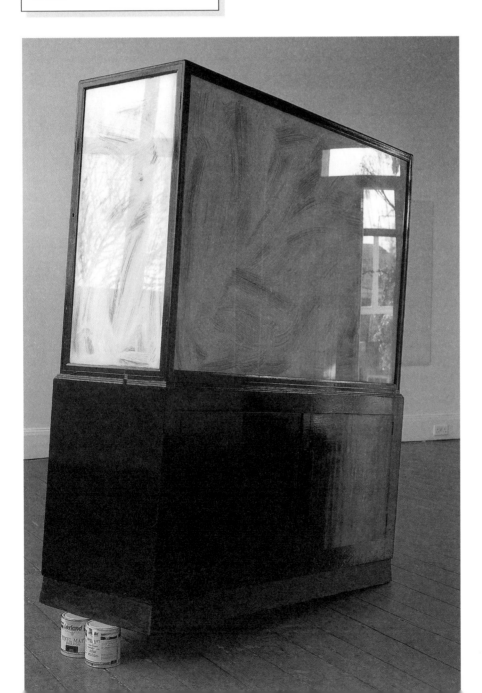

⟳ AMIKAM TOREN
SAFETY REGULATION
PAINTING NO.10
1999

The idea of the vitrine being merely a display structure to protect and enhance its contents is challenged by Toren's work. The panes of glass in the example seen in the foreground are rendered opaque with paint and the paint cans are placed under one side of the base to tilt the cabinet off-balance. Thus the vitrine is stripped of its conventional exhibition function and assumes an entirely different role when viewed as a clearly defined sculptural form.

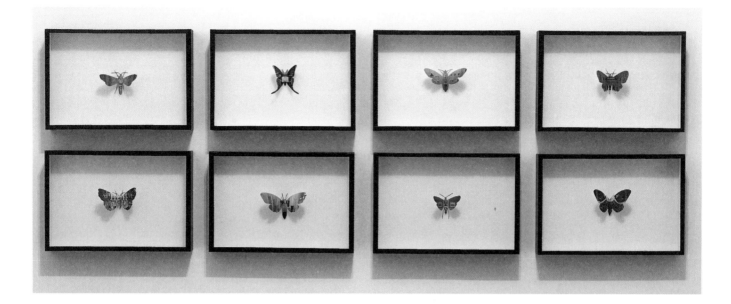

♀ **SUSAN SCHELLE**
MUSÉE
1994

Photographic C-prints provide the basis for cutting out butterfly silhouettes which are then mounted in specimen boxes. The image of insects trapped and pinned is intended as a direct visual statement about culture and classification: the very act of collecting renders nature dead, art becomes distanced from reality, and classification obscures individual identity.

GAVIN TURK ✐
GAVIN TURK RIGHT HAND AND FOREARM
1992

Turk's silkscreen print image suggests that his arm is immersed but still connected to himself as a living person, rather than a severed limb preserved in a specimen jar. The work may also reflect on the notion that the artist and his work, once they have been acquired for an art collection, become like a relic of what was once living

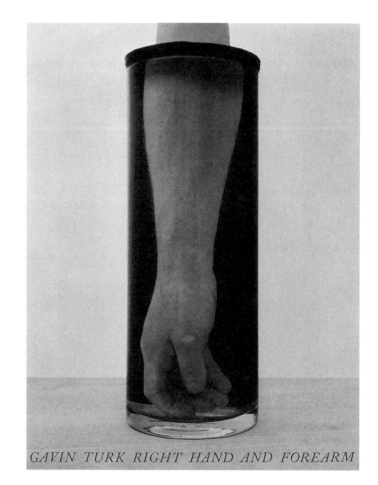

GAVIN TURK RIGHT HAND AND FOREARM

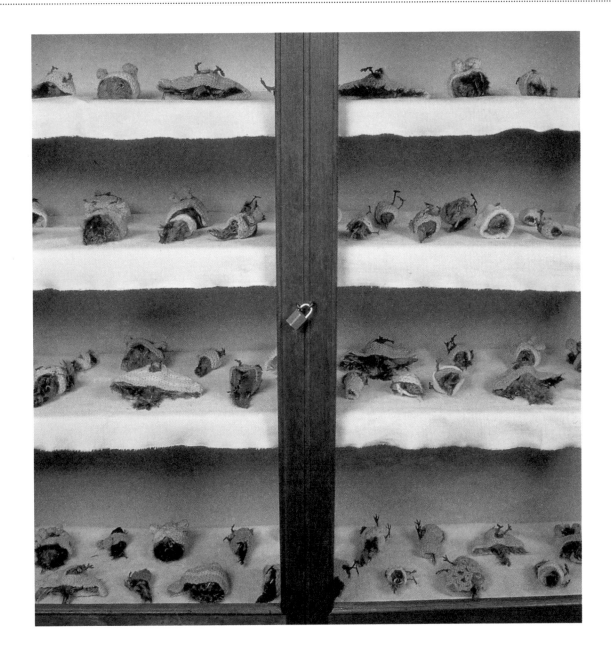

ANNETTE MESSAGER
BOARDERS AT REST
('LE REPOS DES
PENSIONNAIRES')
1971–72
Detail of installation at the Musée de Rochechouart
(Haute-Vienne)
1990

Messager produced in her studio a number of
works that featured taxidermied sparrows. clothed
in tiny knitted woollen garments. She refers to
these specimens as 'boarders'. Many years later,
dozens of these birds were laid out in rows in
display cabinets, presented as if asleep, in the
manner of natural history specimens.

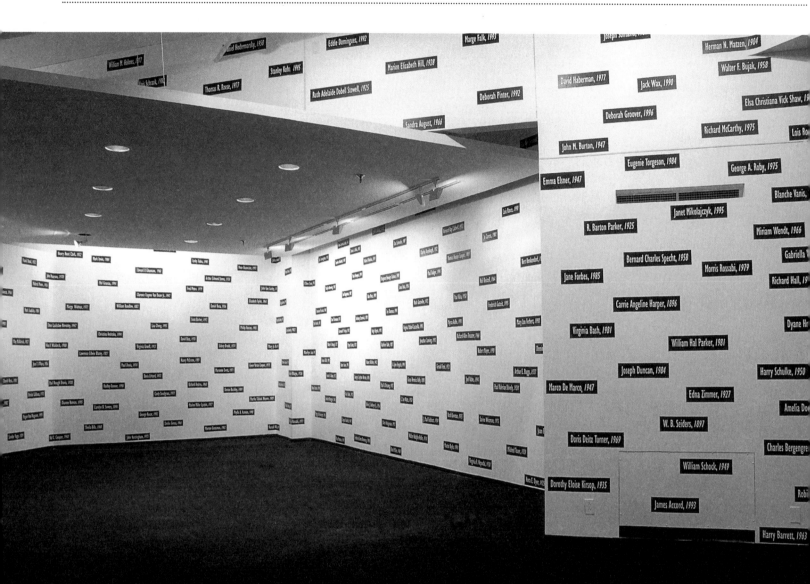

JOSEPH KOSUTH
TAXONOMY (RE) APPLIED

Cleveland Center for Contemporary Art
1996

In both his work and his critical writings, Kosuth has continued to explore the conceptual link between art and language. Inspired by the writings of various major 20th-century thinkers, especially Wittgenstein and Freud, he has produced numerous text-based works which are silkscreened directly onto gallery walls. Evolving from *Taxonomy (Applied) 1*, held in 1991 at the LINC Group Collection, Chicago, this installation includes the names of major philosophers and thinkers from different cultures and historical eras.

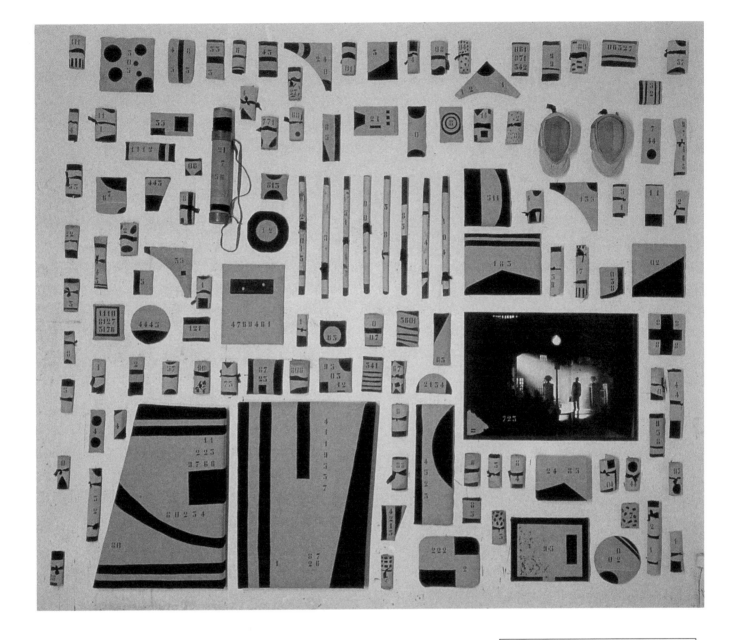

MAURIZIO PELLEGRIN
SECRET OF 723
1986–87

Pellegrin's works often consist of collections of wall-mounted objects precisely arranged within a rectangular grid. This work has 125 individual elements made mainly from padded linen canvas with decoration added using acrylic paint. He wraps them to alter their contours and 'also to contain their energy', and many of them have some association with bodily contact. While his groups of artifacts are often diverse in terms of subject, material and size, Pellegrin creates a hidden relationship between them by the ordering process, so as to create their own sense of rhythm. Their unity is further emphasized by the artist's use of a personally symbolic code of numbers.

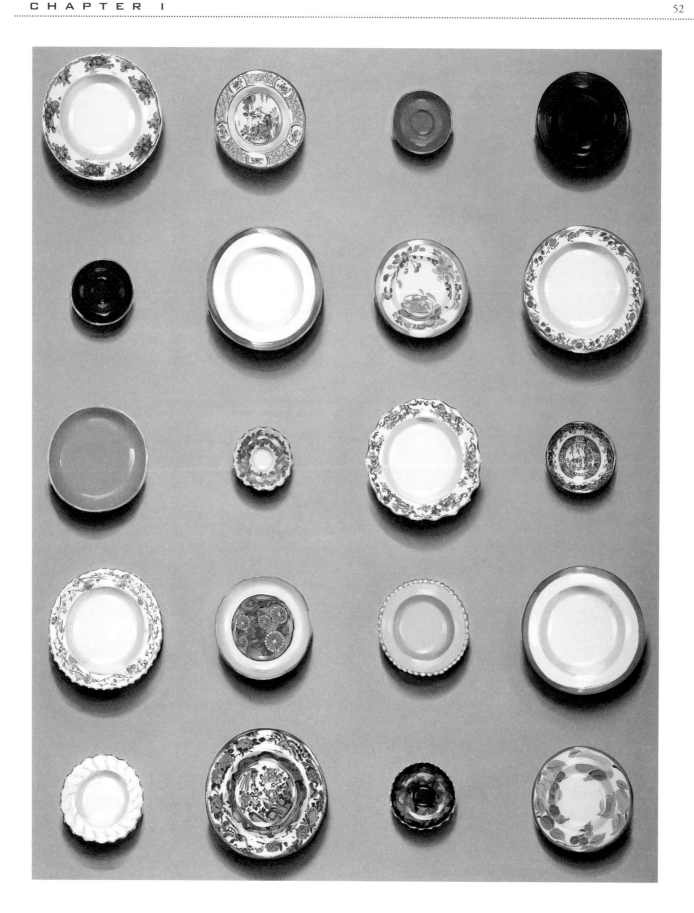

↤ LISA MILROY
PLATES
1992

This large oil painting on canvas is one of a number of works by Milroy which depict groupings of familiar objects. With their diversity of decorative styles, the plates are depicted like a taxonomical arrangement of museum artifacts.

KARSTEN BOTT ↦
TOOTHBRUSHES
Detail of an installation at Galerie Hant, Frankfurt
1991

Bott's large collection of toothbrushes was acquired from a Frankfurt dental practice which had offered new toothbrushes in exchange for old ones. Grouped in accordance with their variously coloured handles, they are arranged taxonomically on the vitrine shelves. Displayed at eye-level, they are presented to the viewer as standard mass-produced objects, each having once had very personal associations.

NEIL CUMMINGS
THE COLLECTION YELLOW
Detail
1998

One of a series of glassless, cardboard 'vitrines' made entirely from recycled, found materials and containing yellow plastic bottles previously used by the artist himself. This represents a reversal of the conventional imposing role of the museum showcase used to provide protection to rare and precious, sometimes unique, objects.

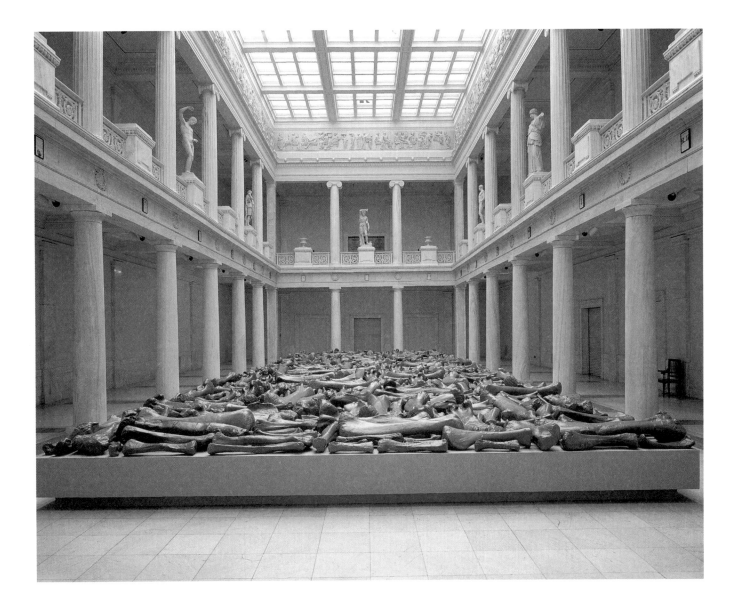

ALLAN McCOLLUM
LOST OBJECTS

Installation at the Carnegie Museum of Art, Pittsburgh

1991

McCollum has used casts taken from moulds of dinosaur bones in the collection of the Carnegie Museum of Natural History to produce this vast horizontal arrangement. The work reflects upon the taxonomical system of classification and the use of copies and replicas in museum displays to represent an absent or 'lost' specimen. Derived from natural fossil remains, the casts of dinosaur bones contrast with the surrounding plaster casts of classical sculptures and architectural friezes in the gallery above.

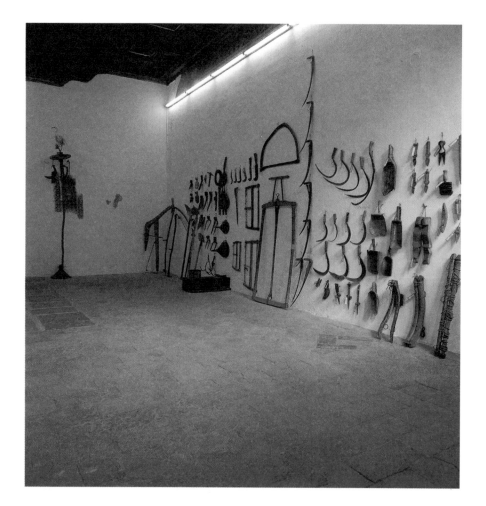

⟿ CLAUDIO COSTA
L'INEFFABILLE CIRCOLAZIONE
DELL'UMANO ('THE INEFFABLE
CIRCULATION OF HUMANITY')

Installation at the Massimo Valsecchi Galery, Milan
1981

Costa's wider fascination for aspects of anthropology led to his interest in the traditional culture of peasant farming communities. His taxonomic arrangements of rustic farming implements not only celebrate their intrinsic beauty, but have parallels with the practice of preserving ethnographic artifacts in museums in an attempt to document a disappearing way of life.

NIKOLAUS LANG ⟿
FOR MRS. G. LEGACY – FOOD
AND RELIGIOUS HOARD

Bayersoien
1981–82

Since the early 1970s Lang's work has centred around the grouping and classification of artifacts which have parallels with museum displays of archaeological, anthropological and ethnographical objects. This installation consists of a vast collection of diverse material that he had discovered in an old lady's house which represents a lifetime's accumulation. This work is a permanent installation in the Nationalgalerie, Berlin.

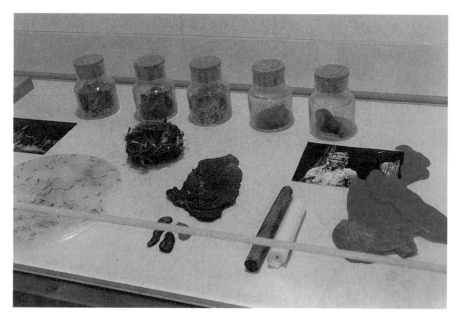

⟿ SIGLINDE
KALLNBACH
THE MUSEUM OF ASHES

Installation view at the Frauen Museum, Bonn
1995

In the course of this ongoing work, begun in 1981, Kallnbach's series of performances have on a number of occasions been characterized by her use of fire, as in 1983 when she burned her university degree certificate. On each occasion she collected up the ash and stored it in a small glass jar which was preserved with related relics and photographic documentation. The collection was displayed in a vitrine to accompany Kallnbach's solo exhibition in Bonn.

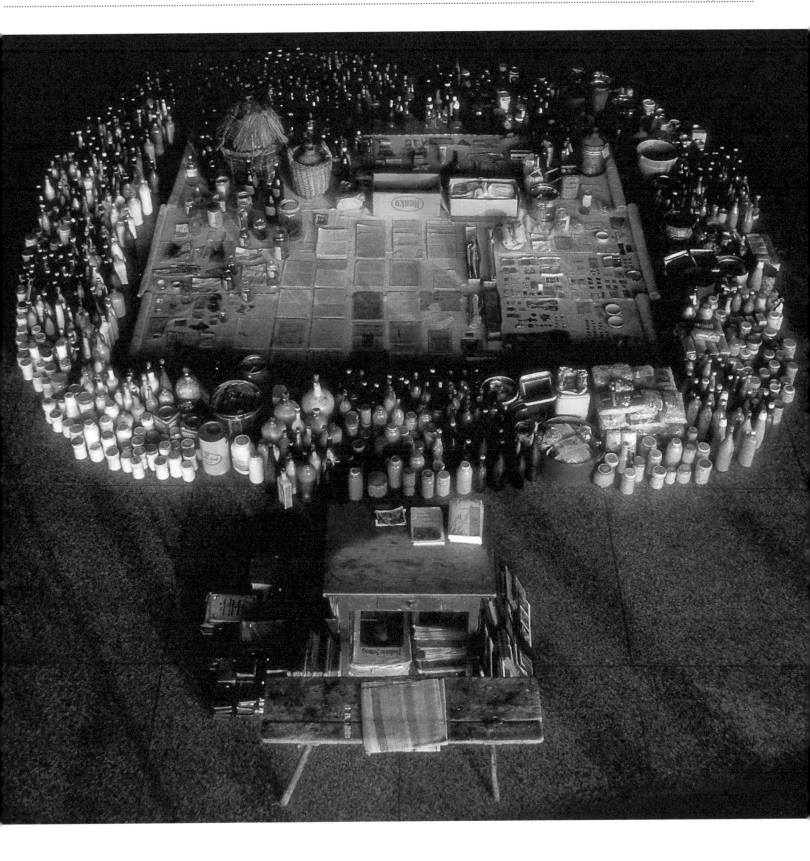

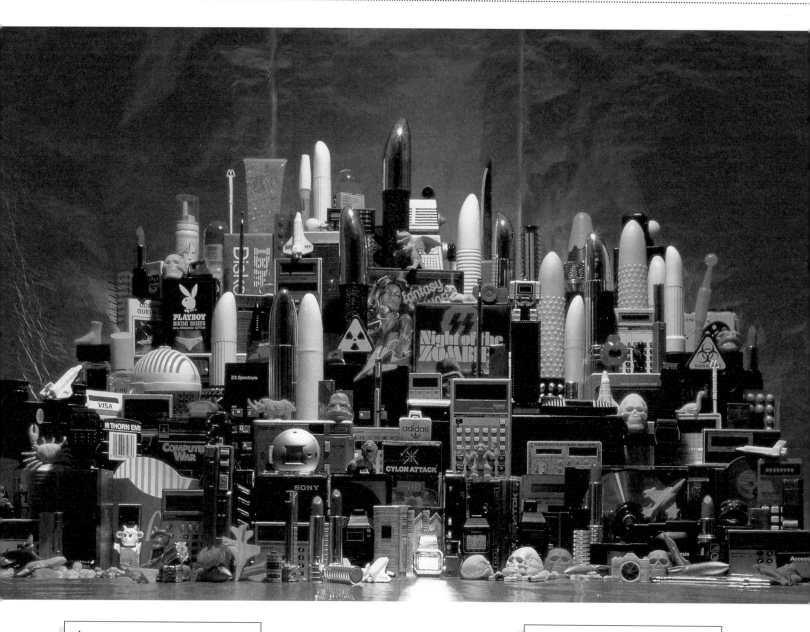

♠ TIM HEAD
STATE OF THE ART

1984

Head's extra-large Cibachrome print measuring
72 x 108 in. (189 x 274 cm) displays a diverse
collection of contemporary objects such as
lipsticks, sex toys, cameras and digital watches.
His method of arrangement according to their
formal similarities leads to a fascinating association
of ideas which accompanies each type of object.
Their display takes on an almost architectural
appearance, as if these vibrators are towering
above some torrid urban nightscape, and the
ensemble illustrates how a collection of unrelated
objects can provide a sobering cultural insight.

ROSEMARIE TROCKEL
BALACLAVA BOX

1986

Trockel frequently uses vitrines and plinths in her
work to emphasize the significance and impor-
tance of the objects she presents. The knitted ski
masks in a vitrine, with a slit for the eyes but with
the mouth covered, symbolize the traditional
concept of female silence and passivity. However,
this role is reversed by the associations of the bala-
clava with urban violence and the many women
who became involved in the German terrorist
movement. The use of knitting is a common
feature in Trockel's work, suggesting an elevation
of women's craft.

HAIM STEINBACH ◊
stay with friends
1986

Steinbach has developed a generic wedge-shaped shelf and its precise construction has parallels with museum display mounts. His choice and arrangements of objects which include everyday, 'ready-made' consumer items, are carefully considered so that they become integral with the shelf as a sculptural form. In this work Israeli cereal boxes are juxtaposed with ancient Judaean pots, and both sets of objects are linked as containers of foodstuffs from different eras. Steinbach dictates very precisely how his metaphorical titles should be displayed (as seen above in lower-case italics) as part of the work itself.

ARHAMAIANI ↩
ETALASE
1994

Many of Arhamaini's installations and performances have addressed the harmful influence of the West, particularly that of America on traditional Indonesian culture. She has been concerned, in works like *Nation for Sale*, with the process of industrialization whereby the country's rich agricultural land is being steadily transformed by the spread of industrial and residential building funded by foreign capital. In *Etalase* the Coca-Cola bottle and the pack of condoms serve as symbols of this American economic exploitation: when presented in a vitrine juxtaposed with significant Indonesian objects, the small collection takes on the wider context of museum display of cultural artifacts.

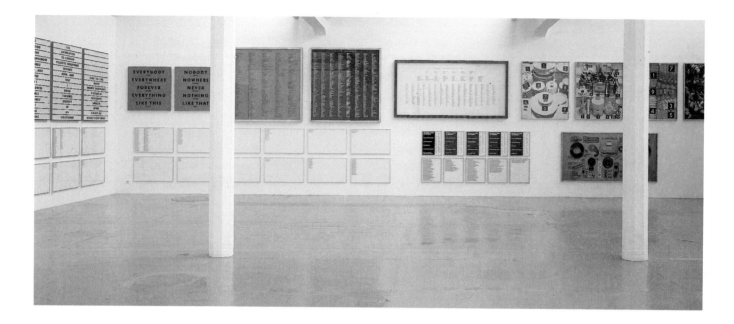

THOMAS LOCHER 🌱
WORDS, SENTENCES,
NUMBERS, THINGS –
TABLEAUX, PHOTOGRAPHS,
PICTURES
Installation at the Kunsthalle Zürich
1993

Locher's work explores the complex relationship
between text and image, which has parallels with
museum labels and graphics panels. His carefully
arranged and ordered colour fields, in various sizes
and with applied numbers and letters, form an
ambiguous museological style of annotation.

ON KAWARA 🌱
ONE MILLION YEARS – FUTURE
Detail
1981

Part of Kawara's work which consists of ten
volumes of loose-leaf binders housed in a card-
board archive box. On each page the years are
consecutively typed in a seemingly endless series.
They were printed in an ordinary copy shop, using
standard printer toner; this medium is considered
unstable for archival purposes, hence over the
course of time the dates should become fainter
and eventually disappear.

**CHRISTIAN
BOLTANSKI** 🌱
INVENTORY OF THE MAN
FROM BARCELONA
Installation at Fundació Antoni Tàpies, Barcelona
Detail of the inventory
1995

Boltanski places an intriguing collection of private
objects from a home in Barcelona into the institu-
tional space of the museum. This process inevitably
endows them with a special significance and
dimension of museological framing when seen in
their new context. It also shifts their association
from the personal to a more distanced sense of
objective neutrality.

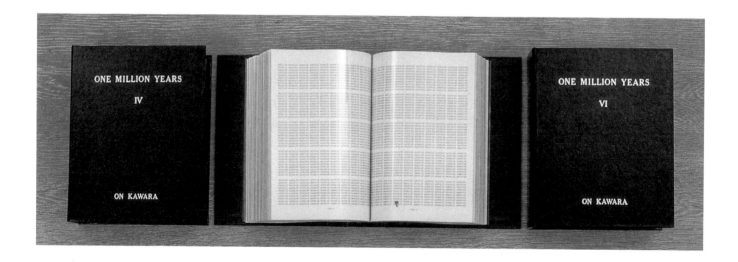

MENJAR PER A GATS	BUTACA	CINTURÓ	DRAP DE CUINA
BOSSA PER A LA COMPRA	AGULLA	CADIRA	GOUACHE
GERRO	TAULA METÀL·LICA	ASSECADOR DE CABELL	LLIBRETA
LLUM DE TAULA	ESCURADENTS	SABATILLES	JOC DE CARTES
NAVALLA	PROJECTOR	FOTOGRAFIA	ROBA
CONTESTADOR AUTOMÀTIC	PENJADOR	APUNTS D'ECONOMIA	MANYOPLA DE CUINA

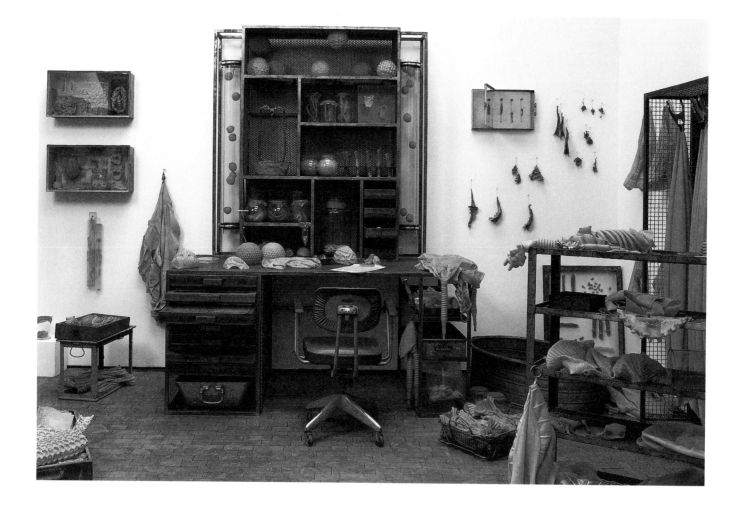

WOLFGANG STILLER
ATTEMPT AT A FUNDAMENTAL
NEW ASSESSMENT OF THE
SURFACE

1994–99

Installation view

Karl Ernst Osthaus-Museum, Hagen

1999

One of a series of installations begun in 1994, in which Stiller has created an imaginary scientific laboratory environment. His strange new 'life forms' made from latex rubber are displayed on metal shelves or in specimen jars and vitrines as if they were real natural history specimens. Since the fictional scientist has effectively created these specimens simply in order to preserve them, the installation also serves to parody the wider museological process.

READYMADES BELONG TO EVERYONE

BACKSTAGE

MAMCO, Geneva

1994

This installation mimicked the museum backroom, complete with technicians' packaging equipment, racking and storage crates. Despite its collective name, this 'group' (which took its name from the Readymades of Marcel Duchamp) was actually one artist called Philippe Thomas. He created a number of exhibitions and installations which were intended to critique museum systems and promote the concept that anyone who purchased a work from his agency would automatically become its author. Thus even a museum could itself become the artist.

⚲ IMI KNOEBEL
ROOM 19
1968

Installation at The Dia Art Foundation, New York
1987

Exhibited in various different configurations since
the late 1960s, Knoebel's installation is reminiscent
of a storage area in both the artist's studio and the
museum reserve. His presentation of different-
sized, blank fibreboard stretchers and forms devoid
of colour represents a celebration of the storage
principle itself, in which a compacted collection of
forms can acquire a sculptural dimension.

CHRISTIAN ⚲ BOLTANSKI
RÉSERVE DU MUSÉE DES ENFANTS
1989

Inventories, archives and storage systems, with
collections of peoples' possessions and memories
are frequently used by Boltanski in his work.
Although lost and forgotten, they become reunited
with their context in the museum space. This
installation, *Children's Museum Storage Area*, is from
the exhibition 'Histoires de Musée', for which
artists were invited by the Musée d'Art Moderne de
la Ville de Paris to create works for a precise site,
function or environment.

CHAPTER II *art or artifact*

Artists are by nature collectors of both forms and images. The resulting accumulations can serve as an extension of an artist's studio, a storage place where both ideas and materials are evaluated. Whereas classic collectors are primarily attracted to the rare and the valuable, artists tend to gather trivial and worthless items which they can then transform into works of art, as demonstrated by the principle of the *objet trouvé*. Since the late 1960s, many artists have exhibited their personal collections as an entity or a 'museum'. Comprising collected or modified objects, which are frequently presented as a form of installation, such collections tend to imitate traditional taxonomic display. The results may be personal, biographical or fictional in character, and the style of presentation may contain elements of parody. The objects are presented with an aura of institutional authority, yet play on the contrast between truth and fantasy in their use of either fake or genuine artifacts.

CLAUDIO COSTA
MUSEUM OF MAN
1974

Costa created realistic replicas of modern man's ancestors by modifying life casts taken from his own head and limbs, thus reversing the evolutionary sequence. He did extensive research in museums by making drawings of and taking casts from real specimens and combining them with his own features. His finished 'anthropology museum' was presented in a former pasta shop display cabinet.

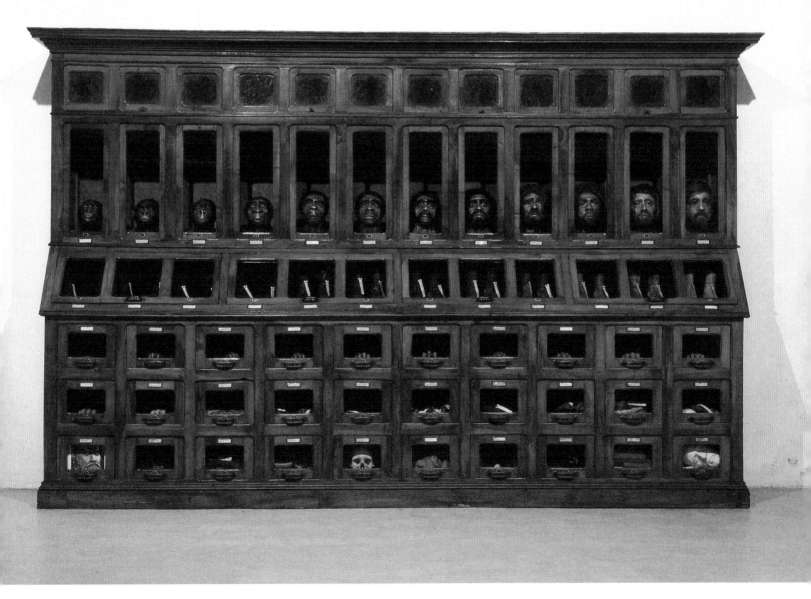

The activity of collecting can be an instinctive part of artistic practice, in which assemblages of diverse material are usually considered or modified in the studio before being presented as works of art. Although the type of objects gathered might have no monetary value in true collecting terms, individual items can be transformed by artists into unique artifacts and then displayed together as an entity in imitation of traditional museological methods. The objects on display may have very personal associations, as in the case of Christian Boltanski's *Vitrine de Référence* works (1970–71) or Joseph Beuys's series of vitrines which contain 'relics' from his past actions or performances.

Some artists choose to call their collections 'museums' since the word is not only synonymous with a repository of everything original, authentic and unique, but also sanctions the importance of an object as a work of art, worthy of preservation. Such collections may be presented in an 'official' museum style, mimicking the familiar use of label texts by offering information about provenance, chronology and function.

The self provides the most fundamental subject matter for the artist's personal museum and acts as a vehicle for expressing

an individual's mythologies and ideologies. Artists often investigate themselves and their memory using associations with certain collected artifacts; rather than being merely expressions of sentimental self-investigation, however, such associations tend to represent broader sociological insights. Over the years Peter Blake has collected an enormous quantity of diverse objects and ephemera, which he often

integrates into his work: 'Partly for my work – a lot of it is about collecting. There's *A Museum for Myself*, 1977, of things I collected which I might have used for other collages but I liked them too much to give them away or sell them. So it consists of autographs and little pieces of china that my children would have picked up when they were young from a stream – things I love.'[1]

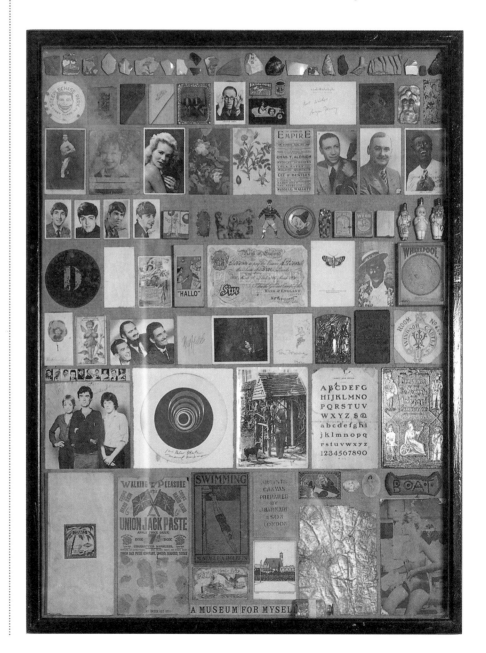

PETER BLAKE
A MUSEUM FOR MYSELF
1977

The collecting process often governs the direction adopted by Blake in his works; this may be triggered by things he has already accumulated or he may acquire objects specially in order to fulfil a creative urge. His working environment is surrounded by so many objects that he has come to regard his studio as a form of museum in itself.

Barbara Bloom has created a different type of personal museum, presenting collections of idealized objects synthesized with her own images and associations which become a vehicle for more universal reflection. Her installation *The Reign of Narcissism* (1989), contained within a hexagonal rotunda, is based on a neoclassical salon or a museum period room (filled) with objects and furniture, reminiscent of both a parlour and a film-set. She employs a number of expressive devices, fussily self-reflective decorative items, including mirrors, upholstered chairs, plaster casts and antique vitrines containing fine porcelain cups, cameos, chocolates and books. All bear her image, silhouette or name, and even the chairs are upholstered with patterns of Bloom's signature, astrological chart and dental X-rays. There are also vanitas images of women gazing at their own reflections in mirrors and the collection generally examines both the fetishistic desire of the private collector, in the tradition of the architect Sir John Soane, and the artist's self-conscious desire for recognition: 'This work is not really about Freudian narcissism, but about the narcissistic aspects of art making and of collecting'.[2] To accompany the installation, she produced a publication with the same title – an artist's book rather than a catalogue – containing

**BARBARA BLOOM
THE REIGN OF NARCISSISM**
1989

Bloom presents a collection of objects bearing images of herself, which include cameos, chocolates, portrait busts and even tombstones. She creates an idealized interior which is essentially neoclassical in style, based on a traditional museum period room or salon. By engaging the viewer in the act of looking at the representation of cultural clichés, she explores the whole notion of personal vanity and its connection to both artistic production and the obsessive collecting tendency.

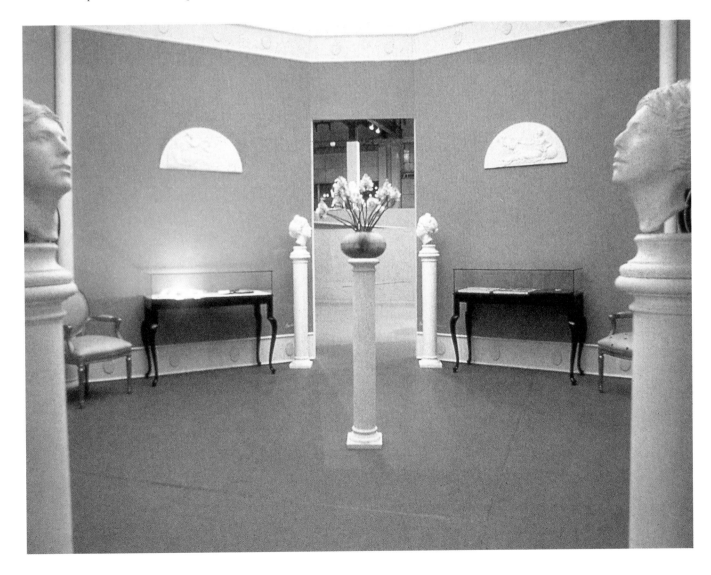

extensive texts and images relating both to her work and to the wider subject of collecting. For her project *The Collections of Barbara Bloom* (1998) at the Wexner Center for the Arts, Columbus, Ohio, she meticulously designed every aspect of an exhibition which included her extensive collections, previous installations and a section devoted to the writer Vladimir Nabokov. Bloom also made reference to the celebrated estate sales of Jacqueline Kennedy Onassis and the Duke and Duchess of Windsor, and listed her own collection in the form of an auction

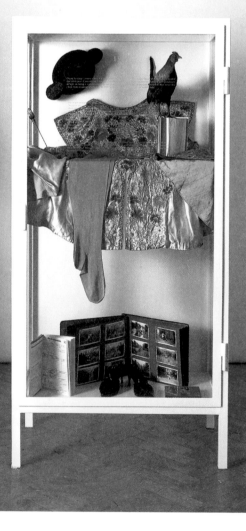

catalogue complete with lot numbers. Sophie Calle's work *Autobiographical Stories* (1988) involves the display of personal items and photographs combined with intimate narrative texts which recount significant memories. Her collection or personal museum consists of keepsakes such as a blonde wig, a wedding dress and a red plastic bucket, artifacts which serve as tangible evidence to substantiate her past. In *The Birthday Ceremony* (1997), Calle displays in vitrines a large collection of objects which were given to her as birthday presents between 1980 and 1993. She devised a birthday dinner as a special annual ritual at a time when she was feeling anxious about the prospect of being forgotten by people. Instead of using or consuming any of the presents she received, she inventoried and exhibited them in order to provide a lasting reminder of her friends' affection.

In addition to the autobiographical aspect, the artist's museum is sometimes concerned with paying homage to a particular celebrity which might hark back to some adolescent or childhood adulation or reflect a wider fascination for their popular

SOPHIE CALLE
THE BIRTHDAY CEREMONY
1991
1997

Fifteen medical-style vitrines display birthday presents to the artist, with an inventory of the items printed on the glass and the following text: 'On my birthday I always worry that people will forget me. In 1980, to relieve myself of this anxiety, I decided that every year, if possible on October 9, I would invite to dinner the exact number of people corresponding to my age, including a stranger chosen by one of my guests. I did not use the presents received on these occasions. I kept them as tokens of affection. In 1993, at the age of forty, I put an end to this ritual.'

public image. Rosemarie Trockel's *Paris Blonde* (1993) consists of a collection of Brigitte Bardot ephemera and memorabilia presented in a showcase with fake artifacts, and also includes a roll of undeveloped film used by her to photograph blonde women in Paris, the movie star's home town. The vast output of commercial memorabilia associated with such icons of popular entertainment as Elvis Presley and The Beatles have inspired works like Joni Mabe's *The Travelling Elvis Museum* (1989) which included a 'May-be Elvis Toenail' found by the artist in the pile of a carpet at Graceland. Jeffrey Vallance's *Elvis' Sweatcloth* (1998) is one of a series of fake Presley relics which link the bizarre, the sacred and the comical. In another work, *Jeffrey Vallance Presents the Richard Nixon Museum* (1991), he exhibits an obsessive collection of Richard Nixon memorabilia, including caricatures and related trivia of every description. Gavin Turk has been inspired by the idea of the wax museum in the creation of works in which his own features are assimilated with a number of his favoured cult personalities. Guillaume Bijl also used the device of the waxwork and the polyester museum-style mannequins in his installations; he calls these 'transformations and situations', in which the displays are created with great attention to detail. The collections of museums of anthropology and archaeology have also been a source of inspiration for artists to create works involving a serious insight into their wider principles. In the early 1970s a number of artists, including Claudio Costa, Anne and Patrick Poirier and Nikolaus Lang, collected, modified

and fabricated objects which they then presented as 'genuine' artifacts to be seen in museological-style displays. They came to be associated with the German term *Spurensicherer* (literally, 'one who discovers and records traces'), a characteristic feature of their work being the inclusion of strands of both history and myth.[3] Their work often involved a combination of real and fake artifacts, presented with a certain degree of 'scientific' methodology and backed up with careful research into museum objects. Nikolaus Lang developed an ability to knap his own convincing 'Neolithic' flint implements and spent a number of years on an Australian project celebrating the aboriginal fusion of nature with culture.[4] Both Lang and Costa conceived projects which investigated the lives of former inhabitants of remote mountain settlements; in these they incorporated examples of found and 'reconstructed' artifacts, thus creating in effect their own anthropological museums.[5]

In 1976–78, Susan Hiller, who had previously trained as an anthropologist, created a work called *Fragments* which consisted of over 400 sherds of Pueblo Indian pottery. This assemblage was presented with the attention to detail that one might expect of a real archaeological report, accompanied by supporting charts showing Hiller's acute observations of the painted decoration expressed in an appropriate descriptive language. Her ongoing interest in this field led her to develop a work entitled *From the Freud Museum*, which was the result of several years of research and preparation between 1991

GUILLAUME BIJL ⚲
DOCUMENTA WAX MUSEUM
Installation at Documenta IX, Kassel
1992

The frontage of Bijl's wax museum in Kassel took the form of a large shop window, enabling passersby to view it from the street. As a satirical overview of the art world in the context of Documenta, it includes figures of well-known collectors and the artist Joseph Beuys, who had many associations with the history of the event.

JEFFREY VALLANCE ⚲
THE TRAVELLING NIXON MUSEUM
1991

This is a suitcase version of a larger project entitled 'Jeffrey Vallance Presents the Richard Nixon Museum' (1991). It consists of an obsessive collection of Nixon memorabilia, including caricatures and related trivia of every description. While based in Las Vegas, Vallance has explored a number of museological themes of local interest, including the Liberace Museum notable for its associations with high kitsch, and the Ocean Spray Cranberry Museum.

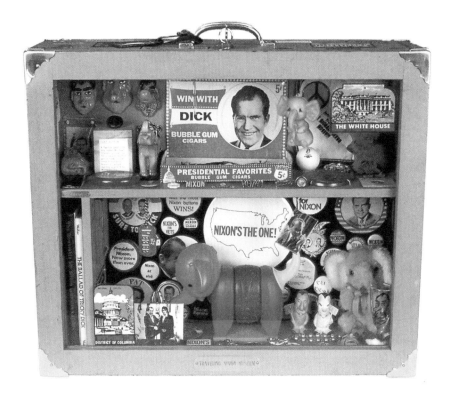

SUSAN HILLER
FROM THE FREUD MUSEUM
Detail of installation

Freud Museum, London

1991–96

Hiller uses fifty customized brown cardboard boxes similar to those intended for archaeological specimens. Each box is individually titled, dated and captioned, and in some cases she has used an ancient or unfamiliar language translated into English. One of the boxes contains a miniature LCD monitor showing Hiller's silent video programme *Bright Shadow* on a continuous loop.

MARK DION
CABINET OF CURIOSITIES
FOR THE WEXNER CENTER
FOR THE ARTS

Installation view

The Wexner Center for the Arts, Columbus, Ohio
1997

Because of its associations with Ohio State
University, the Wexner Center's collection is rigidly
divided into a number of specialist academic de-
partments. This installation functions as a museum
within a museum, which challenges academic sep-
aration and promotes instead an interplay between
the natural and the artificial in the Aristotelian spirit
of the *Wunderkammer*. The shelving units are
arranged in a semicircle, and the viewer is kept at
a distance from them by means of a protective rail-
ing which also serves to suggest the existence of an
intellectual barrier between the various academic
disciplines.

and 1996 and linked with a publication
commission.[6] According to Hiller, with
this work she '... has taken the idea of
the museum as a kind of model' and it is
therefore presented as a vitrine installation

consisting mainly of cardboard archive
boxes containing carefully classified arti-
facts, texts and images.[7] These private
relics, keepsakes and fragments evoke
various cultural, mythical and historical
references and ambiguous associations.
In the process of making the work, Hiller
articulated unexpected links between the
various objects so as to create an appropri-
ate context within the Freud Museum: '…
I've orchestrated relationships, and I've
invented or discovered fluid taxonomies.
Archaeological collecting boxes play an
important role in the installation as
containers or frames appropriate to the
processes of excavating, salvaging, sorting,
naming, and preserving – intrinsic to art as
well as to psychoanalysis and archaeology.'[8]
Some of Mark Dion's installations relate

to his interest in the historical concept and
presentation principles underlying the
Wunderkammer or pre-Enlightenment
private collections. This reference to the
past has prompted him to use specially
constructed wooden cabinets, of a trad-
itional design, to house arrangements
which include natural history specimens,
early scientific instruments and cultural
artifacts. Dion is inspired by the discursive
quality of the *Wunderkammer* as a space of
discovery and reflection and in his writings
he has spoken of his affinity with its imag-
inative display aesthetic: 'I must confess a
fondness for curiosity cabinets particularly
since they most closely resemble the
surrealistic quality of the back room of
many museums, rather than the exhibition
galleries'.[9] For his project *Cabinet of*

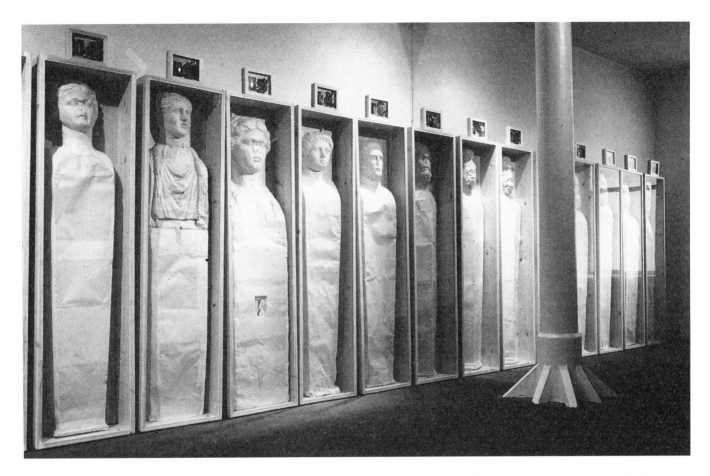

Curiosities for the Wexner Center for the Arts (1996) Dion explores the interrelationship between natural and artificial objects and their links with allegorical paintings by Brueghel, Arcimboldo, Rembrandt and Snyders. By grouping his diverse selection from the Wexner's collections in nine separate cabinets, he suggests that a lack of cross-fertilization of ideas between scholarly disciplines hinders the progress of knowledge.

The interplay between the animal, vegetable and mineral kingdoms that characterized the *Wunderkammer* has modern parallels in the work of Claudio Parmigianni and some of the artists associated with the Italian Arte Povera movement, such as Giuseppe Penone and Mario Merz.[10] There is also an aesthetic link with the early museum's preoccupation with nature's anomalies which has been investigated by Rosamond W. Purcell in her photographic project 'Special Cases' and some of her curated exhibitions.[11] In the seventeenth century, mythical creatures like mermen and basilisks were specially created in order to provide collectors with physical specimens for their cabinets of curiosities. Using a similar practice of grafting together taxidermied specimens, Thomas Grünfeld has created strange hybrid animals for his series *The Misfits* (1990–94), and his imaginative creations are reminiscent of medieval bestiaries. Joan Fontcuberta and Pere Formiguera have also created a series of fantastic creatures in a work entitled *Fauna* (1988), which playfully mimics the aura of authority of the traditional museum display: by substantiating their exhibits with pseudo-scientific data the artists are able to create the illusion of fact. According to Fontcuberta, 'Knowledge has everything to do with its presentation. The scientific institution has enormous power to convince us of what is true by

JOAN FONTCUBERTA / PERE FORMIGUERA
FAUNA
1987/90

(*Cercopithecus Icarocornu*, from the archive of Professor Peter Ameisenhaufen c. 1940 – above: Expedition map / right: Field drawing – cat. 792-LY61-96 / above right: Moment of the magic song over the totem of sacrifices)

As part of a series called 'Fauna', Fontcuberta and Formiguera created a convincing museological display based on the work of an invented character called Professor Ameisenhaufen (literally, 'ant-hill'). His extensive archive of notebooks, laboratory observations and field photographs are used in conjunction with specially modified taxidermied animals in order to lend their fiction greater plausibility and challenge the notion of evidential facts.

the trappings of scientific language and methods.'[12] The display presents convincing photographs of the creatures taken in their supposed natural habitat, with extensive biographical information on the life of the fictitious Professor Ameisenhaufen, accompanied by his field notes, drawings and X-ray plates. It even includes push-buttons to enable the viewer to listen to recordings of the creatures' characteristic sounds. The entire ensemble accompanied by didactic museum captions and maps was created by the two artists with the help of a co-operative taxidermist from Barcelona zoo.

This element of fantasy and the creation of fictional collections and museums is also strongly in evidence in the works of Ilya Kabakov. Countless items of garbage obsessively collected by an invented character are the subject of his installation *The Man Who Never Threw Anything Away* (1985–88). This work is from a series called *Ten Characters*, based on ten rooms of a Soviet communal apartment. The domestic space which these imaginary occupants inhabit serves as a metaphor for both the art community and the museum for which Kabakov acts as curator. In his published *Albums*, which pertain to this series of installations, Kabakov describes this fantasy world in graphic detail: '... myriads of boxes, rags and sticks were set out in strict order ... Almost all the shelves where these things were placed were accurately labelled, and each item had a five or six-digit number glued on it and a label attached to it from below.'[13] Kabakov has since gone on to create fictional museums in installations like

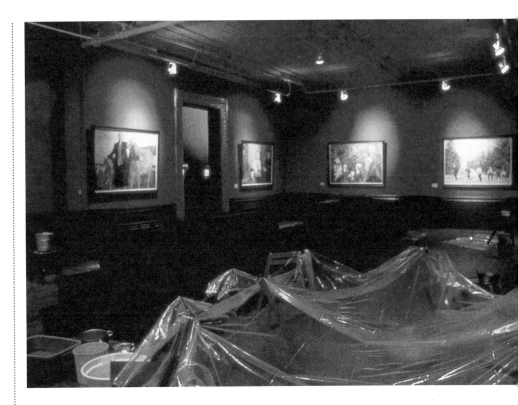

Incident at the Museum or Water Music (1992), for which he created a traditional museum gallery environment complete with historic paintings. His *Museum of Lost Civilizations* (1998) is an ongoing project in which the museum is conceived as a complete entity, presented as an architectural model with every aspect, including the surrounding landscape, carefully considered.

In contrast to the notion of the artist as collector, Michael Landy has reversed such obsessive activities in *Break Down* (10–24 February 2001), staged in London at the recently vacated C & A department store, 499-523 Oxford Street. After listing all his personal possessions, Landy had every single item reduced to its raw materials by methods used in waste disposal plants – disassembly, crushing, shredding etc. While awaiting deconstruction and sorting

**ILYA KABAKOV
INCIDENT AT THE MUSEUM
OR WATER MUSIC**
Installation at Ronald Feldman Fine Art, New York
1992

This installation illustrates a fictional Russian museum's dependence on fluctuating state funding and uses a hypothetical situation in the post-Soviet era in which no funds are available for repairs to the roof to prevent the rain damaging their 'precious' paintings. The complete series is painted by Kabakov himself masquerading as a fictitious Soviet Realist artist called Stepan Koshelev. The phrase 'water music' refers here to the rhythm of the dripping rain, and the installation was accompanied by a special sound composition by Vladimir Tarasov.

by Landy and his assistants, the collection of over 5,000 items was displayed on a vast conveyor belt.

ROSS SINCLAIR
MUSEUM OF DESPAIR
1994

An empty shop on Edinburgh's busiest tourist stretch, the Royal Mile, became Sinclair's 'museum' for three weeks during the Festival. It was essentially a retrospective exhibition of five years' work which included paintings, prints, posters, postcards, tarpaulins, photographs, T-shirts, videos, signs and installations. Marked with day-glo price tickets, everything was for sale and related to his concern with the tendency to treat art simply as a commodity.

GAVIN TURK
POP
1993

Standing 2.75 m (almost 9 ft) tall on its high plinth, Turk's imposing waxwork is a wry synthesis of self with icons from the world of Pop music. His own features are combined with the hairstyle and costume of the Punk singer Sid Vicious at the time of his celebrated rendition of Frank Sinatra's classic 'I did it my way'. The pose and facial expression also relate to Andy Warhol's silkscreen print of Elvis Presley.

TRACEY EMIN
EVERYONE I HAVE EVER SLEPT WITH 1963–1995
1995

The inside of this womb-like frame tent was decorated with the names of every person with whom Emin had shared a bed. It was the central exhibit in the 'Tracey Emin Museum' (1995–98), a former shop in Waterloo Road, London, which the artist opened to the public two days a week and at other times by appointment. The premises also functioned as her studio and gallery.

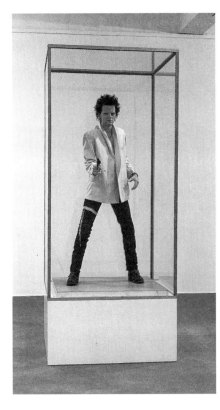

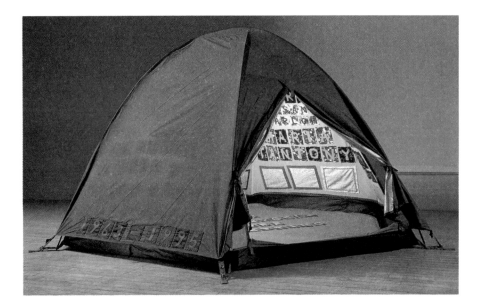

GILBERT AND GEORGE
THE RED SCULPTURE (TAPE ON FLOOR)
Sonnabend Gallery, New York
1976

Concerned to make no distinction between life and art, Gilbert and George first declared themselves 'living sculpture' in 1969. They made numerous appearances at museums and art galleries, where they posed with remarkable self-control, maintaining perfect stillness and resembling statues. For *The Red Sculpture*, with their faces and hands painted an intense red, they moved slowly, adopting different poses in response to statements played on a tape recorder. This work was first presented in Tokyo in 1975 and lasted ninety minutes.

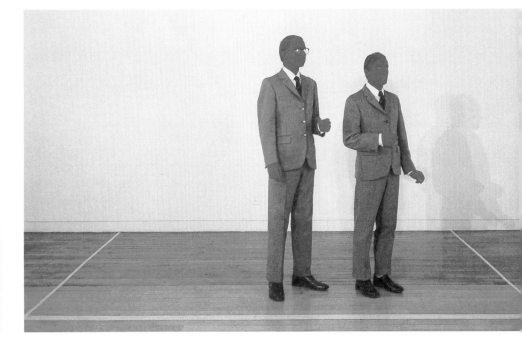

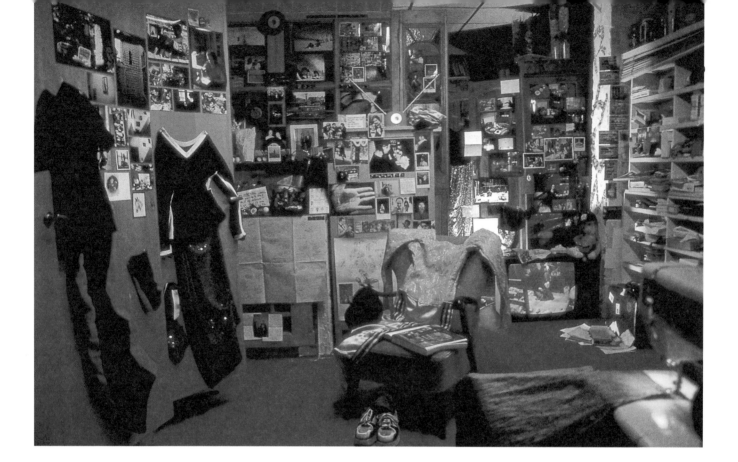

♀ GEORGINA STARR ⚲
THE NINE COLLECTIONS OF THE SEVENTH MUSEUM; THE COLLECTION
(with annotated inventory diagram)

1994

This concept was inspired by a 17th-century painting by the Antwerp artist Willem van Haecht, *Alexander the Great Visiting the Studio of Apelles* (Mauritshuis Collection, The Hague), a classical subject having as its setting an imaginary museum gallery containing art treasures. On the chair is placed an open book showing a detail of this picture – Apelles painting Campapse – and Starr's installation is similarly replete with allusions to both the painting by van Haecht and the nine subsidiary collections. It covers themes like loneliness, and there are various hidden references to sorrow.

SIDE PANEL (FIRST EDITION)

1 *The Garden at Lahey* (Lahey Collection, Den Haag)
2 *Plated Exterior* (Lahey Collection, Den Haag)
3 *Wooden Sculpture* (C. Lahey, Lahey Collection, Den Haag)
4 *The Narrow Corridor* (Lahey Collection, Den Haag)
5 *The Guest Room* (Lahey Collection, Den Haag)
6 *The Secret Closet* (Lahey Collection, Den Haag)
7 *The Birth of Sculpture* (Recollection Collection)
8 *Stairway at Lahey* (Lahey Collection, Den Haag)
9 *Stairway and Mosaic wall* (Lahey Collection, Den Haag)
10 *Statue* (location unknown)
11 *Aquarius the Water Carrier* (Recollection Collection, Den Haag)
12 *Escape by Plane* (The Seven Sorrows Collection, Depression)
13 *Portrait of a Horse* (Recollection Collection, Den Haag)
14 *Costume for Dining with the Third Storyteller* (Costume Collection, Den Haag)
15 *Costume for Junior No. 3* (Costume Collection, Den Haag)

SIDE PANEL (SECOND EDITION)

16 *Market Scene in Den Haag* (Costume Collection, Den Haag)
17a *First daughter* (Lahey Collection, Den Haag)
 b *Second daughter* (Lahey Collection, Den Haag)
 c *Third daughter* (Lahey Collection, Den Haag)
18 *Portrait of Christine Lahey* (Portrait Collection, Den Haag)
19 *The Making of the Golden Gown Part 1* (Costume Collection, Den Haag)
20 *The Making of the Golden Gown Part 2* (Costume Collection, Den Haag)
21 *Choosing the cloth* (Costume Collection, Den Haag)
22 *The Making of the Golden Gown Part 3* (Costume Collection, Den Haag)
23 *The Material Landscape* (Lahey Collection, Den Haag)
24 *Costume for Dining with the Second Storyteller* (Costume Collection, Den Haag)
25 *Costume for Junior No. 2* (Costume Collection, Den Haag)

MIDDLE PANEL (FIRST UPPER SECTION)

26 *Voyage around a Den Haag Kebab Shop* (The Seven Sorrows Collection, Depression)
27 *You're the one that I want* (The Allegory of Happiness Collection, Songs)
28 *The Faceless Florentine Couple* (The Allegory of Happiness Collection, Holidays)
29 *A Charmed Life* (Lahey Collection, Den Haag)
30 *On the Beach at Yarmouth* (The Allegory of Happiness Collection, Holidays)
31 *Allegory of Peace* (Recollection Collection)
32 *Blackpool Entertainment* (The Allegory of Happiness Collection, Holidays)
33 *A Sleeping Nymph at the Boathouse* (The Allegory of Happiness Collection, Holidays)
34 *A Venetian Couple* (Recollection Collection)

35 *Mary had a Little Lamb* (Allegory of Happiness, Songs and Visit to a Small Planet Collection)
36 *Van Gogh by the Sea at Christmas* (The Allegory of Happiness Collection, Holidays)
37 *Long Haired Lover from Liverpool* (The Allegory of Happiness, Songs and Junior Collection)
38 *The Ventriloquist's Dummy Boy* (Portrait Collection)
39 *Study for the Face of Junior* (Junior Collection, Den Haag)
40 *Ping Pong Balls for Entertaining* (Junior Collection, Den Haag)
41 *Playing Cards for Entertaining* (Junior Collection, Den Haag)

MIDDLE PANEL (SECOND UPPER SECTION)

42 *On the Beach at Scheveningen* (Junior Collection, Den Haag)
43 *Conversation at Scheveningen* (Junior Collection, Den Haag)
44a, b, c, d, e *Relaxing at Scheveningen* (Junior Collection, Den Haag)
45 *Whistling Workers* (The Seven Sorrows Collection, Den Haag)
46 *A Yorkshire Couple* (Portrait Collection)
47 *Rose from The Clairvoyant* (Recollection Collection)
48 *Yellow Cup* (The Seven Sorrows Collection, Anger)

MIDDLE PANEL (FIRST LOWER SECTION)

49 *The Motorbike Song* (The Allegory of Happiness Collection, Songs)
50 *Joseph Explaining Dreams (Before)* (Mauritshuis Collection)
51 *Joseph Explaining Dreams (After)* (Mauritshuis Collection)
52 *A Guide to Ventriloquism* (Junior Collection)
53 *The Seven Sorrows* (Notes on The Seven Sorrows Collection)
54 *New Shoes* (The Seven Sorrows Collection, New Shoes)
55 *Sliced finger* (The Seven Sorrows Collection, Pain)
56 *Scraped Thumb* (The Seven Sorrows Collection, Nervousness)
57 *Scissors* (The Seven Sorrows Collection, Pain)
58 *The Letter* (The Seven Sorrows Collection, Depression)
59 *Portrait of a Mother* (Recollection Collection)
60 *Note on Vanity* (Portrait Collection)

MIDDLE PANEL (THIRD UPPER SECTION)

61 *Interior* (Lahey Collection, Den Haag)
62 *Still life and Painting* (C. Lahey, Lahey Collection, Den Haag)
63, 64, 65 *Breakfast for One (Still life)* (Lahey Collection, Den Haag)
66 *Breakfast for One (Still life)* (Lahey Collection, Den Haag)
67 *Interior with Sculptures* (Lahey Collection, Den Haag)
68 *Interior with Button Floor* (Lahey Collection, Den Haag)
69 *Spring Clean* (Lahey Collection, Den Haag)
70, 71 *Interior with Treasure Chest* (Lahey Coll, Den Haag)
72 *Scattered Pictures* (Recollection Collection)
73 *Skip* (Recollection Collection, London)
74 *Interior with Picture Collection* (Galerij Willem V)
75 *Street collection* (The Seven Sorrows Collection, Depression)

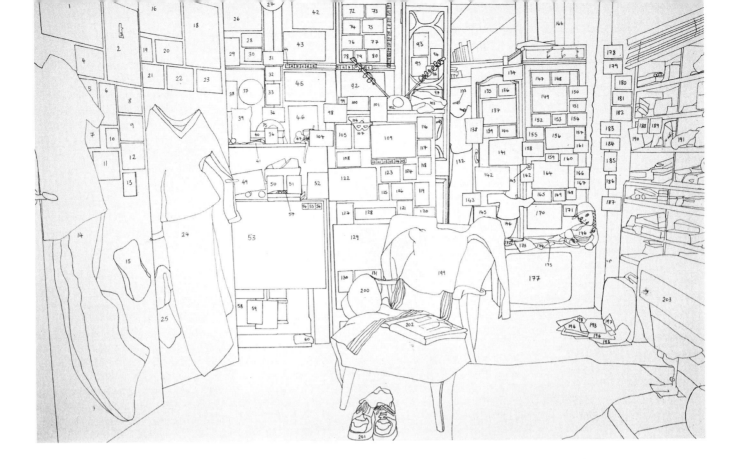

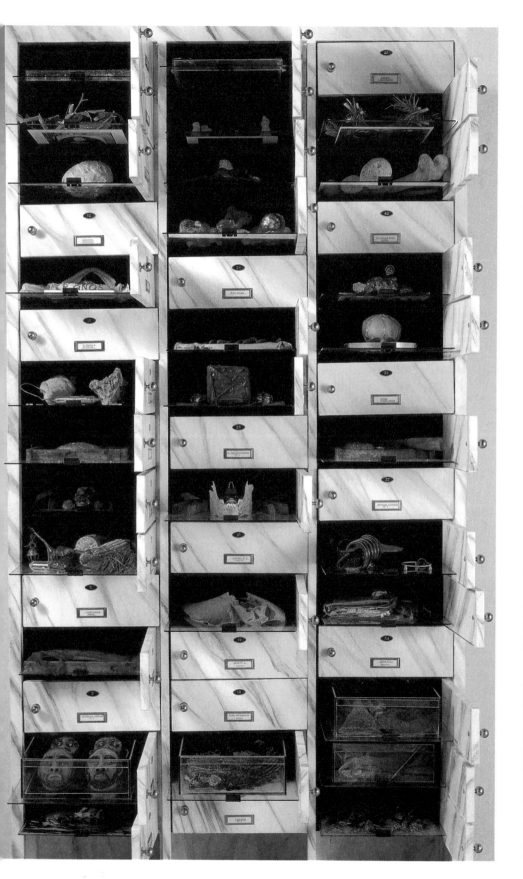

THE ART GUYS ⚲
**APPROPRIATION #9,
PETER MARZIO, 11/12/92,
10:39AM**
1992

One of a series of objects surreptitiously 'appro-
priated' by the Art Guys (Michael Galbreth and Jack
Massing) from various museum directors, gallery
owners, patrons and artists. The artists went on to
display these items in vitrines bearing brass plaques
identifying the former owners and noting the
precise date and time of acquisition of each. The
coffee-mug had belonged to the director of the
Museum of Fine Arts, Houston, Texas.

⟿ CLAUDIO COSTA
**ONTOLOGIA ANTOLOGICA
(ANTHOLOGICAL ONTOLOGY)**
1994

Costa acquired this 45-drawer cabinet from a
mental hospital, where it had housed patients'
records. He painted the outside to resemble marble
to allude to a tomb and the interior black to suggest
the subconcious. Costa's collection (unfinished
when he died in 1995) was meant to include a series
of videos with the artist's commentaries on the work.

NIKOLAUS LANG ⟿
**TO THE GÖTTE BROTHERS
AND SISTERS**
Installation at Bayersoien
1973/74

The archaic lifestyle of seven brothers and sisters
living in an isolated farming community in
Southern Bavaria is investigated by Lang through
artifacts gathered in the vicinity of their self-built
cottages. The work is accompanied by biographical
information and extensive field notes, compiled by
the artist, in wihch he recorded every trace and
find-spot as if he were a professional archaeologist.

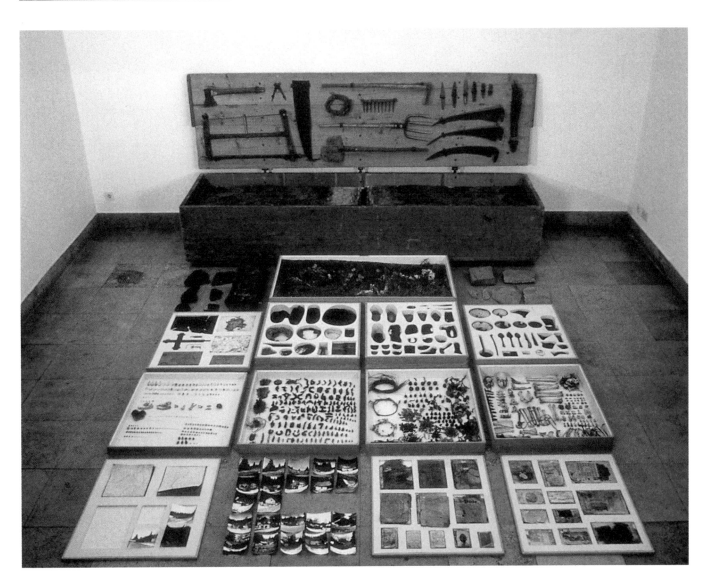

☝ KARSTEN BOTT
TROUSER POCKET
COLLECTION
1996

Bott gathers from the streets a plethora of colourful discarded items each small enough to fit into his trouser pocket. These are mostly broken plastic objects which he displays in serried ranks as if they were fragments of ancient pottery; in this way, even the most obsolete, low-quality items can acquire a sense of museological solemnity and significance.

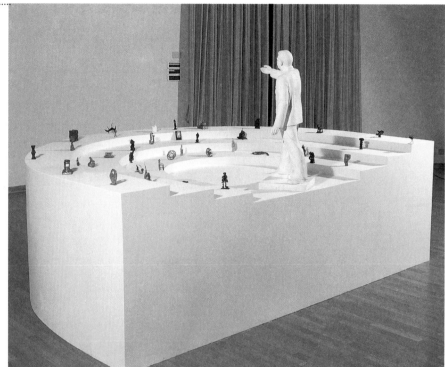

LEONID SOKOV
STALIN MEETING WITH
MODERN SCULPTURE
1993

Sokov has effectively created his own collection, pastiches of the most celebrated masterpieces of modern sculpture in miniature which are dwarfed by a colossal figure of Stalin. As an émigré who left Moscow in 1980 and settled in New York, Sokov frequently makes play with the ironic results of juxtaposing Communist and capitalist imagery.

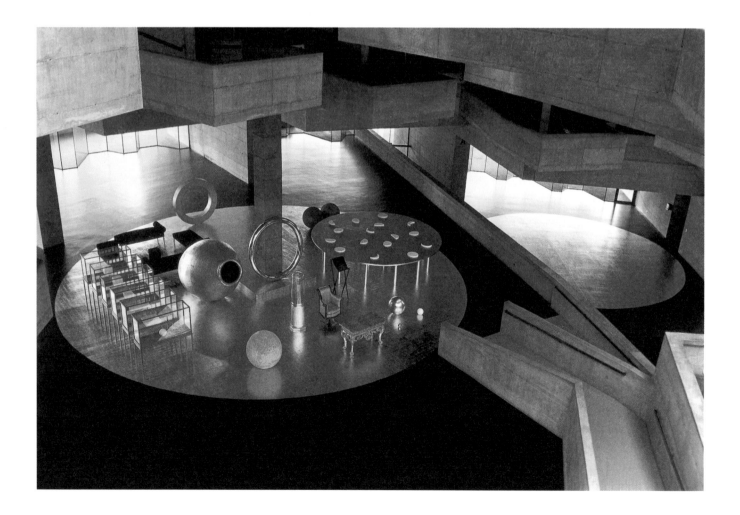

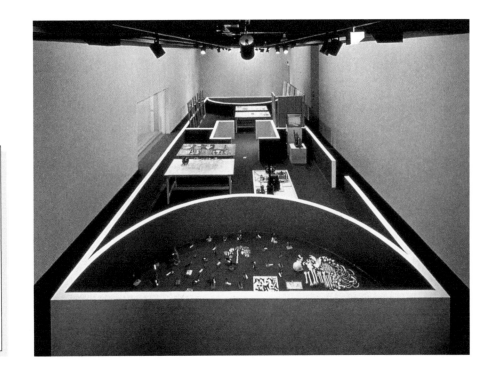

MATT MULLICAN ✧
UNTITLED

Installation at the List Art Center, Cambridge, Mass.
1990

Mullican's constructed environments are influenced by the concept underlying both the encyclopaedia and the World's Fair. The choice of scale creates an intermediate area between architecture and model – an open-ended museum-like structure within which signs, objects and artifacts are sometimes incorporated. This invites the viewer to enter into a physical space with low wall partitions 3 ft (1m) in height, creating separate areas with two sections housing objects borrowed from the museum of the Massachusetts Institute of Technology.

✧ JAMES LEE BYARS
THE PERFECT THOUGHT

University Art Museum, Berkeley, California
1990

This installation was centred around two circles of gold leaf applied to the floor of the museum gallery. The larger circle 42 ft (12.80 m) in diameter, contained an arrangement of 23 individually titled works, some consisting of several items that Byars had collected. Visitors were not allowed to enter the circle, but could view the work from the various balconies and stairways. Thus Byars had complete control over the display and viewing arrangements within his own museum space.

GUILLAUME BIJL ✧
MAN CONQUERS DISTANCES

Vienna Secession, Vienna
1993

Bijl's pastiches of various specialist museums, like this one dedicated to forms of transport, relate to a phenomenon which he calls 'Cultural Tourism'. Such displays are intended to provoke reflection on the artificial values accorded to such historical representations and to comment on the banality of mass-tourist culture.

THOMAS GRÜNFELD
THREE MISFITS
Detail
1994

One of three imaginary creatures which Grünfeld fabricated from parts of different taxidermied animals and displayed in vitrines. This work demonstrates the penchant among certain contemporary artists for focusing on the anomalies of nature, a sensibility which has its roots in the tradition of the *Wunderkammer*.

MARIO MERZ
NIGER CROCODILE
1972

Merz's work, in which a stuffed crocodile is juxtaposed with neon lighting, harks back to the surreal aspect of some early *Wunderkammer* displays, with their interplay between the natural and the artificial. The presence of stuffed crocodiles suspended from the ceiling in *Wunderkammer* collections (and sometimes in the nave of medieval churches) hints at the physical resemblance of the large scaly reptile to the traditional concept of the appearance of dragons in legend and art.

CLAUDIO PARMIGIANNI

GEOMETRIC ZOO, 1968–69

Installation at the exhibition 'Wunderkammer',
Venice Biennale

1986

The thought-provoking, mysterious meaning of
some of Parmigianni's works and their combination
of textures of exotic natural and man-made
materials reflect the links between his ideas and the
sensibility of pre-Enlightenment collections. The
work was featured in a special exhibition for the
Venice Biennale which was intended to trace the
continuing history of the *Wunderkammer* effect' in
more recent art.

JOÃO PENALVA ↩

MR RUSKIN'S HAIR

Installation view at the South London Gallery
1997

Invited to create a work based around an object from the South London Gallery's collection, the Portuguese artist Penalva chose a framed lock of John Ruskin's hair. He made seven convincing counterfeits mounted in deliberately aged frames, and these were hung in the gallery along with the original, teasing the viewer to distinguish the real from the fake. This guessing game was reiterated by displaying a card-table on which three thimbles were placed to suggest choosing the one that concealed a non-existent pea.

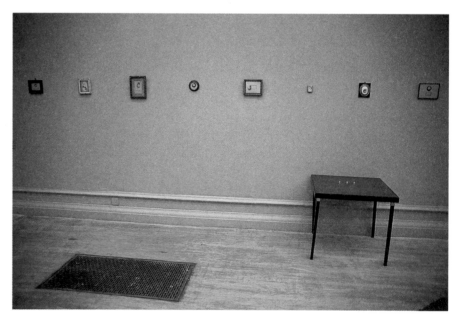

⇦ JOÃO PENALVA
THE ORMSSON COLLECTION
presented by João Penalva, installation view (detail)

Museu da Cidade, Lisbon

1997

In order to address issues of provenance and
authenticity, Penalva gathered together an
imaginary collection based on the principle of
unlikely pairings. This comprised works of art and
objects borrowed from the Lisbon City Museum
and from friends, combined with items from his
own collection which included the work of a
fictional artist made by himself. An introductory
panel in the exhibition presented biographical
details of the invented character, Ormsson, and
Penalva's acquaintance with him was narrated in
detail in the accompanying catalogue. A panel at
the end of the show, explained the true
provenance of the 'collection'.

ILYA KABAKOV ⇦
THE MAN WHO NEVER THREW
ANYTHING AWAY
From *Ten Characters*, 1985–88

Installation details at the National Museum of
Contemporary Art, Oslo

1995

Originally created in his Moscow studio, this work
evolved from Kabakov's writings and album series,
Ten Characters. Building his own viewing spaces in
art institutions, Kabakov creates dream-like display
settings; he describes the resulting hybrid of
sculpture and theatre as 'total installation'. This
work focuses on the oppressive environment of a
fictional reclusive character's obsessive amassing,
inventorying, labelling and display of rubbish. ⑂

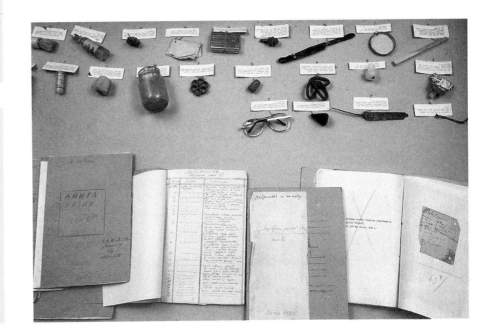

CHAPTER III *public inquiry*

The practice of questioning established systems of power has led artists to examine the role and mechanisms of cultural institutions. By imitating and critiquing the hierarchical systems of museums, their work addresses key issues relating to ownership, censorship, privilege, curatorial prejudice and the links between commerce and culture. Challenging the institution's overview of history, artists have revealed the existence of alternative cultural narratives. Rather than being directly critical, they tend to be more interested in making viewers aware of rigid systems of interpretation, thus encouraging them to question rather than passively accept the 'official' version of things. The concept of a supposedly neutral viewing environment in museums has led artists to investigate how works of art are read, appraised and valued. Complex relationships now exist between museums and those funding them, and artists have therefore sought to expose these hidden aspects of power within the institutions. This process has led them to explore the links between the museum and the art market, as well as its dialogue with artists, dealers, collectors and critics.

ROSE FINN-KELCEY
BUREAU DE CHANGE

The Matts Gallery, London

1988

Finn-Kelcey made this adaptation of Van Gogh's *Sunflowers* following the sale of the famous painting to a Japanese insurance company for a record auction price. Her careful arrangement of gold-, silver- and copper-coloured coins represented a transformation from oil paint to money. A specially constructed viewing platform allowed visitors to look down on the work in its entirety, and the presence of a uniformed security guard, as part of the installation, emphasized the idea of art in terms of monetary value.

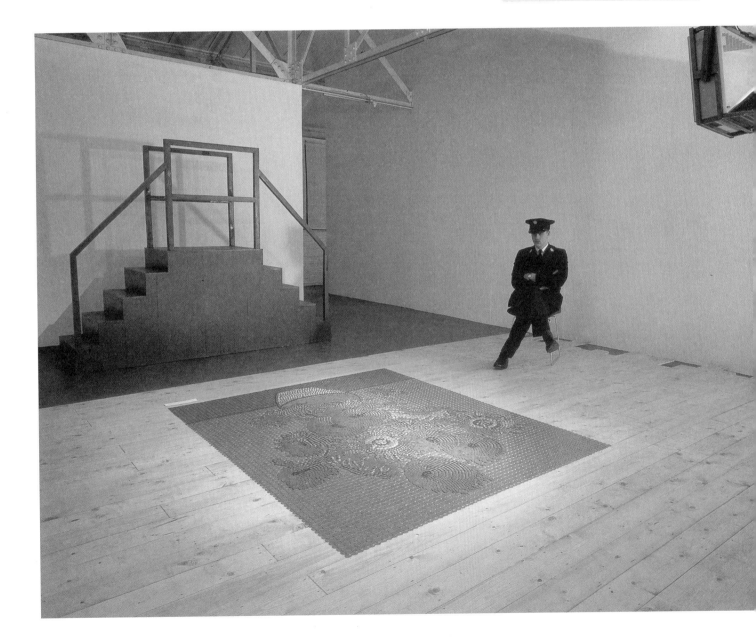

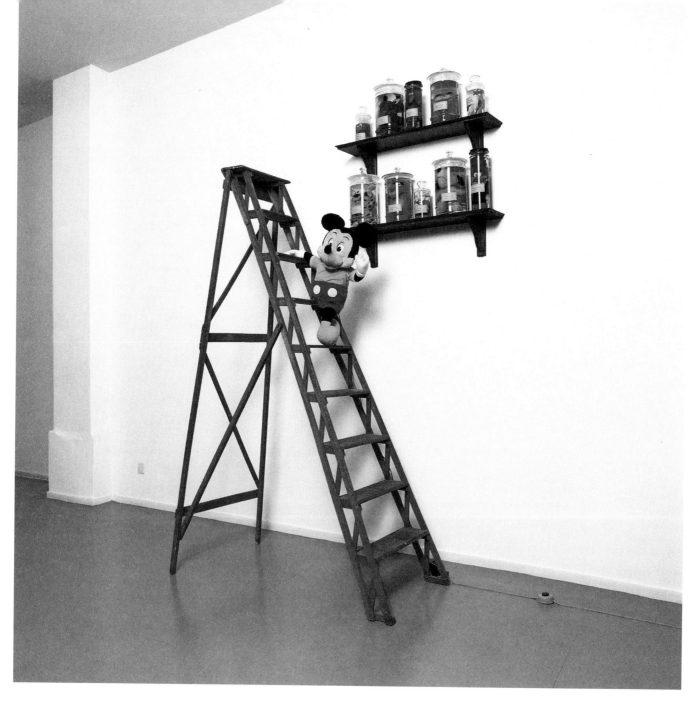

For an artist it is natural to question the nature of art, hence it follows that artists should also feel a need to question the role of institutions that exist to house art. One result has been an increasing interest in examining the museum's part in shaping our view of art and making it accessible. The museum's traditional hierarchical structure and provision of a historical overview thus present an ironical challenge to artists. The critique of art's broader institutional context, which has its roots in the early avant-garde movements, first appeared in the late 1960s and early 1970s. This tendency coincides with the growth of the market in contemporary art, the expansion of museums of modern art and the development of museological and cultural studies generally. The interweaving of politics and art in the wake of student unrest in the late 1960s led artists to question the museum's inbuilt idealism and sense of sanctuary from the real world, and to propose an alternative art more in keeping with the reality of the day. Yet artists have also become aware that new work which initially represents a critical stance will eventually be displayed within the museum as part of a broader cultural process. This view is proposed by Ilya Kabakov: '… the war with the "museum" continues as an ordinary strategy of artistic production that has already become traditional for our century…. And nevertheless, the only place where all this ultimately winds up is the museum, that same culture it is fighting

against and which it repudiates. And as a result this very "struggle" itself, or more precisely, the history of this struggle, comprises the very fabric, the very history of culture.'[1]

Taking advantage of the museum's function as a kind of sacrosanct container, but without sacrificing their critical view, various artists have gone on to produce works that set out to investigate its institutional role and principles. Although on the face of it this might appear to be a subversive area of inquiry, it is usually intended to promote awareness and understanding of the interrelationship of art and institutional power without being overtly anti-museum. Some artists have also gone on to publish their own critical writings on various aspects of the museum. In his essay 'On the Function of the Museum' (1970), Daniel Buren points out the wider implications of the authority of institutional display and its power to manipulate culture: '… the Museum makes its "mark", imposes its "frame" (physical and moral) on everything that is exhibited in it, in a deep and indelible way.'[2] This 'frame', as he calls it, is fundamental to the museum's exhibition methods. The very process of

selecting and presenting an object for museum display, as something worth looking at, involves an implied statement about it and the culture it comes from. And a further series of implications arise from various objects being placed together in a vitrine.

Museum critique has become a central feature of some artists' works, either presented in commercial galleries or in museum displays. The immediate concerns of these artists have included the museum's policies regarding classification, acquisition, provenance and display, as well as the links between commerce and culture. Mark Dion explains how he assimilates typical museum 'tactics' into his working practice: 'To better understand the museum, I have at various times had to become the museum, taking on the duties of collecting, archiving, classifying, arranging, conserving and displaying. Personifying the museum condenses its activities and articulates how the museum's various departments function like vital organs in a living being.'[3] With a passion for the cabinet of curiosity and early natural history displays, he frequently uses preserved specimens and museum methodology, undertaking extensive research into historical personalities and scientific principles. These are cleverly articulated in his works to reflect a concern for wider contemporary issues like ecology and the extinction of species. Dion has a particular interest in natural history museums, since he feels they 'ask bigger questions about life and history'.[4] His *Taxonomy of Non-endangered Species* (1990) is one of a series of works based around Baron

Georges Cuvier, the early nineteenth-century French zoologist and founder of comparative anatomy who demonstrated the phenomenon of extinction. Representing Baron Cuvier in the form of a Mickey Mouse toy placed in front of a group of specimen jars in which his competitors have been pickled, Dion is able to express present-day concerns about species extinction and corporate world domination.

As a result of the sensitive and complex relationships that now exist between museums and their funding sources, artists have sometimes attempted to expose these hidden aspects of power behind the institution. Hans Haacke has illustrated, both in his art and in his writings, the indirect relationships that exist in the world of art and museums between the cultural and political activities of certain individuals and corporations. His projects have delved into the area of patronage and sponsorship, illustrating how governments and businesses manipulate art to their strategic advantage, and showing that what may at first sight appear to be outwardly philanthropic or a public gesture of goodwill could in fact have deeper and more questionable motives. Dedicated to factual accuracy, Haacke draws attention to the way in which corporate sponsorship influences the seemingly neutral status of a public museum and how political considerations are often linked to the appointment of directors and trustees.

Haacke has focused particularly on the activities of powerful individuals from the commercial sector who have exerted their

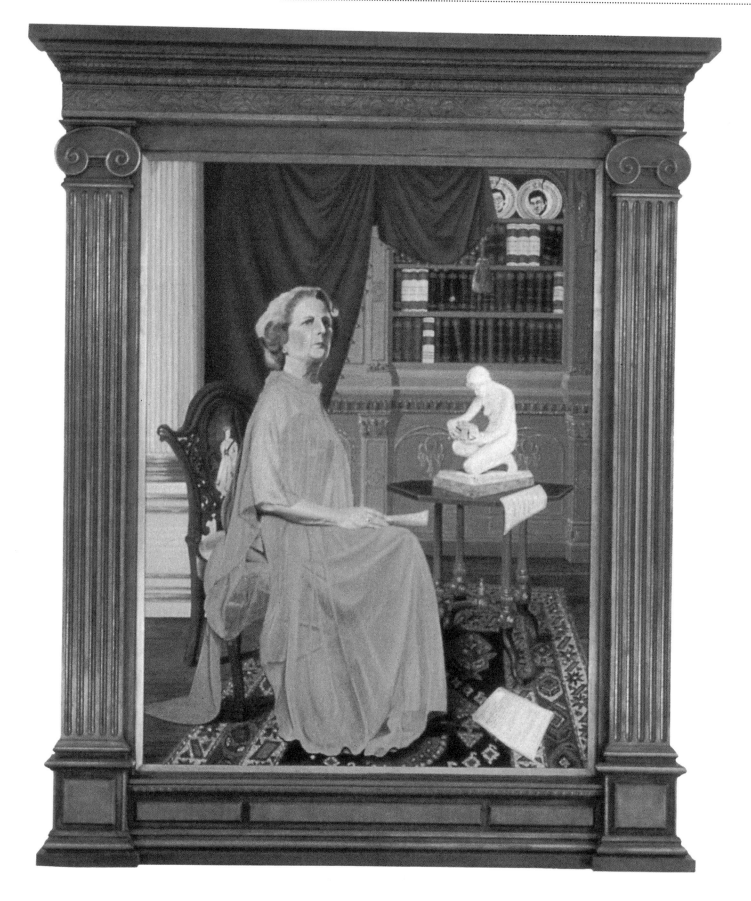

⊕ **HANS HAACKE**
TAKING STOCK (UNFINISHED)
1983–84

Haacke's painting is full of symbolic details intended to reveal the affiliation between political power, wealth and the shaping of contemporary artistic taste. The broken plates and the initialled book spines refer directly to Charles Saatchi, whose company organized the advertising campaigns which helped the central subject, Margaret Thatcher, to election successes. Shortly after this painting was shown at Haacke's exhibition at the Tate Gallery in 1984, Saatchi resigned from the influential position he had held on its Patrons of New Art Committee.

⊕ **MICHAEL ASHER**
THE MICHAEL ASHER LOBBY
Installation at the Museum of Contemporary Art, Los Angeles
1983–84

Museums have become increasingly dependent on wealthy individuals for assistance in funding building projects. In order to acknowledge such benefactions, museum administrations are frequently obliged to name a gallery after the particular sponsor. Asher's work is intended to draw attention to such displays of personal vanity and to the wider implications of the appropriation of public space by donors.

influence on major public art collections. As Haacke puts it, '… such collectors seem to be acting primarily in their own self-interest and to be building pyramids to themselves when they attempt to impose their will on "chosen" institutions …'. His work *The Chocolate Master* (1981) examines the '…*de facto* takeover of museums (among others, museums in Cologne, Vienna, and Aachen)' by the wealthy German industrialist and collector Peter Ludwig.[5] Haacke questions Ludwig's public role as a cultural benefactor by exhibiting panels about the successful business enterprise that had facilitated his acquisition of an important collection. This included publicity material for Ludwig's Chocolate company and information about his employees' working conditions. Haacke has also illustrated how the particular aesthetic tastes of such collectors can dominate museum acquisition policy, since those individuals might also be members of the very committees which take important decisions on such matters. 'As experienced toilers in that

branch of the consciousness industry, the Saatchis now seem to have an impact on the art world that matches or even surpasses that of corporations, particularly in regard to contemporary art.'[6] Haacke's painting *Taking Stock (unfinished)*, shown in his 1984 Tate Gallery exhibition, featured a number of elements intended to illustrate the connections that existed between the part played by the Saatchi brothers' collecting activities in the shaping of the Tate Gallery's contemporary art acquisition policy and its endorsement by the British Government of the day, led by Margaret Thatcher.

By donating large sums of money to the building and refurbishment of museum galleries, wealthy individuals and corporations can publicly lay claim to the buildings and, indirectly, to the collections within by having their name associated with them for posterity. Michael Asher drew attention to this increasing phenomenon in a work entitled *The Michael Asher Lobby* (1983). At a gallery entrance to the Museum of

Contemporary Art in Los Angeles, he installed a plaque suggesting the power of a private sponsor to 'possess' a public space. By using his own name, Asher was indirectly claiming the public site as a space for artistic reflection, and in critiquing the appropriation by donors of institutional space, he used the practice to make his own statement. In his project for the exhibition 'The Museum as Muse: Artists Reflect' (1999) at MoMA, New York, he addressed the touchy subject of de-accessioning of works in museum collections; this presentation took the form of a printed inventory, listing all the

↩ **JAC LEIRNER**
NAMES (MUSEUMS)
1989–92

Leirner's works are frequently created from every-day materials that she has carefully collected, ordered and classified. One of a number of wall installations by her using this medium, this example consists of plastic bags gathered from museum shops around the world. Besides forming lively abstract compositions of colour and tone, the work suggests the increasing interaction of commerce and culture, thanks to the logos or corporate identities of the various institutions competing with one another for the viewer's attention.

L.A. ANGELMAKER ↩
BAD PENNY: FOR MUSEUM PURCHASE ONLY
January 1996
Part I of XII
1997

The first of a series of modified auction catalogues displayed on pedestals, intended to draw attention to de-accessioned works of art from U.S. fine art museums sold through auction houses. After negotiation with the new owners, both the original objects and these related contemporary works were re-offered for sale back to the museums. Hence, as the title suggests, they keep coming back, just like the proverbial 'bad penny'.

museum's de-accessioned works, and copies were available to museum visitors on request. This exercise was intended to reveal the museum's normally hidden process of choice, and in the catalogue Asher wrote: 'The construction of the museum collection suggests at least two histories, the one that the museum wants to tell to the viewer and the history of selection.'[7] The subject is examined more provocatively in L.A. Angelmaker's work *Bad Penny: For Museum Purchase Only* (1996), where the artist was able to trace specific works of art that had been sold off by museums. This interplay between auction house and museum administration has been one aspect of a wider area of artistic scrutiny that examines the notion of art as commodity and the monetary value regularly cited in association with important works of art.

The museum's obsession with seeking to distance itself from the triviality of consumerism has prompted artists to explore some ironic parallels. The most blatant example of commercial enterprise is the merchandising of art souvenirs, which may be seen as evidence of the buyer's cultural experience. Museum shops as sites where money and culture mingle have therefore provided an important source of inspiration. In *Names (Museums)* Jac Leirner created, between 1989 and 1992, a number of different wall installations composed of museum carrier bags decorated with colourful attention-grabbing logos. Artists have also imitated museum shops and created their own versions like the group General Idea's *Boutique* from the 1984 Miss General Idea Pavilion, featuring a counter in the form of a large dollar sign displaying their publications and multiples. Some artists have also examined the potential links between the marketing strategies of museums and department stores. Focusing on the seductive power of the commercial sales brochure introduced into a museum context, Neil Cummings and Marysia Lewandowska produced *Browse*, an illustrated leaflet which was distributed simultaneously in London at the British Museum and in Selfridge's department store in 1997. [8]

Christie's, Inc.
502 Park Avenue, New York, New York 10022
Telephone: (212) 546-1000 Telex: 672-0345
Fax: (212) 980-8163

CHRISTIE'S

⟲ **LOUISE LAWLER**
POLLOCK AND TUREEN
1984

Rather than show the familiar situation of modern art displayed in the pure aesthetic white surroundings of a gallery, Lawler's series of photographs reveal such works in the very domestic context of a wealthy collector's home. In many cases she has included captions which credit each arrangement to the particular collector. The juxtaposition of her deliberately cropped detail of a painting by Jackson Pollock and the ceramic tureen suggests that the owner might have chosen to arrange the display according to purely decorative criteria.

Since the mid-1980s a number of artists, including Louise Lawler, Andrea Fraser and Fred Wilson, have directed their attention towards key museological issues such as ownership, cultural heritage, taste, privilege and racial stereotyping. The way in which individual museums interpret their collections has been a major area of the artists' investigations which are intended to prompt a healthy scepticism towards institutional narratives. This tendency has also been stimulated by the growth in cultural and museological studies, which have in turn led museum administrations to become more receptive to artistic scrutiny.

A consistent practice among artists has been to create works that disrupt the spaces that exist between the viewer, the work and the museum. Louise Lawler has looked into how art is read, consequently appraised and valued, and how its meaning can shift according to its context. Her photographs often chart the journey of a particular work of art from the artist's studio to its eventual place of display, whether in museums, the offices of corporations or the living rooms of private collectors. In her series entitled 'Home/Museum – Arranged for Living and Viewing, 1984', Lawler compared and contrasted modes of display prevalent in private homes and museums. Focusing mainly on Burton and Emily Tremaine's arrangements of their art collection at home, her photographs capture 'high-art' rubbing shoulders with interior furnishings and domestic appliances. Her photographs were later exhibited at the Wadsworth Atheneum, Hartford, Connecticut; the related works from the Tremaine collection were displayed in conventional museum manner in an adjoining gallery.

Artists have also examined the educational practices of museums, creating works which question the conventional role of the museum visitor as being merely a passive spectator. This area has been addressed by Andrea Fraser in her performance work consisting of a series of guided tours, entitled *Museum Highlights: A Gallery Talk*, held at the Philadelphia Museum of Art in

ANDREA FRASER ⟲
MUSEUM HIGHLIGHTS:
A GALLERY TALK
Performance at the Philadelphia Museum of Art
1989

Fraser invented a fictional *alter ego* as the primly suited and bespectacled guide Jane Castelton. She offered a lecture tour, in which she pointed out some of the more unlikely objects and sites in a parody of the museum's fixed educational and interpretative viewpoints.

1989 and subsequently documented on video. Fraser took on the role of a fictional museum guide and, besides visiting the exhibition galleries, her tour also took in visitor facilities such as the cloakroom, shop and cafeteria, with a continuous commentary on various details. Quite apart from being an amusing send-up of guided tour clichés, Fraser's performance was a critique of the art museum's often aloof and patronizing interpretation of its collections. She seamlessly included many carefully researched quotations from museum policies and strategies: 'The museum's task could be described as the continuous, conscientious and resolute distinction of quality from mediocrity.'[9] In 1993, Fraser issued what she called her 'Preliminary Prospectus' advertising her artistic services to provide both an interpretative and interventionary role for public and non-profit art museums. She has also gone on to define her view of the art museum's essen-

tial public role: 'The primary operation of art museums is the turning of bourgeois domestic culture and specialized artistic culture into public culture. And the induction of those not predisposed to this culture into the habits and manners of its appropriation is what constitutes the public education that defines museums as educational institutions.'[10]

A comprehensive examination of viewing as an essentially interactive process was undertaken by Muntadas in his exhibition, 'On Translation: The Audience' (1999) at Witte de With (The Centre for Contemporary Art) in Rotterdam, which proclaimed the message 'Warning: Perception requires involvement'. It included his seminal multimedia project, *Between the Frames: The Forum*, which shows numerous individual points of view about the art system. This project was presented as a series of video interviews

with leading figures in the art world made between 1983 and 1992, juxtaposed with metaphorical images – what Muntadas himself calls 'open visuals' – with the aim of revealing the 'hidden' institutional agendas that condition the production and reception of art. Each of his video chapters opens with this text: 'Art, as part of our time, culture and society, shares and is affected by rules, structures and tics like other economic, political and social systems in our society.' These visual commentaries explore the roles of the people and institutions located between the artist and the audience, the dealer, the collector, critic, historian and museum curator.

In his critical essay entitled 'Valéry Proust Museum', Theodor Adorno indirectly accuses museums of draining the life out of objects and art: 'They testify to the neutralization of culture.' The museum's supposedly neutral viewing environment is

essentially an idealistic construction created for public contemplation. According to Fred Wilson, the confident statement of this neutrality by museums is even symbolized by their use of transparent non-visible display materials such as the glass case, glass shelves and clear Perspex mounts. In Wilson's installation *In the course of arrangement* for the exhibition 'Collected' (1997) at the British Museum, his display of historical and contemporary exhibition mounts was intended to illustrate the museum's growing obsession with impartiality. As he noted, 'I feel that museum professionals try to be impartial but to my mind there's no way that they can be neutral. Just by attempting this they're avoiding what they're really thinking, so by not being fully aware of what they're presenting in an ideological way then they are not completely in control of the ideology.'[11] He adopted the title for this work from the wording used by British Museum curators on temporary labels to indicate to the public that a display is not yet completed

The museum's interpretation of its collection is of course linked to a viewpoint which shifts according to the ever-changing social and political climate. The museum's architecture, display and interpretative labelling all serve to convey a particular narrative to its visitors which may be linked with its institutional history. This is all part of what Wilson calls 'the Silent Message of the Museum'. A consistent aspect of his work is the inclusion of supplementary information of the kind deliberately omitted by museums: 'I am interested in bringing historical information to the aesthetic experience in order to reveal the imperialist reality of how museums obtain or interpret the objects they display. I believe doing so makes clear the complexity of things on display.'[12]

MUNTADAS
BETWEEN THE FRAMES: THE FORUM
1983–92

First shown at the Wexner Center for the Arts, Columbus, Ohio, in 1994 and subsequently at other venues, this multimedia installation provides an overview of the entire art system. It consists of numerous video interviews gathered and edited by Muntadas over a period of many years, presented as a series of eight chapters; these are screened individually on monitors in separate booths arranged in a circle. Stills from four of the chapters are included here. Different images were also cut in, such as footage of the Tokyo Stock Exchange in order to provide a financial context to some of the interviews.

CECILE ABISH ↩
MUSEUM RECONSTRUCTED: FOGG

Displayed at the Anderson Gallery, Richmond, Virginia, 1991
1980

Abish's project comprises 83 photographs of the Fogg Art Museum in Cambridge, Mass., all taken on a single day. The photographic prints were mounted on cardboard modules, which in turn were arranged in an installation based on the museum's floor-plan, accompanied by a backlit sign with the word 'Age'. Each photograph was shot from the same position at the threshold of a museum space, first on entering it, then on exiting. In this sculptural reconstruction, the museum becomes a neutral container where the images of its collection lose their individual significance.

↩ MICHAEL ASHER
UNTITLED

Installation view, Carnegie International at the Carnegie Museum of Art, Pittsburgh
1991

Asher used the four existing cast-iron radiators within the hall of architecture as bases for displaying a series of initial letters. These stood for organizations which both test products and distribute information concerning the health hazards associated with materials, including those used in the production of art: MSDS stands for 'material safety data sheets', and NIOSH for the 'National Institute for Occupational Safety and Health'. The significance of his use of plaster of Paris for these initial letters relates to conventional casts of sculptures displayed in the gallery for art students to draw.

↩ FRED WILSON
IN COURSE OF ARRANGEMENT

Installation at the British Museum, London, as part of the multi-site exhibition 'Collected'
1997

Wilson's installation included a vitrine containing a collection of redundant display mounts and labels, dating from the 19th century to the present. This choice of material was intended to illustrate how the museum's perceived need to appear both impartial and impersonal is reflected in its use of less visible materials for mounts and in the transition from handwritten to printed labels.

LOUISE LAWLER ⟨⊖⟩

UNTITLED 1950–51

The Museum of Modern Art, New York
1987

In her exhibition at MoMA's Project Space, Lawler included this photograph of a bench with three of her identical Cibachromes of a similar bench in front of a painting by Miró, taken in the gallery immediately above. By inviting viewers to spot the similarities and differences, this image also gave them the opportunity to reflect on the museum's use of display and interpretative devices. It was also intended to reveal the significance of framing, lighting and label text in relation to the 'reading' of a work of art.

JOHAN VAN GELUWE
ART OPENING

Neues Museum Weserburg, Bremen
1998

Van Geluwe's installation mimics a formal exhibition opening, and the array of international flags and imposing lectern for the invited dignitary's speech convey the underlying political agenda of such an occasion. As part of the work, the artist himself performed the inauguration ceremony by cutting the traditional ribbons in the company of the museum director.

⬙ MARK DION
COLLECTORS COLLECTED
Installation, Museo Nacional Centro de Arte
Reina Sofia, Madrid
1994

For this installation Dion researched various museum and library archives to investigate the personalities behind the 'Expedition al Pacifico' (1862–66) and their significance in relation to the natural history collections. In contrast to typical museum exhibitions in which the founder of a particular collection is celebrated, his installation proposed the original collectors themselves as exhibits, presented in the same way as they might have displayed representatives of other cultures in ethnographic systems of their time.

JULIAN WALKER ⬙
COLLECTORS COLLECTED
The Natural History Museum, London
1997

Instead of following the usual museum practice of carefully preserving rare specimens in boxes, Walker's work suggests an ironical reversal of roles where they are replaced by images of the 19th-century naturalists who collected them.

Collectors collected 2

JOHAN VAN GELUWE ⬙
THE MUSEUM OF MUSEUMS
1975

According to van Geluwe, 'Art is the captive of the Museum. The Museum alienates art from her own environment. The Museum of Museums (M.O.M.) is the real, partly imaginary, institution that wants to abolish this alienation.' His official-looking rubber stamp is one of many he has devised to critique the museum establishment's aspirations of power, censorship and lumbering bureaucracy.

THE MUSEUM OF MUSEUMS ✳ JOHAN VAN GELUWE BOUCKAERTSTRAAT ✳ BE-8790 WAREGEM FLANDERS

SOPHIE CALLE ↢
LAST SEEN ...
(EAGLE SILHOUETTE)
1991

This framed silhouette represents a gold finial from a Napoleonic flagpole which was among a number of items stolen from the Isabella Stewart Gardiner Museum, Boston, in 1990. Calle asked some of the museum staff to describe their recollection of the missing objects while standing at the original sites. These texts were then displayed adjacent to images of the vacant spaces against the museum wall. This reveals the extent to which human perception is prone to very personal interpretation in piecing together reality from memory.

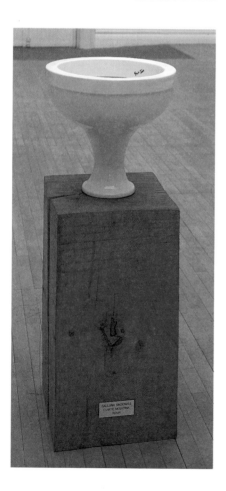

↢ GAVIN TURK
FONT (GALLERIA NAZIONALE
D'ARTE MODERNA ROMA)
1995

One of a series of ceramic sculptures which have obvious references to Marcel Duchamp's famous Readymade. He attached an individual bronze plaque to the plinth of each sculpture which bears the name of a major international art museum with the fanciful notion that they could just end up in them. He took inspiration in this pursuit from Richard Hamilton's series of fibreglass relief sculptures (1965–66) representing the spiral form of the Solomon R. Guggenheim Museum in New York, which, although not commissioned by that museum, were eventually acquired for its permanent collection.

GUILLAUME BIJL
AUCTION HOUSE

Kunstverein Hannover
1996

From a series of installations which are perfect fabrications of fictional sites, intended to provoke a reflection on the way both history and culture are visually presented. The idea of an auction house, using some objects borrowed from museums, within an art gallery makes obvious reference to art as a commodity. Bijl has also mimicked museum period rooms, complete with mannequins which deal with the phenomenon he refers to as 'Cultural Tourism'.

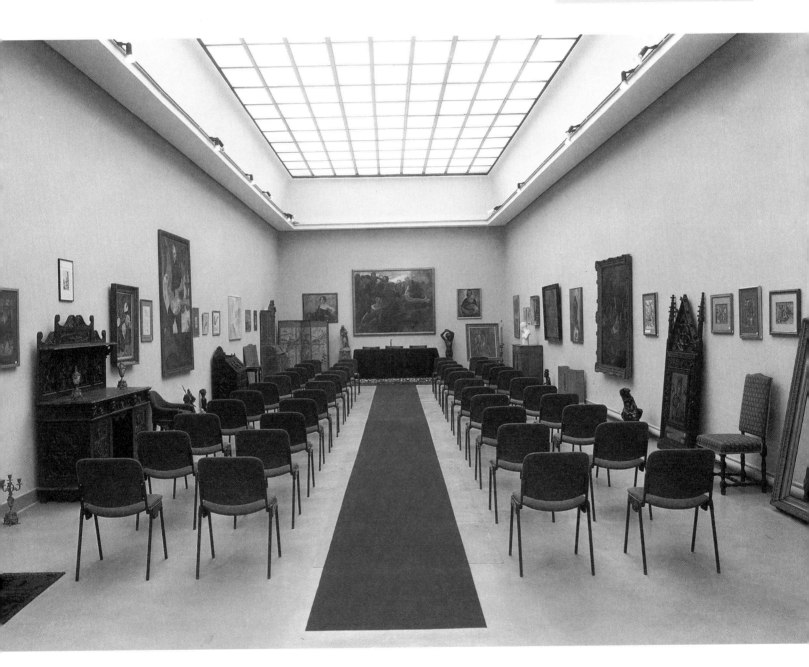

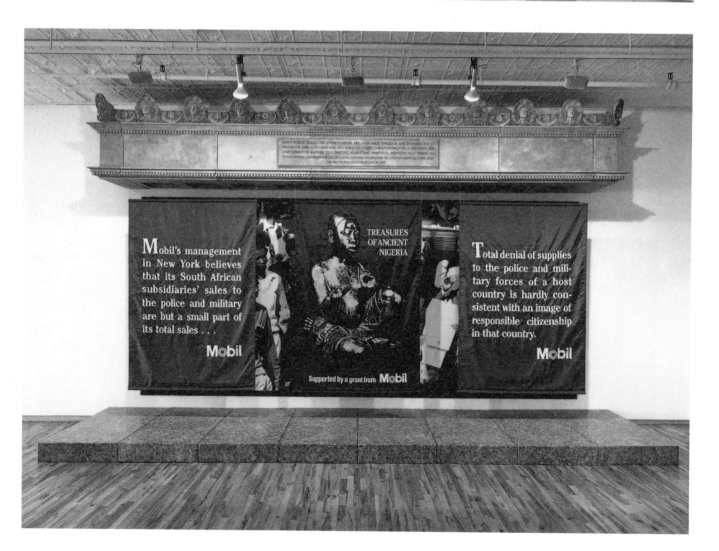

INKLUSION : EXKLUSION GRAZ, 22. 9. - 26. 10. 1996 IM REININGHAUS u. KÜNSTLERHAUS	
WHITE	14
BLACK	11
OTHER	16
MALE	30
FEMALE	11
MISCELLANEOUS	0
GAY	3
STRAIGHT	19
UNKNOWN	19
UNACCOUNTED	16
DECEASED	3
LOST	9
JEWISH	2
TOTAL	153

KENDELL GEERS
TITLE WITHHELD (SCORE)
1995-97

This was part of the group exhibition 'Inclusion: Exclusion' at the Künstlerhaus, Graz, Austria. The 'scoreboard' reflects on the institutional obligation to present exhibitions that fulfil politically correct criteria by inviting an ethnically and sexually un-biased balance of artists in order to avoid issues of identity exclusion. Shortly before, the work was refused a showing in the Berlin Exhibition of South African artists (at Haus der Kulturen der Welt).

⇦ FRED WILSON
GUARDED VIEW
1991

Wilson exhibited mannequins each dressed in guard's uniforms from four New York museums: Metropolitan, Whitney, MoMA and Jewish Museum. He was seeking to make the point that African Americans are usually visible in American museums only in low-level service positions. This was part of his show 'Primitivism: High and Low', at Metro Pictures, New York, conceived in response to the Museum of Modern Art's exhibitions 'High Low' and 'Primitivism'.

⇦ HANS HAACKE
METROMOBILTAN
1985

Haacke's 'MetroMobiltan' illustrates how corporate sponsorship influences the seemingly neutral and apolitical museum. Imitating the banners adorning the façade of the Metropolitan Museum of Art, New York, this work alludes to Mobil's sponsorship of an exhibition held there entitled 'Treasures of Ancient Nigeria'. It goes on to suggest that economic exploitation by this multi-national company had links with the apartheid regime of the day by incorporating a photograph of a funeral procession for black victims killed by South African police.

ALFREDO JAAR 🌳 ⇨
MUSEUM
Hirshhorn Museum and Sculpture Garden, Washington, D.C.
1991

Jaar painted the building's vast horizontal window grey, leaving six square peep-holes which framed panoramas of the surrounding Federal buildings. Beneath each opening he placed a mirror of the same size and a row of double-sided light-boxes on which he showed harrowing images of Gulf War victims. The front side of the light-boxes spelled out the individual letters of the word 'museum'. Jaar's reference to this supposedly 'just' war in the context of Washington's premier modern art museum, served to question publicly current government policy.

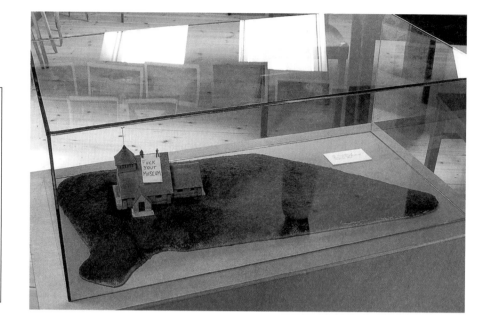

NILS NORMAN ⬦
THE OCCUPATION OF
ST THOMAS À BECKET
CHURCH, FAIRFIELD, KENT
(DETAIL OF OPPOSITION TO
TATE PROPOSAL)
1996

Norman's project is based around a 'fictional
proposal' to site a branch of a national museum of
modern art in a small village. His work centres on
the campaign by the local people to combat the
proposed scheme, including their occupation of
the parish church. As supporting documentation
he has also created a bogus church newsletter
which, besides voicing the villagers' objections,
offers a humorous reflection on rural lifestyle.

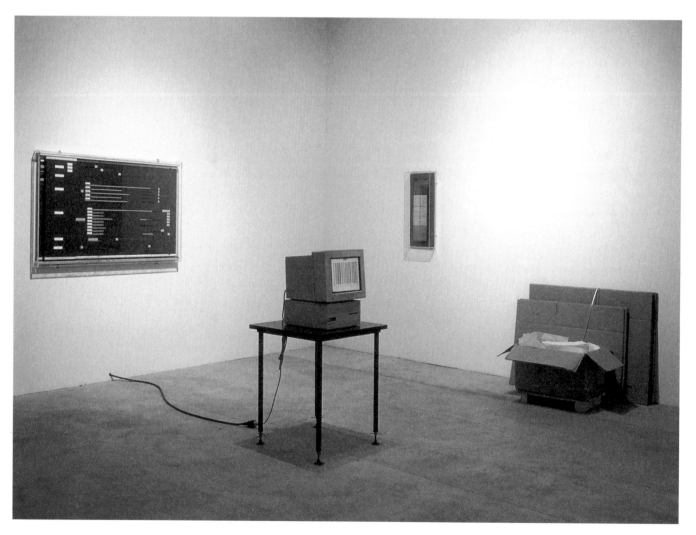

⚘ NILS NORMAN
PROPOSAL 10, THE GENERALI
MULTIPLE EXCHANGE
MACHINE (DETAIL)
1998

This was part of a group exhibition in which each invited artist was asked to submit a proposal for the use of the Generali Foundation's space in Vienna. Somewhat ironically as a participating artist, Norman proposed that they should immediately auction off their collection and spend their funding on something more worthwhile than art. His model and plans include the development of a centre for ecological farming and alternative therapy.

UTA META BAUER/ ⊹
FAREED ARMALY
'?' SECTION
Installation view of the entrance, from the exhibition 'Now Here' at the Louisiana Museum of Modern Art, Humlebaek, Denmark
1996

This exhibiton involved placing the entire permanent collection of the Louisiana Museum in storage so as to make way for a number of contemporary art sections, each individually curated. As a guest curator Bauer worked closely with the artist Fareed Armaly on this project, which examined the nature of various museum spaces as sites for 'cultural production'. The '?' figure or 'Sign System' by Fareed Armaly, which alluded to signs used at theme parks, was placed at specific locations, both inside and outside the museum.

⊹ READYMADES
BELONG TO EVERYONE
THE INDEX
Installation from the exhibition 'Feux Pâles' ('Pale Fires')
CAPC, Musée d'Art Contemporain, Bordeaux
1990

Using a collective pseudonym, Philippe Thomas pro-duced bar-code paintings which critiqued the art and museum world. Collectors and museums who purchased one were obliged to sign it, thereby questioning the status of an artist's unique signature.The computer screen displays an end-lessly repeated list of names of people who have signed his paintings, while on the wall behind is a chart listing his agency's activities for the year.

GÉRARD
COLLIN-THIÉBAUT ✎
STAMP MACHINE

Installation view, from the exhibition 'History of
the Museum', Musée d'Art Moderne de la Ville
de Paris
1989

By inserting a 10 franc coin into each of these
vending machines in the gallery, the visitor had the
opportunity to purchase a set of of Collin-
Thiébaut's six stampbooks, which included images
of the museum's most celebrated paintings. There
was also a vitrine in his installation which displayed
the entire range of artist's stamps with special
albums to mount them in. Deluxe editions could
also be purchased for collectors to personalize by
perforating their initials in the stamps.

Detail showing stampbooks ✎

NEIL CUMMINGS /
MARYSIA
LEWANDOWSKA
BROWSE
1997

This leaflet was available from dispensers in both
the British Museum and Selfridge's department
store, Cummings and Lewandowska invited the
public to view precious historical artifacts in the
same light as seductive consumer products and
vice-versa. Most significantly it examined the link
between commerce and culture and comparative
display strategies.

DELLBRÜGGE ✎
& DE MOLL
MUSEUM (STAFF)
1991

This series of 28 black-and-white photographic
portraits, ironically present the staff of the Museum
für Neue Kunst, Freiburg, as being works of
contemporary art themselves.

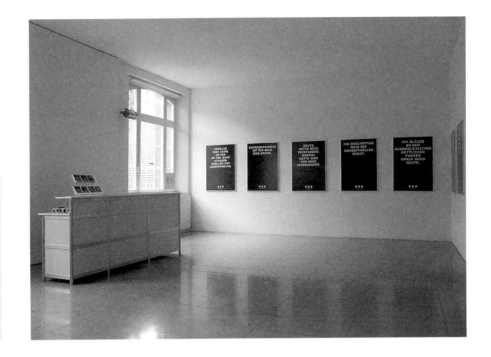

DELLBRÜGGE
& DE MOLL
MUSEUM BOUTIQUE

Installation with posters and postcards,
Museum für Neue Kunst, Freiburg, Germany
1991

As part of their exhibition entitled 'Ein Leben
für die Kunst' this installation was a fictional
museum shop. Its merchandise included posters
with statements and attitudes of art consumers
and distributors as well as postcards showing
museum shops from all over the world.

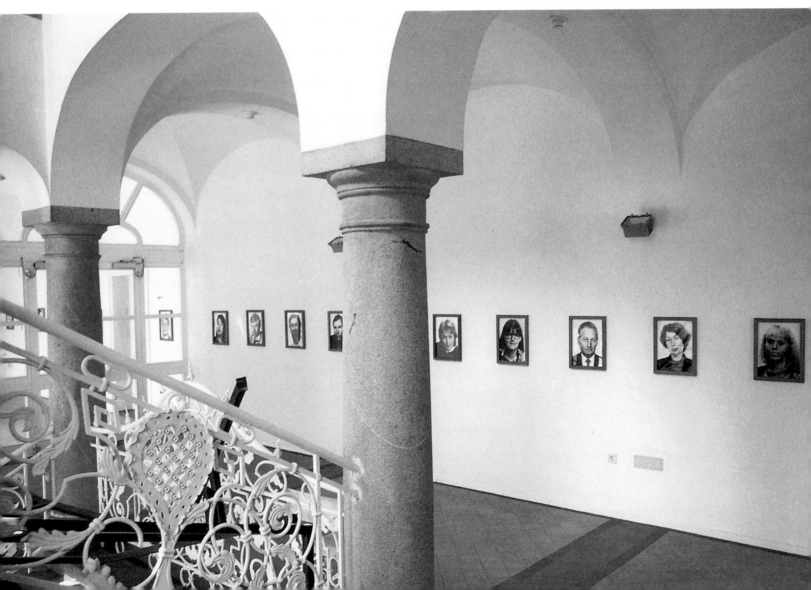

CHAPTER IV *framing the frame*

The medium of photography is well suited to objective observation of museum spaces by artists. Direct documentary photographs of specific exhibits sometimes evoke the museum's traditional qualities and role in inspiring a sense of strangeness and wonder.

Photographing gallery interiors from a distance can produce a unique overall spatial effect which incorporates art, architecture and audience, giving perhaps a bird's-eye view of a spectator reacting to a work of art, or of an unoccupied space which takes on an imposing presence. Working behind the scenes in museum storerooms and reserves, artists can capture in photographs amusing juxtapositions or works of high art in compromising situations. Natural history museums in particular can provide especially rich and ironic subject matter, where stuffed animals appear to come to life and return to the wild, all in an entirely artificial environment. Photography also provides the opportunity to examine and question the presentation of art in the context of its institutional framing, thus offering profound insights into the relationship between the museum and its visitors.

DARIO LANZARDO
RESTORED SKELETONS
OF APES
1995

This group of skeletons of various apes in the
Natural History Museum, Turin, take on an
animated appearance beneath their polythene
dust covers.

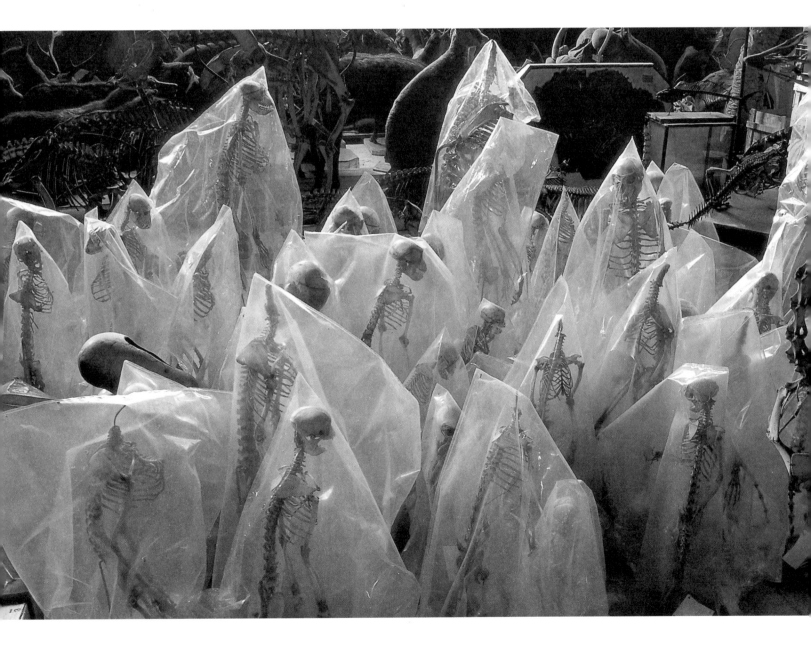

The medium of photography adds something magical to the sites it records, and the artist's approach to viewing the museum's different spaces through the camera lens can be analytical or purely documentary. The artist becomes observer and participant, using photography as a subjective and objective framing device, thereby creating images of displays which are in turn themselves displayed. The photograph conserves a particular moment, and as such comes to resemble a metaphor for the museum's sense of preservation in time within its own giant frame. A parallel situation exists in the context of the natural history specimen preserved in formaldehyde and the permanent photographic image fixed by means of a chemical process.

As has been proposed by Roland Barthes in *Camera Lucida*: 'What the Photograph reproduces to infinity has occurred only once: the Photograph mechanically repeats what could never be repeated existentially.'[1] In the nineteenth century great photographers like Roger Fenton recorded the grandeur of museum galleries, the results being enhanced by a unique quality of light. When photographing museum galleries, general views can serve to frame interior spaces like an installation, by exploiting the art, architecture and the audience. This process also provides an opportunity to examine the ways in which culture is shaped by the formality of the museum environment and can therefore call into question both the power of the institutional framing of an art object

on display and the neutralizing force of its setting.

André Malraux's innovative concept of the 'Museum Without Walls' (1947) created a hypothetical situation in which the physical body of the museum would dissolve, to be replaced by photographs. As Douglas Crimp has explained in *On the Museum's Ruins*, 'photography not only secures the admittance of various objects, fragments of objects, details of objects to the museum; it is also the organizing device: it reduces the now even vaster heterogeneity to a single perfect similitude.'[2] Photography is an important means of investigating a museum's interface with its public by capturing the act of viewing. In Henri Cartier-Bresson's

museum photographs the visual emphasis is not on the inanimate museum artefact but on the presence of the living audience. The museum object is thus secondary, and observation of its effect on the spectator now becomes the primary subject. Cartier-Bresson captures the aesthetic of the audience's moment of engagement with a work of art, that moment of contemplation and thought stimulation. This key aspect of the collaborative significance of art and viewer has been noted by Guy Debord in *The Society of Spectacle*: 'The Spectacle is not a collection of images; rather it is a social relationship between people that is mediated by images.'

The fascinating dialogue between the viewer and the museum display is also explored in photographs by Thomas Struth. As part of his broader interest in public spaces, museum galleries provide Struth with subject matter for a unique

discourse on site and the conditions of spectatorship, or what he has called 'the intensity of viewing'.[3] The photographs offer an opportunity to make an objective study of the museum visitors' reaction when viewing famous paintings; as Struth himself puts it, 'The photos illuminate the connection and should lead the viewers away from regarding the works as mere fetish-objects and initiate their own understanding or intervention in historical relationships . . .'.[4] They also provide reflections on what it is that attracts people to visit museums in the first place and on the nature of visitors' received experience. Struth's large-scale colour prints of photographs taken with long exposures of up to 1 second convey a sense of arrested time. They create a superhuman view of the 'image within an image' and possess a seductive depth and illuminosity. In contrast to Struth's portrayal of the public interaction with the museum collection,

artists such as Larry Fink and Garry Winogrand have captured the glamour of exclusive private views at modern art museums, when prominent artists, celebrities and wealthy collectors are seen mingling with the works of art on display.

The somewhat voyeuristic approach of observing the observer, favoured by artists like Struth, is deliberately avoided by Candida Höfer, who prefers photographing museum spaces without a human presence using standard 35 mm film. Her C-prints are therefore of relatively small dimensions. She carefully constructs her own compositions, creating aesthetic arrangements from unlikely museum elements. Her interest in their impartial, institutional context has led her to examine areas of less obvious interest, such as empty lobbies and function rooms, as part of a broader sociological study of the public space devoid of its public. Höfer's work

HIROSHI SUGIMOTO
DEVONIAN PERIOD
1992

This photograph, taken at the American Museum of Natural History in New York, was part of Sugimoto's series which explores the illusionary aspects of the museum diorama and the frozen moment in time.

has a quality of serene, impersonal observation characteristic of the documentary photographs of Bern Becher, under whom she studied.

The attempts by natural history museums to endow dead specimens with a life-like appearance within an unnatural institutional environment have proved particularly fascinating for artists.

Photographs taken by Richard Ross and Dario Lanzardo have often captured satirical situations arising from chance arrangements of taxidermied animals both on display and in reserve storage. By acute observation and framing they are able to reanimate the museum specimens to enact ironical dramas or take on human personality traits which stimulate our wider reflection on the real and the imagined. Hiroshi Sugimoto explores the latter area further in his Diorama Series, focusing on this highly illusionistic form of museum display with its meticulously crafted large-scale reconstructions of landscapes which show taxidermied animals in simulated natural habitats. Presented as large-format black-and-white gelatine silver prints, these

works capture frozen moments in time where the three-dimensional space becomes unified within a photograph, thus creating a further play on the real and the artificial. Some artists have been granted privileged access behind the scenes to photograph the hidden reserves of public institutions. The resulting images may show rare specimens or precious artefacts crammed together in storage racking just like other commodities, or works of high art seen in compromising situations. Isolated from the grandeur of the exhibition spaces, important masterpieces are photographed in the museum's more low-key, functional and practical areas, where they reside semi-permanently. It is as if the antique

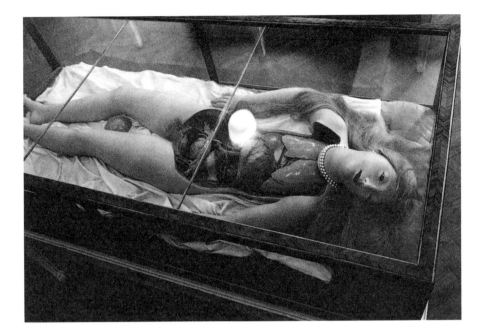

ZOE LEONARD
WAX ANATOMICAL MODEL,
FULL VIEW FROM ABOVE
1990

Leonard's image of a wax model now in the
Muséum National d'Histoire Naturelle, Paris, is
intended to draw attention to the traditional
portrayal of women as submissive, here seen in the
context of 18th-century mannequins used to
instruct male students in human anatomy.

LOUISE LAWLER
OBJECTS
1984

Lawler is able to capture humorous and ironical
juxtapositions of everyday objects and material
through the seemingly casual, *ad hoc* arrangements
found in some museum storage areas as seen here
at the Queens Museum, New York.

plaster casts in a museum basement, as photographed by Louise Lawler, secretly and mischievously come to life, once they are away from both the public and curatorial gaze.

Lawler's work simultaneously scrutinizes, critiques and participates in the the art world that she observes and documents.

This process involves taking photographs of the presentation of other artists' work in galleries and museums as an examination of how art changes in meaning according to its display context. As she puts it, 'Art is part and parcel of a cumulative and collective enterprise, viewed as seen fit by a prevailing culture. My work always includes the work of others.'[5] Yet she

frequently crops out large portions of major works, thereby creating her own frames and compositions to coincide with her particular critical agenda. Lawler often adds short texts, applied to the photographic mount in imitation of the 'official' museum-style descriptions. But rather than treat them merely as captions, she uses these words as elements of the

work itself, and they also relate to the display context of each site, creating a specific reflection on what is seen and how it is read. For *Glass Cage, Part I* (1991/3), Lawler included an accompanying text quoting a critic's reaction to a well-known sculpture by Degas, in which he likened the figure of a dancer to a human foetus. Using this association, the vitrine or 'cage' that encases the little ballerina acts like a metaphor for the museum's stifling containment of art, isolating its free spirit from its former context.

Zoe Leonard's museum photographs examine historical representations of women as a means of invalidating the traditional portrayal of submissive femininity. This is reflected in her series of images of eighteenth-century female wax anatomical models taken at various European medical museums. Their sensual poses and beautiful facial features imitate the religious and allegorical art of the period, and yet their yielding, ecstatic expressions contrast ironically with the graphic anatomical detail of their exposed internal organs. Leonard's work has also touched on the area of gender ambiguity, raising questions about 'official' perceptions of normality. On the subject of her museum photography, Leonard has written: 'I've always been interested in ways of framing "truth". What's interesting about a science museum is how it projects a very subjective view of what is supposed to be an objective practice – i.e. science. Watching those exhibits struggle with fact – walking the line between fact and art – made me realize that science is subjective.'[6] In their choice of unusual and striking

ROSAMOND W. PURCELL
BABIES WITH BEADS
1992

This striking photograph by Purcell, taken in the Museum of Anatomy, Leiden, captures these remarkably well preserved babies in miraculous detail; the viewer is thus presented with an opportunity to reflect simultaneously on the mysteries of birth and death.

museum exhibits as suitable subjects for photographs, artists like Richard Ross, Dario Lanzardo and Rosamond W. Purcell succeed in conveying the flavour of the museum's traditional qualities, displaying strange and wonderful objects. Purcell's series of photographs from eight early natural history collections, published under the title of 'Finders Keepers', convey the vital link between curiosity and the quest for scientific knowledge, a subject on which she has undertaken extensive academic research. Purcell's work has particularly focused on the early collectors' predilection for preserving nature's anomalies, pickled in formalin, and has managed to capture the special illusionary quality of photographing specimens in jars: 'Preservative liquids of various viscosities contrive to grant subjects unexpected depths, faint or dramatic reflections, absent, displaced, or exaggerated detail, and sometimes a selectively mirrored surface…'.[7] Her compelling images of these weird and wonderful specimens also reflect a broader human fascination for macabre beauty.

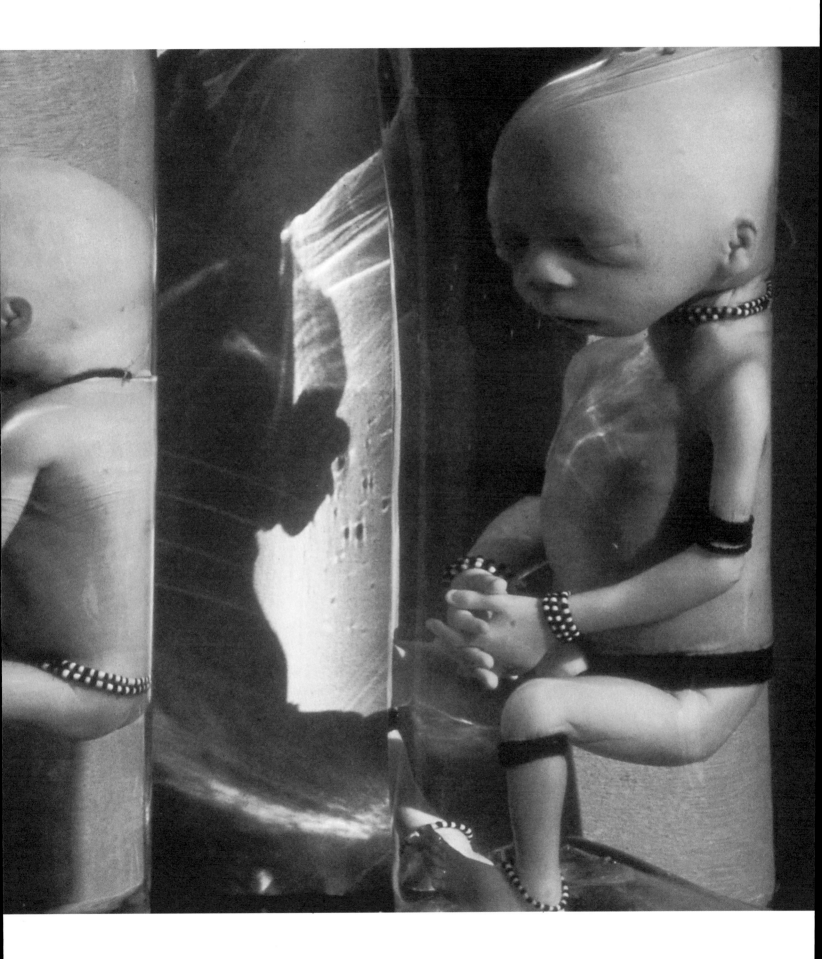

DARIO LANZARDO ⟳
MONGOOSE (VIVERRIDAE) FROM AFRICA
1995

This image of a preserved mongoose specimen from the Turin Natural History Museum is included in Lanzardo's extensive published project entitled 'Arca Naturae'.

⟲ ROSAMOND W. PURCELL
ARM HOLDING EYE SOCKET
1992

Purcell's photograph, taken in the Museum of Anatomy, Leiden, shows an anatomical preparation by the noted 17th-century Dutch embalmer Frederik Ruysch which was intended to allude to an allegorical theme.

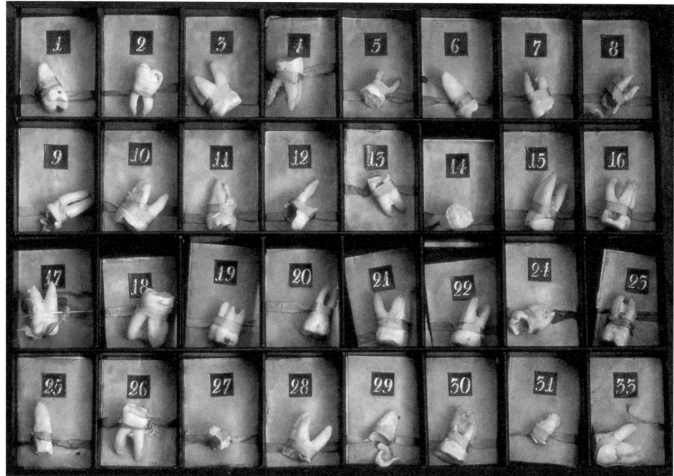

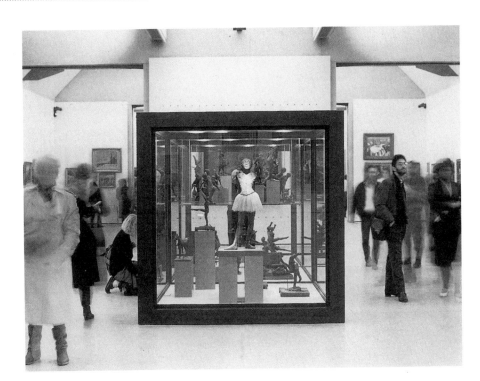

⊕ LOUISE LAWLER
GLASS CAGE, PART I
1991

The first of two black-and-white photographs by Lawler showing Degas's *Little Dancer of Fourteen Years* (*c.* 1880) as installed in a large vitrine ('glass cage') in different arrangements in 1991 and 1993 at the Musée d'Orsay, Paris.

⊕ DARIO LANZARDO
TURTLE (RESTORED)
1995

Lanzardo's dramatic foreground close-up of a turtle's head emerging from its protective polythene covering suggests its rebirth as the daylight penetrates the gloomy and lifeless unnatural context of the museum interior. This is one of a series of photographs taken in the Turin Natural History Museum during renovation work.

⊕ ROSAMOND W. PURCELL
TEETH PULLED BY PETER THE GREAT
1992

Purcell's photograph of a taxonomic arrangement of teeth from the collection of Tsar Peter the Great of Russia (reigned 1682–1725) in St Petersburg takes on inevitable associations with his reputedly cruel personality and obsession with scientific knowledge.

⟿ DARIO LANZARDO
ENSEMBLE OF MAMMALS
1995

A group of mammal specimens in the Turin Natural History Museum appear bewildered, not knowing which way to turn, in their apparent stampede to escape the seemingly imminent crumbling of the museum's walls.

RICHARD ROSS ⚲
AUSTRALOPITHECUS
AFARENSIS
1986

In this photograph of an extraordinary diorama (portraying a reconstruction of the oldest-known hominids) in the Hall of Human Biology and Evolution at the American Museum of Natural History, New York, Ross manages to invert the highly realistic illusion of depth so that the scene takes on the appearance of a vast painting.

⚲ MARZIA MIGLIORA
NATURAL HISTORY MUSEUM,
BERLIN
1999

In her second project based around the museum space entitled 'Vacuum-packed' (1997–99), Migliora included numerous images of taxidermied animals displayed in natural history museums in order to explore the boundary between the real and photographic illusion.

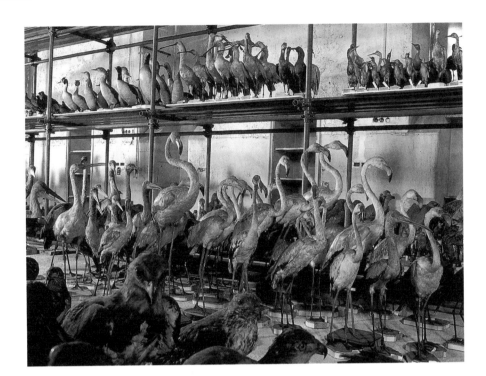

↩ **DARIO LANZARDO**
ENSEMBLE OF BIRDS OF PREY,
FLAMINGOS, HERONS,
SPOONBILLS ETC.
1995

These historic taxidermied bird specimens in the
Turin Natural History Museum, seen here lined up
on the floor and on scaffolding planks, are placed
in the contemporary time-frame of the Museum's
building undergoing refurbishment.

↩ **RICHARD ROSS**
POTTER'S MUSEUM OF
CURIOSITY, ARUNDEL,
SUSSEX, ENGLAND
1986

Ross has taken photographs in different museums
all over the world, ranging from major public
institutions to small provincial museums like this
one featuring some 10,000 specimens. Founded in
1861 by Walter Potter, an eccentric taxidermist,
the collection has since moved to Jamaica Inn on
Bodmin Moor, Cornwall.

MARZIA MIGLIORA �⟩
MUSEUM OF CRIMINOLOGY, ROME
1999

Migliora is particularly interested in recording the non-public areas of museums and their archives, and her photographs often deliberately mimic technical faults seen in amateur snapshots.

⟐ CHRISTINE BORLAND
SPY IN THE ANATOMY MUSEUM
1997, detail

As part of her Frankenstein project, Borland included images from the Montpellier Anatomical Museum in France.Since all photography was strictly forbidden, she worked secretly with a tiny spy camera and the resulting images are inevitably somewhat out of focus.In the final work, they are presented as a rapidly changing slide show using a carousel projector together with some of her related drawings.

⟐ HIROSHI SUGIMOTO
ST ALBANS POISONER
1994

From Sugimoto's Wax Museums series which show reconstructions of famous murders as displayed at Madame Tussaud's, London. Without the illusion conveyed by three-dimensional tableaux, his two-dimensional photograph gives an even more convincing impression of reality, a history outside its real time-frame.

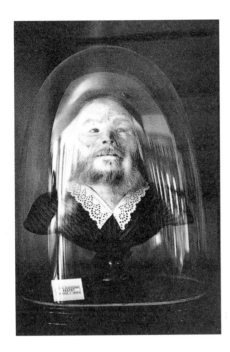

✿ ZOE LEONARD
PRESERVED HEAD OF A
BEARDED WOMAN

Musée Orfila, Paris

1991

Leonard's photograph (one of a set of five) draws attention to the fact that the bearded woman is completely depersonalized and presented merely as a rare museum specimen.

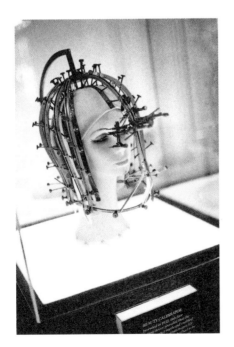

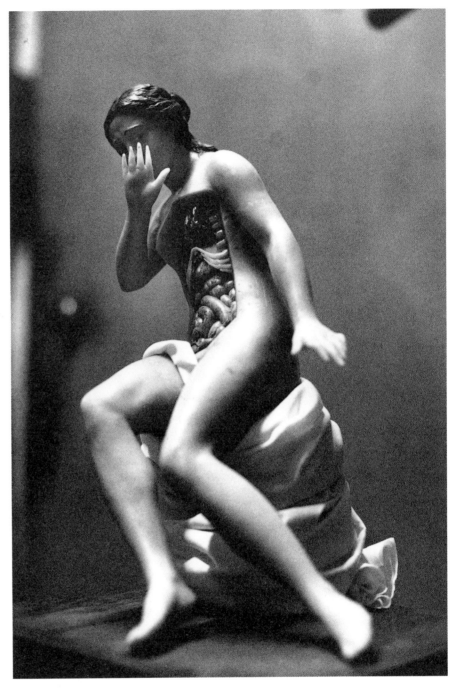

↩ ZOE LEONARD
BEAUTY CALIBRATOR #2

Museum of Beauty, Hollywood

1993

Leonard's photograph of this bizarre device for measuring female features to verify a canon of ideal beauty has the appearance of a medieval torture instrument. It is linked to her frequent investigations into male perceptions of the female form.

✿ ZOE LEONARD
SEATED ANATOMICAL MODEL

1991–92

One of a series of photographs, taken by Leonard in the basement of the Muséum National d'Histoire Naturelle, Paris. The wax model by André-Pierre Pinson dates from the mid-18th century: it depicts a seated figure in a classic pose of fear which was directly influenced by the allegorical paintings of the period.

LOUISE LAWLER ⟿
UNTITLED (OSLO)
1993–95

By encapsulating her Cibachrome prints within glass crystal, Lawler suggests the museum's containment of its classical casts. This is from a series of paperweights, each in an edition of ten, that she produced between 1982 and 1995. She also added a cryptic caption below inviting the viewer's response.

THOMAS STRUTH ⟆
STANZE DI RAFFAELO II, ROME
1990

Struth captures the energy of the heaving mass of tourists thronging the galleries of the Vatican Museum, where the iconic works of art they have come to venerate seem to take on an almost overpowering presence.

She made no attempt to rescue art from ritual

YES ☐ NO ☐

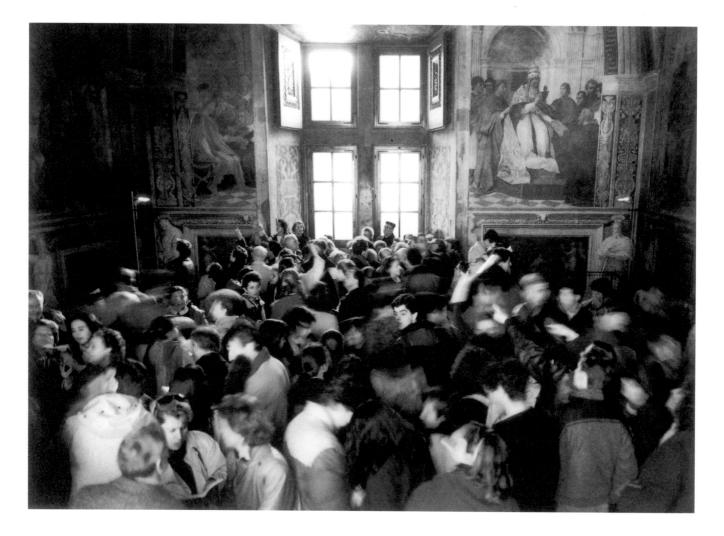

⚘ CANDIDA HÖFER
NATURAL HISTORY MUSEUM, LONDON IV
1993

While many artists are attracted to the idea of capturing the antiquated quality of 19th-century displays, this work emphasizes the imposed minimalist aesthetics of the modern approach in which the natural objects, with their pristine display mounts, are presented like works of contemporary sculpture.

↩ LOUISE LAWLER
HOW MANY PICTURES
1989

Lawler's photograph captures the striking effect created by the reflection of a protractor painting by Frank Stella on the highly polished surface of an exhibition gallery floor in the Museum of Modern Art, New York.

⊕ **CANDIDA HÖFER**
MUSEUM FÜR VÖLKERKUNDE,
DRESDEN I
1999

The freshly painted museum vitrine bases and
display mounts are presented like contemporary
sculpture in Höfer's photograph of this airy white-
walled gallery.

SKY BERGMAN ⊕
GLYPTOTEK, COPENHAGEN,
DENMARK
1996

Photographing from a distance using a panorama
camera, Bergman captures the unique spatial
quality and grandeur of the museum architecture.
In the gallery the marble sculptures assume a
unique sense of presence which helps to
emphasize the temple-like quality of the interior.

CHAPTER V *curator/creator*

As a result of the recognition by museum curators of artists' intuitive sense of perception and presentation, there has been a growing tendency for museums to invite artists to choose and arrange material from their collections. This collaboration might involve the staging of a special exhibition within a particular museum or the loan of objects from its collection for showing at contemporary art venues. Artists' selective criteria reveal the diversity of their individual interests, which help to break down the more formal standard classification system, and their frequent preoccupation with the self also works well in helping to deconstruct the impersonal nature of museum displays. Drawing frequently on reserve collections, artists tend to choose objects which may be of less significance in the eyes of the museum curator, and the groupings and juxtapositions that result are not restricted or regulated by historical conventions and ordering systems. In this situation the process of selection, arrangement, presentation and labelling becomes essentially an artist's personal construction and concept using the museum's collection as working material. The increasing phenomenon of the artist-curator often crosses the boundaries between exhibition design and installation and is regarded by some artists as a natural extension of their everyday practice.

RICHARD WENTWORTH
QUESTIONS OF TASTE
Display at the British Museum, London.
Part of the multi-site exhibition 'Collected'
1997

Wentworth created what he called a 'display' using ancient Egyptian drinking vessels from the British Museum's collection juxtaposed with various modern drinks containers discarded in the museum vicinity. These were arranged in a vitrine placed in the Egyptian Gallery. To match the official museum labels, the modern tins, cartons and plastic bottles were similarly described, including details of their manufacturing process and the find-spot in each case. This juxtaposition set up dialogues between valuable and worthless, precious artifact and discarded rubbish, the unique handmade object and mass-produced packaging.

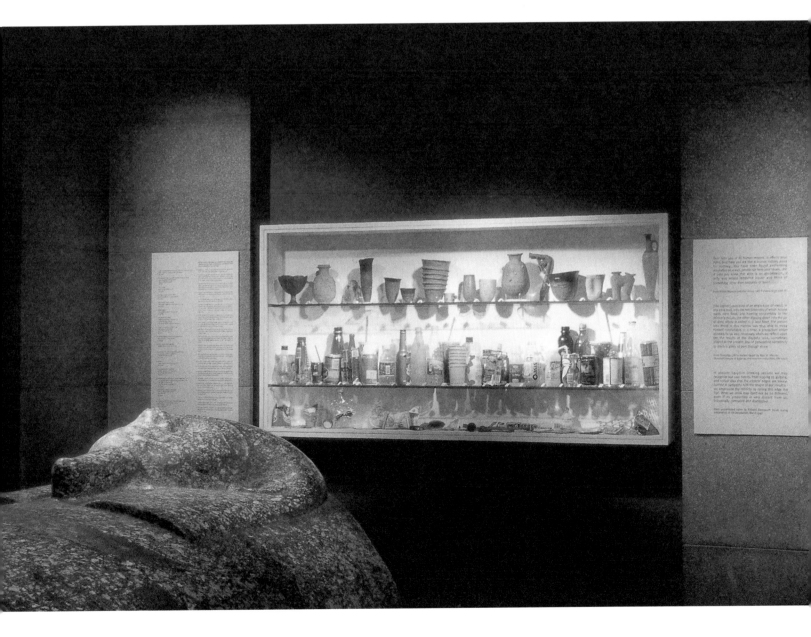

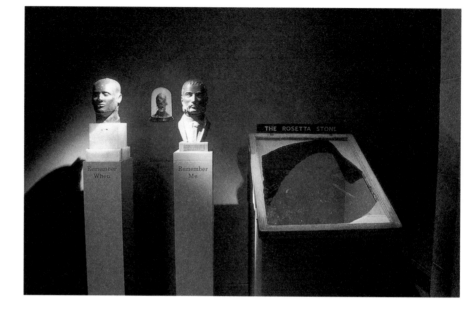

FRED WILSON
IN COURSE OF ARRANGEMENT
Installation at the British Museum, London,
as part of the multi-site exhibition 'Collected'
1997

Creating an installation using artifacts from the
British Museum's Department of Egyptian
Antiquities accompanied by label texts, Wilson
addressed issues of acquisition history. He
displayed an ancient stone head, a photograph of
a mummy head mounted like a taxidermied
specimen, and a bronze bust of Giovanni Belzoni,
who in the 19th century was responsible for
acquiring major sculptures which now form part of
the Museum's permanent collection. He also
exhibited the original display case for the Rosetta
Stone with a caption asking 'What are you looking
at?', challenging the museum visitor to think
beyond the conventional museum interpretation
of the artifacts.

Fred Wilson's exhibition 'The Museum: Mixed Metaphors' (1993), involved his temporary reinstallation of some of Seattle Art Museum's permanent collection as a means of interconnecting different cultural perspectives. It involved him in extensive preliminary research, spending time with museum staff and local artists in order to learn about both the museum and the community. By observing the museum's existing modes of interpretation and presentation he was able to achieve a subtle interweaving of his own work with the objects in the permanent displays so as to make the two categories virtually indistinguishable to the average visitor. Wilson has developed a form of artistic practice in association with museums which has the effect of blurring the boundaries between the roles of the artist and the curator, but he clearly defines his creative role in this process. In connection with his exhibition 'Mining the Museum' (Baltimore, 1992), he writes: 'I didn't curate the show, this was my artwork. I make that distinction. Although people

looked at the exhibition and saw it as a curated exhibition, which is fine, for me it's something else entirely, it's my work'.[1]

The choice and display of museum objects, deciding how one form or idea relates to another, involves a number of different faculties and the growth of 'creative curating' owes much to the parallel existence of both conceptual and installation art. It might also be argued that, according to Duchampian principles, the entity of an exhibition could become 'art' through the temporary appropriation and presentation of its content by the artist. Some artists are thus able to assimilate the theme of an exhibition, their selection of museum objects and the mode of display with their own individual working practices. In his installation entitled 'The Play of the Unmentionable' (1990) at the Brooklyn Museum, which took the form of an exhibition, Joseph Kosuth described the precise nature of his artistic input in these words: '…This particular exhibit tries to show that artworks, in that sense, are

like words: while each individual word has its own integrity, you can put them together to create very different paragraphs. And it's that paragraph I claim authorship of…'.[2]

Kosuth made a selection of over a hundred paintings, sculptures and photographs, drawn from the museum's different curatorial departments, and lesser-known works (some taken from the reserve collection), and these were exhibited next to the museum's acknowledged masterpieces. His selective criterion was the fact that these unfamiliar works would have been considered shocking or inappropriate at a particular time in history and, viewed in a broader context, that the exhibits reflected the history of taste running parallel to the history of art. Kosuth's juxtaposition of various quotations with groupings of museum objects distributed throughout the installation set up a unique thought-provoking process linking historical objects with current issues. His installation was conceived in direct response to recent

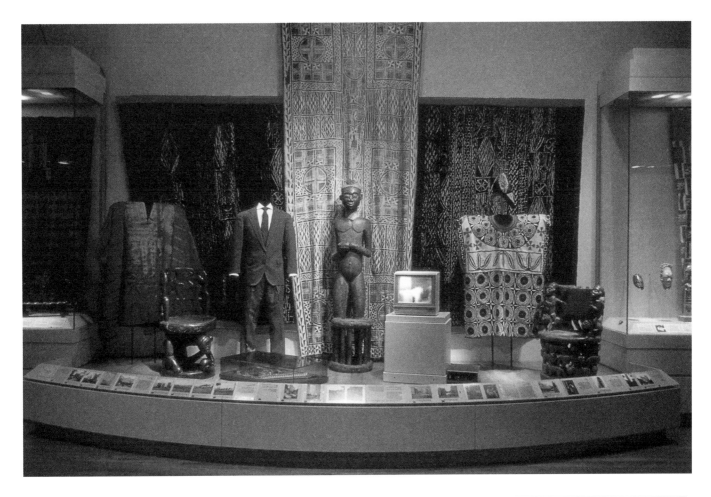

threats to the freedom of artistic expression in the USA linked to the funding policies of the National Endowment for the Arts. It also proved especially topical because of a court case concerning the alleged obscenity of certain photographs by Robert Mapplethorpe, the outcome of which was a verdict accepting that 'pornography' can be considered 'art' once it enters a museum.[3] By placing texts of the reactionary views that greeted the exhibition of Cubist art in 1913 alongside others associated with more recent art controversies, Kosuth was also able to illustrate how at any given time contemporary art tends to become associated with ideas of immorality and degeneracy in the public consciousness.

The opportunity given to certain artists to select and arrange objects and works of art from museum collections is an acknowledgment of their powers of inquiring perception, the so-called 'artist's eye', and of their experience as practitioners in the same field. Invitations are extended to different kinds of artists, according to the nature of the institution, and major public museums with collections of historic masterpieces tend to favour established 'celebrity' artists. The growing tendency for museums to invite artists into their previously exclusive curatorial inner sanctum also represents part of a wider movement for museological reappraisal and reform, as well as the need to attract new audiences. These collaborations might

FRED WILSON
THE MUSEUM: MIXED METAPHORS
Installation view
Seattle Art Museum
1993

Wilson placed a man's suit with a group of traditional African robes and artifacts associated with power, and composed the accompanying label text as a parody of typical museological interpretation: 'Certain elements of dress were used to designate one's rank in Africa's status-conscious capitals. A grey suit with conservatively patterned tie denotes a businessman or member of government. Costumes such as this are designed and tailored in Africa and worn throughout the continent.'

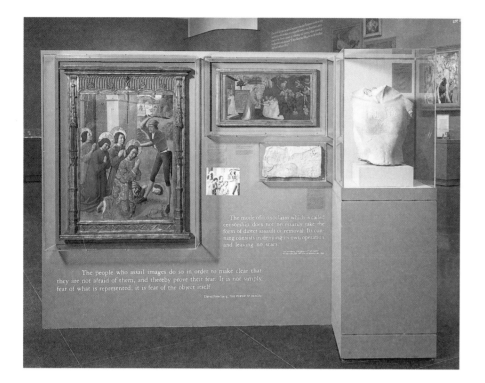

⟲ **JOSEPH KOSUTH**
THE PLAY OF THE
UNMENTIONABLE
Installation views
The Brooklyn Museum,
New York
1990

Kosuth's installation focused particularly on issues
of censorship and iconoclasm throughout the
history of art as dictated at various times by taste or
political and religious circumstances. In contrast to
neutral museum object labels or wall texts, his
selection of quotations addressed viewers directly
in order to encourage them to explore their
meaning and implications. ⟳

involve an artist in acting as guest curator of the museum's own collection or in participating in loans to other institutions. As free agents, artists can offer fresh insights beyond academic interpretations and take initiatives with groupings and juxtapositions that no museum curator would normally be allowed to consider. This opportunity to experiment exists because artists are not constrained by any formal museological precepts and have the freedom to deconstruct the self-conscious, enforced neutrality of conventional museum displays.

As guest curators, artists have a tendency to select objects very different from those chosen by museum curators, and they frequently draw on an institution's reserve collections. This suggests that the objects selected had been deemed by the museum to be only of secondary importance because its curatorial agenda is completely differ-ent. The appraisal of less famous museum objects can provide a clearer cultural perspective than the familiar 'over-institutionalized' works. Eduardo Paolozzi's exhibition called 'Lost Magic Kingdoms' was the result of extensive research into the unexhibited ethnographic collections and archives at the British Museum, where it was staged in 1987 before touring various regional venues.[4]

Collecting has been a consistent feature of Paolozzi's working practice since his formative years as an artist and his cura-torial process in this exhibition had links with his earlier collages and his 'Krazy Kat' archive of popular ephemera. In his exploration of the ethnographic collec-tions, he was able to find an affinity between his own penchant for re-using discarded materials and practices in non-Western cultures: 'Materials which are commonplace to us [in the West] are rare and valuable to others who, with the power of imagination, transform them into new creations.'[5] Paolozzi personally selected and arranged in thematic tableaux over 200 objects retrieved from the British Museum's reserve storage; the items he chose consisted mostly of previously unexhibited material. On the opening page of the exhibition catalogue was reproduced an image of his earlier work, *Blue print for a new Museum* (1980–81), a montage of line drawings of various mechanical inventions and works of art contained within a mythical abandoned cathedral. This idealized museum proposed by Paolozzi offers a flexible alternative to the traditional museum practice of isolating and categorizing objects with '… all parts movable – an endless set of combinations, a new culture in which problems give way to possibilities'.[6] This has parallels to the idea of the *Wunderkammer*, where multiple associations stimulate both thought and

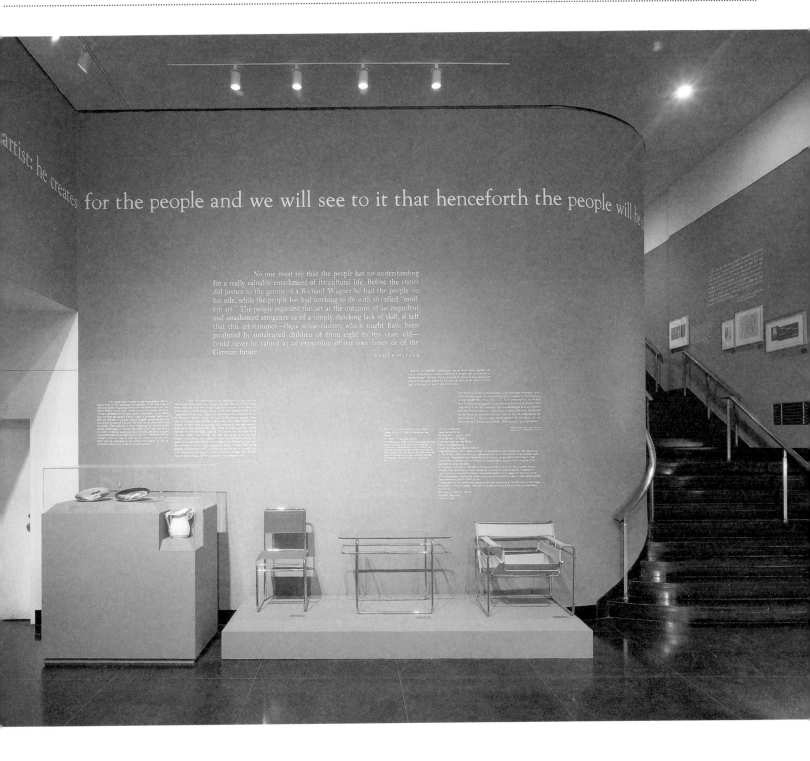

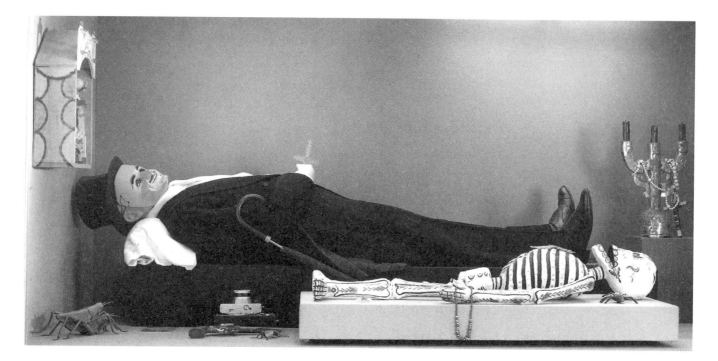

wonder. With this in mind he chose to mix together all manner of different objects from diverse cultures – objects that would never normally be juxtaposed. These were arranged in displays together with his own sculpture, photographs, childhood scrapbooks, and mass-produced objects from modern Western culture. 'Among the values I've tried to exorcise is the idea of authenticity,' he noted.[7] By combining original and fake objects and avoiding the conventional museum emphasis on historical and geographical criteria, he was able to show that the items exhibited could have an intrinsic visual appeal outside their customary context.

Another challenge to conventional museum display criteria is presented by John Cage's complex and extraordinary project *Rolywholyover A Circus* (1993) at the Museum of Contemporary Art, Los Angeles,[8] in which context the medium of exhibition curating provided a vehicle for

Cage's methods of musical composition. The project had several components, sited in different museum galleries, that employed the same random principles that Cage had adopted in his music since the early 1950s, and he was also influenced by the chance systems of the Chinese book of oracles, the *I Ching*. The exhibition included work by artists who had inspired him, objects loaned from local museums, as well as a selection of his own paintings, prints, musical scores and personally significant ephemera. The method of selection and their arrangement, which in some cases was subject to change every day, all followed random principles. According to Cage, 'The basic idea is that the exhibition would change so much that if you came back a second time, you wouldn't recognise it.'[9] Even the numerous ancillary events that were presented in the museum auditorium – performances, readings, talks and discussions – were reprogrammed on a daily basis.

EDUARDO PAOLOZZI 🜍
LOST MAGIC KINGDOMS

Museum of Mankind, The British Museum, London
1987

Paolozzi constructed one of his tableaux in the display case to suggest a wake based on the Mexican Day of the Dead, the annual festival in which the dead are remembered with offerings. Paolozzi noted that the masked figure in formal dress 'comes from the same culture which produced the skeleton made of the most … inexpensive material – recycled paper'.

For another display, which included a saxophone, an Indian rattle, a finger piano and clay pipes, Paolozzi constructed his own 'magical' musical instrument, comprising a guitar with a built-in tape recorder, activated by the press of a button. In this way, by pretending to play the instrument 'everybody … becomes a musician'. 🜍

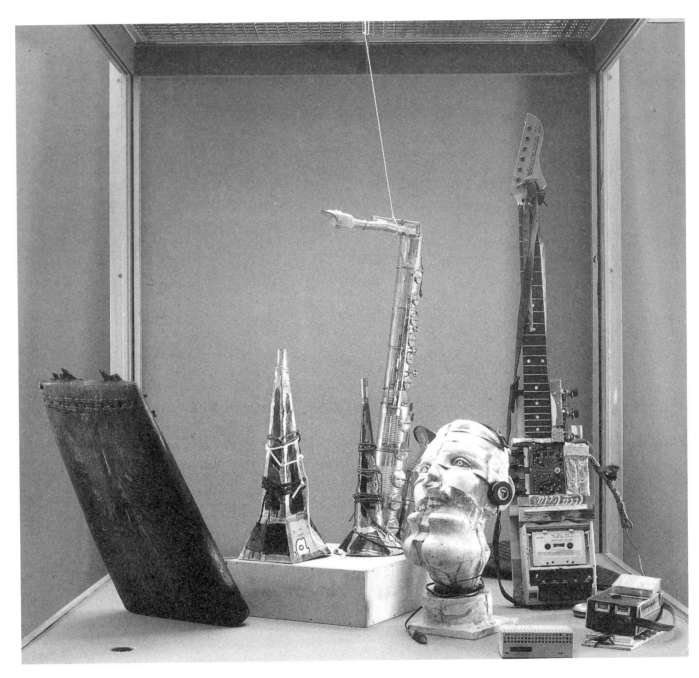

Although chiefly renowned as a composer, Cage was a multidisciplinary artist whose work had a major influence on aesthetic thought. The idea of inviting artists whose work traverses different artistic fields has an obvious appeal to museums. Between 1990 and 1993, a number of European institutions invited the film director Peter Greenaway to curate exhibitions, and these inevitably relate to his own approach to film-making and reflect his fascination for a number of ongoing themes. Perhaps his most ency-clopaedic concept in museological terms was '100 Objects To Represent The World', an exhibition held at the Semper Depot and the Hofburg Palace in Vienna in 1991. This concept was based around an idea of the use of U.S. Voyager space-ships to send representative objects relating to life on Earth into outer space so that extraterrestrial beings might learn about our world. In the catalogue introduction he wrote: 'Since every natural and cultural object is such a complex thing, and all are so endlessly interconnected, this ambition should

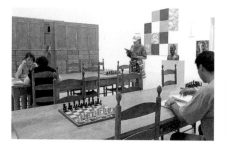

not be so difficult to accomplish as you
might imagine.'[10] Embracing historic
cultural artifacts borrowed from various
Viennese museums, like the famous pre-
historic figurine known as the Willendorf
Venus, the exhibition also included such
items as a large block of gently melting ice,
a dead cow, a live baby accompanied by
its mother and the tangled remains of a
crashed aircraft.

For his slightly earlier exhibition called
'The Physical Self', held at the Museum
Boijmans-Van Beuningen , Rotterdam,
in 1991, Greenaway illustrated the
human body in terms of a chronological
progression, using a selection of historic
paintings, drawings and prints from the
museum's collection. Greenaway was
able to visualize the numerous elements
of the exhibition in a coherent scheme:

'like the cinema, it offered frames, iso-
lated images, to be seen in a sequence'.[11]
At various points, where they could be
viewed by visitors from every angle, nude
models were exhibited in vitrines, seated,
standing or reclining in conventional
art studio poses. Thus, by introducing
living people combined with the use of
dramatic lighting the artist was making
a provocative challenge to the conven-
tionally static and inanimate world of
museum display.

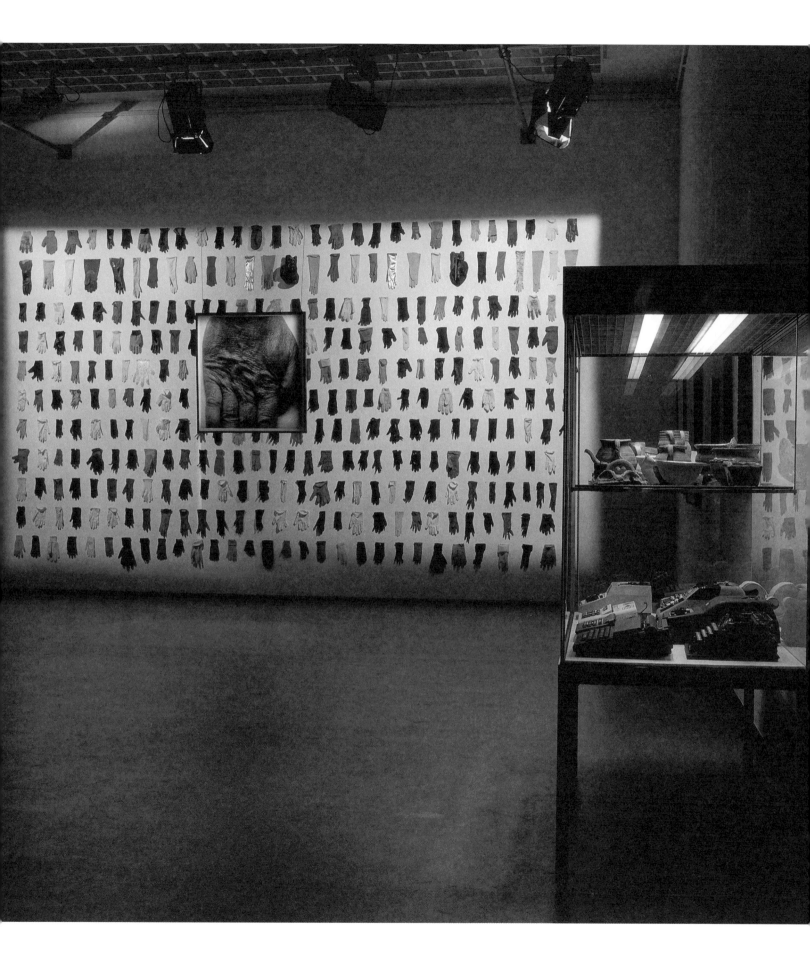

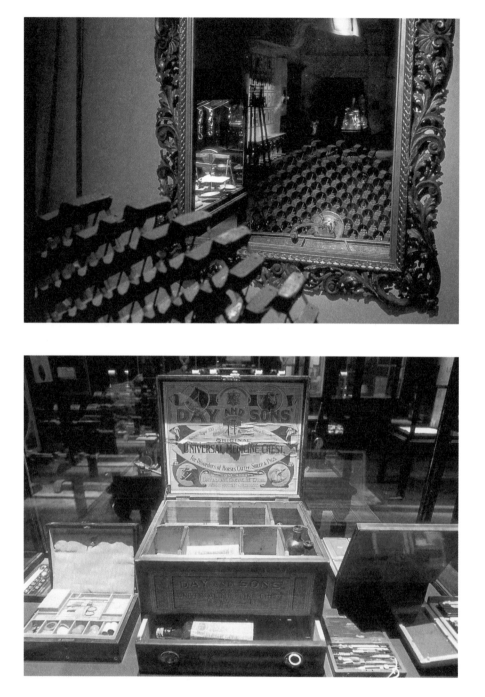

According to Peter Greenaway, the museum exhibition possesses enormous inherent visual potential which need not be limited to its conventional static experience. He notes that 'In the contemporary exhibition, all manner of sophisticated cultural languages can be successfully integrated, making it a form of three-dimensional cinema with stimulus for all five senses where the viewer is not passively seated, can create his or her own time-frame of attention, and can (as good as) touch the objects he is viewing and certainly have a more physical-visual relationship with them.'[12]

As part of the same programme of inviting guest curators, Hans Haacke's project *Viewing Matters: Upstairs* (1996) at the Museum Boijmans-Van Beuningen, Rotterdam, offered an in-depth examination of the way art is displayed and read. It comprised three sections, each reflecting a different way of approaching art, the expla-

nation of images and the categorization and ordering of styles and themes. Haacke's presentation confronted the viewer with a highly diverse range of objects from different eras. Paintings were chosen randomly from the reserve collection by museum technicians and hung close together on screens, as in the museum's storage area. Amidst the racks of paintings, beneath a chandelier, Haacke also installed two computer stations, which provide inventory data and the standard art historical program about the museum's Old Master holdings. The exhibition combined themes like the history of the museum, the origin of the collections and the way art is treated in museums. In character with his wider museological interests, Haacke also investigated the interplay between the collection's origins and the respective careers of the museum's founder, the lawyer F. J. O.

Boymans (who bequeathed his possessions to the town of Rotterdam in 1847), and Daniel George van Beuningen (a wealthy businessman who had made many gifts to the museum and whose own art collection was purchased by the city in 1958, three years after his death). Haacke was also invited to choose works from the collection of the Victoria and Albert Museum to be displayed in 2001 at the Serpentine Gallery, London, as part of a special collaboration between the two institutions entitled 'Give & Take'.[13] In his catalogue essay (p. 51) Haacke takes an objective view of the curatorial process. He writes: 'Together with the choice and arrangement of artefacts, curators implicitly exhibit the social environment to which they themselves belong. They frame and (unwittingly) are framed. Of course, this is also true for the exhibition I have put together.'

Sharing the same sense of acute observation, Richard Wentworth's exhibition 'Thinking Aloud' (1998) was concerned with quite a different curatorial agenda and, as the title suggests, constituted an extension of his own cognitive process.[14] His choice of objects and works of art, whether loaned from various types of museum, private collectors, fellow artists or just found or acquired by himself, was both eclectic and personal. Featuring preliminary sketches, maquettes, architectural models, maps, plans, prototypes and patented inventions, his show was also a celebration of many forms of human ingenuity. In fact the various contemporary works of art became so comfortably assimilated with the other objects on display that it seemed no longer important to distinguish art object from non-art object. In his unusual groupings he was able to reveal the existence of intriguing relationships between objects of completely different categories and media. Wentworth's curatorial approach served to blur the boundaries of traditional museological classification and interpretation: 'I am not interested in being illustrative or didactic. Part of the predicament in presenting a show is to keep this fluidity and open-endedness, where meanings are fugitive and things can coalesce in different ways …"Thinking Aloud" is an opportunity to see what happens if you fray the edges and actually provoke more open-ended ways of looking.'[15]

In the exhibition called 'The Maybe' staged at the Serpentine Gallery, London,

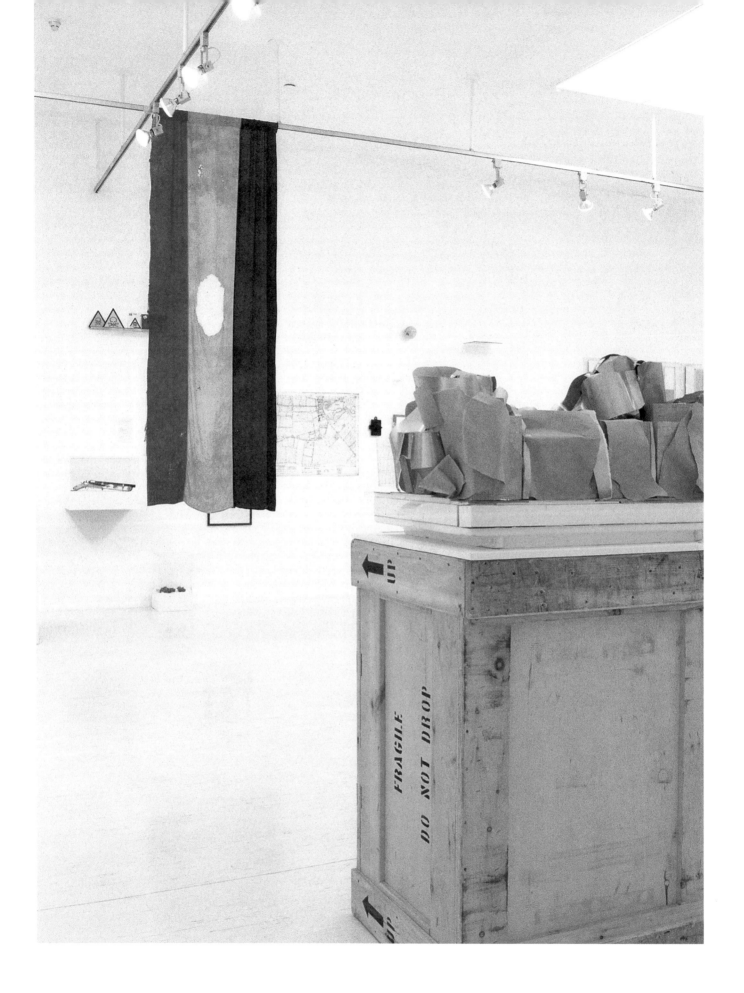

⟲ **RICHARD WENTWORTH**
THINKING ALOUD
Camden Arts Centre, London
9 April–30 May 1999 (detail)

For this exhibition, staged in Cambridge, Manchester and London, Wentworth chose a diverse selection of artworks and non-art objects, juxtaposed and categorized personally to reveal and suggest a new 'way of looking'. Thus, a banner bearing the emblem of the former Socialist Republic of Romania removed by Revolutionaries found itself placed near an architectural model by Frank O. Gehry.

Wentworth's arrangement also included assorted Patents, a French collapsible ladder, contemporary imitation toy tools, named and unnamed. ⟲

in 1995, Cornelia Parker and Tilda Swinton combined a performance with an installation involving museum objects in vitrines. During the exhibition's opening hours, Swinton lay 'asleep' in a display case situated in the central part of the gallery, while in the surrounding rooms objects that had associations with famous historical figures were displayed. These items had been selected by Parker from museums in Britain and each was accompanied by a simple descriptive label that she had written. The miscellany included a fragment of Charles Lindbergh's aircraft in which he crossed the Atlantic in 1927, a quill used by Charles Dickens when writing *The Mystery of Edwin Drood*, a stocking worn by Queen Victoria, as well as the brain of the man who invented the first computer, Charles Babbage. Although quite visually unremarkable

CORNELIA PARKER AND TILDA SWINTON ⚥
THE MAYBE

The Serpentine Gallery, London
1995

This performance/installation was the result of a collaboration between the artist Cornelia Parker and the actress Tilda Swinton, who lay 'asleep' in a vitrine in the centre of the gallery during opening hours.

In the surrounding rooms Parker displayed her unusual selection of 35 objects borrowed from various museums. These were objects or personal relics associated with historical persons and each was accompanied by a label written by the artist. One of these was 'Babbage's Brain', the preserved brain of the mathematician Charles Babbage (1792–1871), inventor of the computer.

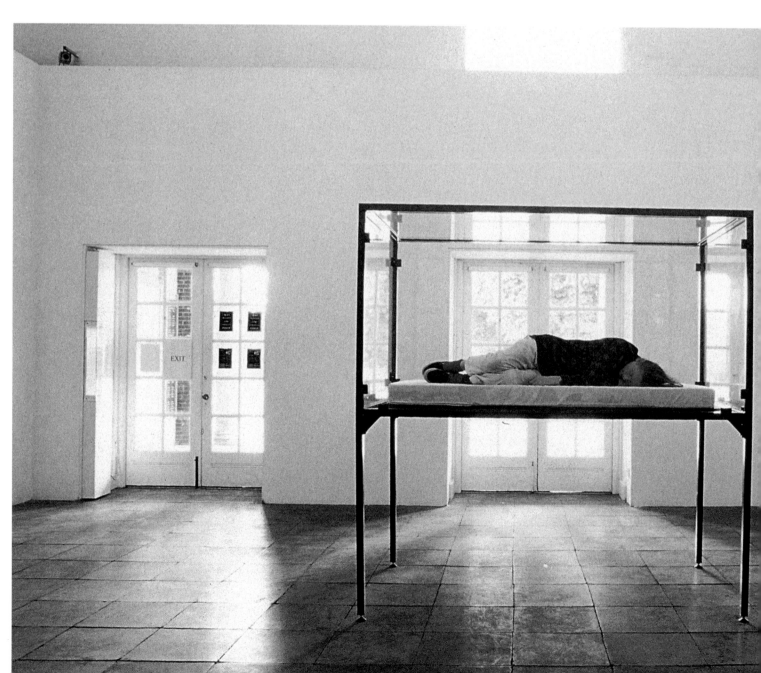

when viewed simply as museum objects, they now became poetic ideas enabling the spectator to evoke a whole mental picture, thanks to Parker's selection, arrangement and labelling. As she noted, '… because the experience or history of the object had been conferred by someone else, my role was to isolate these objects and put them together like a sculptural material.'[16] Like reliquaries from medieval churches, their associations with specific people rendered them worthy of con-

templation. By juxtaposing one object with another Parker was able to establish further associations and emphasize the significance of a living human presence in their vicinity: 'I liked playing around with these little histories. I wanted to breathe new life into these objects by their juxtaposition and their relation to Tilda, living and breathing only a few inches away.'[17]

When the artists' collective Group Material (founded in 1979) received an invitation to participate in the 1985 Whitney Biennial in New York, its members chose to curate an exhibition, presented in the form of an installation, under the title *Americana*. The group's original members were Doug Ashford, Julie Ault and Felix Gonzalez-Torres, who became known for organizing shows on social and political themes. Their general approach was described in 1989 by Julie Ault: 'We see ourselves as artists redefining the role of curating. We shy away from the word "curating" because it has connotations of connoisseurship and exclusiveness – we've always called it "organizing".'[18] For the Whitney Museum they created a kind of 'unofficial' biennial within the official biennial, presenting the work of 53 largely unrecognized artists from various ethnic backgrounds who would otherwise have had little hope of showing their work there. The group's curatorial activities were described by Gonzalez-Torres: 'Our shows are not simply visual. They are very complex and inclusive – everyone's there in terms of approach, style, ethnicity, gender, or sexual orientation. If every show was like that, in every

museum, culture would be different.'[19] In this lobby installation the walls read as giant collages with pictures of all kinds hung edge to edge, floor to ceiling in traditional salon style. The exhibits included paintings, drawings, photographs, printed ephemera, supermarket packaging and even Norman Rockwell commemorative plates. There were also domestic consumer goods and a black-and-white television set continuously relaying pictures. The centrepiece of the installation was a deluxe washer and dryer which was inevitably read as a metaphor for the laundering of art by museums. Although Group Material's involvement was viewed by some as a patronizing and neutralizing gesture on behalf of the Whitney, the founding members were able to maintain a vital curatorial voice and suggest alternative narratives and points of view using an institutional forum. Doug Ashford explains the significance of their curatorial role as artists: 'Traditionally, the curator is a keeper of the treasures. Our project has always questioned what is treasured, what is culturally important – and how ideas are finalized about what art is supposed to be. We don't deny the label of curator, but we want to expand what the label implies socially.'[20]

⏎ BARBARA BLOOM
NEVER ODD OR EVEN

Installation view
Carnegie Museum of Art,
Pittsburgh, Pennsylvania
1992

Bloom's installation was linked to the themes of
twinning and symmetry, both natural and artificial,
from the curious to the grotesque. A large vitrine in
the centre of the gallery contained butterflies,
while on the walls she exhibited a selection of
photographs showing formal gardens, Nazi
architecture and conjoined twins, which were
pinned in shallow box frames to mimic the
butterfly specimens.

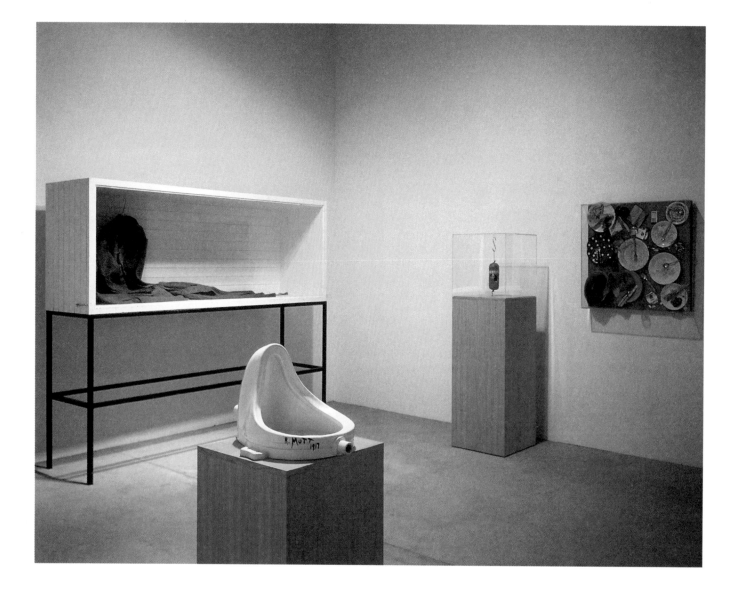

READYMADES BELONG TO EVERYONE
CREATIVE USE OF LEFTOVERS
Installation view

CAPC, Musée d'Art Contemporain, Bordeaux

1990

Using a collective pseudonym inspired by Marcel Duchamp's Readymades, Philippe Thomas curated an exhibition devoted to the nature of display entitled 'Feux Pâles'. He also presented a series of historical room installations, ranging from an 18th-century *Wunderkammer* to an arrangement of modern art using works chosen from the museum's own collection.

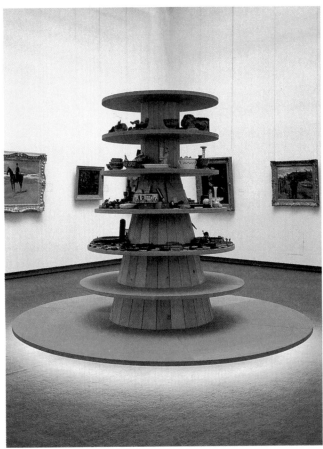

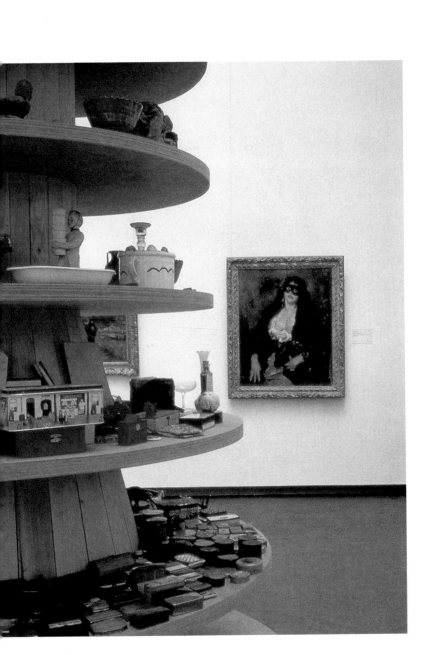

⊕ HAIM STEINBACH ⚲
An Offering – Collectibles of Jan Hoet
Documenta IX; Neue Galerie, Kassel
1992

One of two inter-related works presented by
Steinbach at Documenta IX that were concerned
with different approaches to installing curated
objects. He chose a square room to display items
from the personal collection of the exhibition
organizer, Jan Hoet; they were arranged in a similar
order to that seen on shelves in Hoet's museum
office in Ghent. They included some family
heirlooms, works given to him by artists and bric-à-
brac acquired by Hoet on his travels. Steinbach
designed a circular wooden shelving unit
incorporating a concealed neon light below the
first tier; he thus invited the viewer to walk around
it while at the same time taking in the paintings on
permanent display in the room. This work alluded
to the creative mental process of choosing and
arranging objects and to the curatorial roles of
Hoet as both a private collector and a public
exhibition organizer.

GROUP MATERIAL ⌀
AIDS TIME LINE

Biennial, Whitney Museum of American Art,
New York
1991

Group Material (Doug Ashford, Julie Ault, Felix
Gonzalez-Torres and Karen Ramspacher)
displayed artists' works amongst all kinds of
AIDS-related documentation arranged around a
horizontal museum-style time-line with caption
texts. Rather than being made to appear
precious, the exhibits were simply taped or
pinned to the wall. Covering the decade from
1979 to 1989, they included information and
statistics, press cuttings, medical reports,
safe-sex pamphlets and even a pair of rubber
gloves. A computer database and a six-hour
video component showing both art and documen-
tary material also formed part of the installation.

GROUP MATERIAL ☖
AMERICANA

Biennial, Whitney Museum of American Art,
New York

1985

Group Material (Doug Ashford, Julie Ault, Mundy
McLaughlin and Tim Rollins) decided to curate an
'alternative' exhibition within the Whitney Biennial
in order to challenge its claim to be a survey of the
most significant new American art. They included
works by many women and artists of cultural
diversity, distinct from the established New York
gallery scene; these were juxtaposed with everyday
objects of material culture. Their site-specific
installation, packed into a small lobby space close
to the museum entrance, was in effect a 'salon des
refusés', representing work that was significantly
excluded by the Whitney's curatorial agenda.

CHAPTER VI *on the inside*

Contemporary art can be installed in existing museums in such a way as to give rise to an immediate dialogue with established collections, displays, architecture and public services. Instead of being set apart in special exhibition galleries, these so-called 'interventions' involve the interweaving or juxtaposing of artists' work so that it merges or interferes in some way with the museum collection or site. Most significantly, artists are sometimes given the opportunity to undertake a temporary rearrangement of galleries and to provide a more personal commentary on permanent exhibits. Interventions have a tendency to address museological policies of acquisition, interpretation and display or other more provocative topical issues, thus challenging the traditional impartiality of the institutional context. Alternatively, a museum's architecture or artifacts may add a unique spatial, conceptual or aesthetic dimension to the installation of an artist's work, whether existing or specially made for the occasion. While interventions tend to occur more frequently in historical and modern art museums, some projects have been staged in essentially 'non-art' contexts which offer a challenge to interact with specialized collections such as archaeology, ethnography or natural history, and thus engage with a different audience.

ANDY GOLDSWORTHY
SANDWORK

Installation view, from the exhibition 'Time
Machine: Ancient Egypt and Contemporary Art'
British Museum, London
1994–95

Made from thirty tons of sand, compacted by
hand, Goldsworthy's installation remained in the
museum gallery for only three days because it
restricted public access. However, the artist's own
large-format photograph, with his preferred view-
point and lighting conditions, subsequently
became the 'work' which was shown in the gallery,
together with a video of its making. The ephemeral
nature of the installation itself served to echo the
idea of museum objects merely representing the
legacy of lost civilizations. The exhibition also
included some of Goldsworthy's smaller works
(made from leaves, sand and pebbles) placed in the
ancient sarcophagi.

A significant tendency evident since the 1980s has been the increasing number of opportunities for artists to create within museums site-specific works that respond to both the location and the existing collections. Sometimes referred to as 'museum intervention', such projects have frequently been occasioned by special initiatives on the part of institutions with historical and 'non-art' collections. These moves have evolved from the need to cast off the staid image of tradition in order to attract new audiences, while also reflecting an increasing climate of institutional self-criticism and observing political correctness. Interventions provide an opportunity for museums to reanimate sometimes tired-looking displays by adopting a fresher contemporary approach. Artists are in turn offered an exciting challenge to show their work to a wider 'captive' audience who may be visiting a museum principally to view historical artifacts. In such a situation they are therefore inspired by the 'insider' possibilities of placing art in a non-art context. Mark Dion feels that for living artists the opportunity to collaborate with and show work in other types of museum has certain virtues over and above those of exhibiting their work in a contemporary art gallery: 'I think for artists in my general category working with institutions is infinitely more exciting than working in a modernist white cube.'[1]

An entrance hall provides an effective site for an intervention since it offers an exhibition space with the potential to be visited by a museum's largest captive audience. This was demonstrated by Joseph Kosuth's installation for the

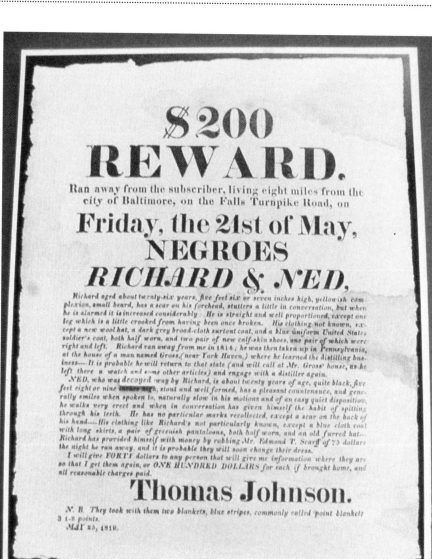

Brooklyn Museum's Grand Lobby, *The Play of the Unmentionable* (1990). The use of a social space (see p. 33), close to the outside world, provided a more immediate context for showing historical museum objects which would usually be found deeper within the building. His carefully chosen images which related to forms of censorship were juxtaposed with striking quotations stencilled directly on the wall. Museum visitors, many of whom were simply passing through the Grand Lobby while on their way to other galleries, were both intrigued and disturbed by the installation. In an interview at the time, Kosuth noted their response: 'Some people appear to be shocked that such things could ever appear in a museum. They tend to see a museum as an oasis away from the problems of the world; but my art has always tried to resist a position in which we're supposed to be passive consumers of culture – here it is, this is what it means. I refuse to do that. The viewers complete the work. They're the other half of the making of meaning.'[2]

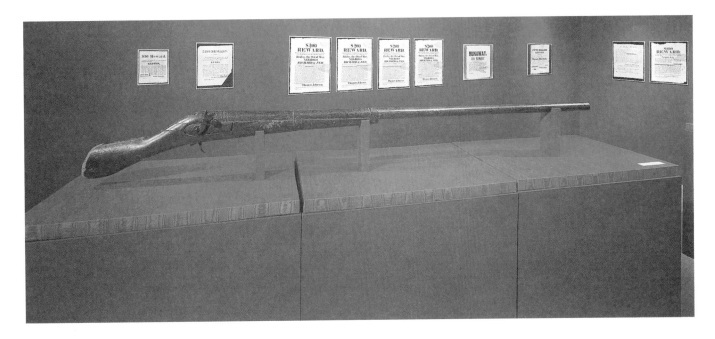

⊕ FRED WILSON ⊕

MINING THE MUSEUM

Installation view at the Maryland Historical Society,
Baltimore
1992

Wilson's exhibition challenged the conventional
version of Maryland's cultural tradition by bringing
to light the suppressed history of African Americans
in the state. In the Museum's reserve collection
he discovered a series of reward posters for the
recapture of runaway slaves and made enlarged
copies of them. After highlighting phrases which
suggested that the slaves had been abused
by their masters, he displayed them against a
blood-red wall-covering, adjacent to an oversize
hunting gun.

Artists who have been invited to create
projects within museum collections often
rearrange displays or introduce their own
labels for exhibits as an accepted feature of
their practice. In describing his exhibition
The Museum: Mixed Metaphors, held at
the Seattle Art Museum in 1993, Fred
Wilson points out the importance of this
essential dialogue set up by the fact of his
work becoming an integral part of the
existing display: 'I view museums as mixed
metaphors and my installation [as] another
way to mix them up. I was not given one

particular space – rather I was given the
whole museum as a site for my installation.
My work was interspersed throughout
and in juxtaposition with the museum's
permanent collections.'[3] In this project he
was concerned with challenging the notion
that in museum terms the art of certain
cultures is frequently viewed as dead
rather than living. Among the elements
he introduced were videos created by
contemporary Native American artists
which were shown in galleries displaying
artifacts made by their forebears. His
strategy of 'camouflaged' intervention
proved both challenging and thought-
provoking to visitors. Some might come
across his installations unexpectedly, while
others set out deliberately to find them,
and there were inevitably those who missed
them completely.

Wilson's interventions have also addressed
sensitive racial issues. In *Mining the
Museum*, held at the Maryland Historical
Society in 1992, he created installations

and rearranged the existing displays to
illustrate concealed histories of slavery
and racism in the state's colonial past.
By making ironic juxtapositions of objects
like a pair of slave shackles and examples
of fine silverware (see p. 30), he demon-
strated that such exhibits do in fact have
a potential historical connection. Wilson's
ability to grasp the essential character of
an existing museum display, and to go
with it rather than work against it, enabled
him to get his message across with a
surprising degree of subtlety and effective-
ness. He was thus able to illustrate the way
in which many unpleasant aspects of social
history had been conveniently overlooked
by the institution. His extensive research
into the Museum's reserve collection and
archives led to the discovery of many
significant artifacts that had been consid-
ered either too unimportant or too
confrontational to be exhibited. 'Often
what museums put on view says a lot about
the museum, but what they do not display
says even more. I called the installation

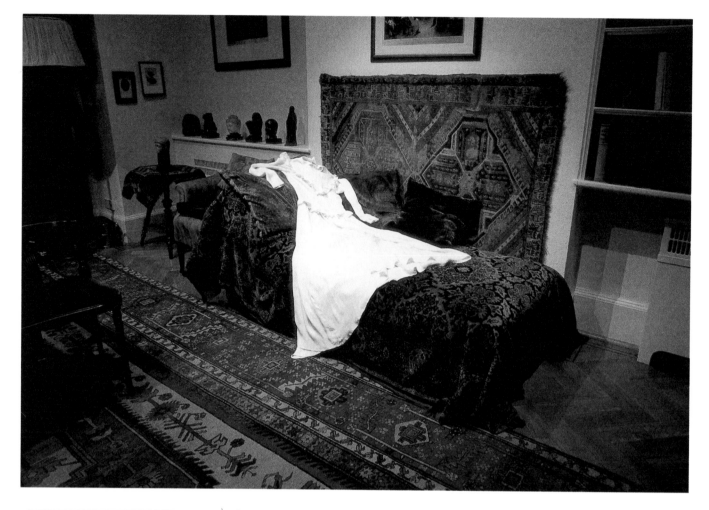

SOPHIE CALLE
THE WEDDING DRESS
Installation view, from the exhibition 'Appointment' at the Freud Museum, London
1999

In Freud's study, Calle placed her wedding dress on the celebrated psychoanalytical couch as if it were the ghost of some former patient. From her 'personal museum' she chose examples of her own keepsakes, intermingling them with Freud's furniture, personal belongings and collection. Each 'installation' was accompanied by a text which narrated a very significant memory from her childhood or love life. This work had also been presented in a slightly different form at both the Boymans-Van Beuningen Museum, Rotterdam (1994), and the Tel-Aviv Museum, Israel (1996).

"Mining the Museum" because it could mean mining as in a gold mine – digging up something rich with meaning – or mining as in land mine – exploding myths and perceptions – or it could mean making it mine.'4 Wilson's groundbreaking exhibition was a collaborative project between the host museum and the museum for contemporary art in Baltimore, and it occupied the entire third floor, extending through a linked sequence of eight rooms. The hidden histories of African-Americans are also alluded to in Renée Green's installation, *Bequest* (1991–92), at the Worcester Art Museum, Worcester, Massachusetts. This was a site-specific work created within the museum's permanent collection as part

of its 'Insights' exhibition programme. Green's work frequently challenges aspects of ethnic identities within cultural conventions, and *Bequest* was an examination of how the Worcester Museum's sense of heritage had been formed: 'My idea is to make some reference to existing objects in the museum. I'm considering how museums establish a national identity through acquisitions.'5

Artist's interventions do not necessarily involve changing permanent museum displays, and in practice existing gallery arrangements may well become an important feature of an installation. At the British Museum in 1994, Andy

Goldsworthy incorporated the ancient sculpture on display and the imposing architecture into *Sandwork.* He was one of twelve artists invited to create a response to the Museum's Egyptian collection for the exhibition 'Time Machine', in which contemporary works in various media – painting, sculpture and video – were intermingled with the historical artifacts. The modern works needed to be carefully and sensitively sited to avoid giving offence to the British Museum's regular visitors and, since the installation was staged in a principal gallery which also served as a through route leading to other departmental collections, it could be seen by potentially millions of visitors.[6] Contemporary art interventions can be equally effective when seen in the more homely interiors of former private houses. Such sites and collections frequently reflect the character of the former occupants and can offer a more intimate context for a dialogue between them and a living artist. The Freud Museum in London has provided an evocative venue for contemporary artists to create site-specific installations in response to the aura surrounding one of the major thinkers of the twentieth century. These projects inevitably involve curatorial criteria in terms of matching appropriate artists with the inherent qualities of a particular museum site.

There are also occasions when artists have decided to make their own unauthorized interventions, either in response to the museum's autonomy or as a result of having had their proposals or work rejected. One of the most brazen examples of an artist's use of 'guerrilla tactics' was

Jeffrey Vallance's unofficial exhibition of paintings on electric wall-sockets at the Los Angeles County Museum of Art in 1998. Artists have also used the galleries of major public museums to stage unofficial, *ad hoc* performances in which the collection itself or other property of an institution are incorporated in some way into their actions. In 1976, Dove Bradshaw affixed her own label to a glass-encased fire-hose

DOVE BRADSHAW
PERFORMANCE
Postcard edition of 1,000
1978

This work evolved from a label Bradshaw had composed and placed secretly next to a fire-hose in a principal gallery of the Metropolitan Museum of Art, New York, in 1976. Having photographed the 'exhibit', she went on to produce her own postcard, copies of which she placed unofficially in the Museum shop. These sold well, and eventually the Museum acquired Bradshaw's original photograph, which was reproduced as the authorized version of the postcard.

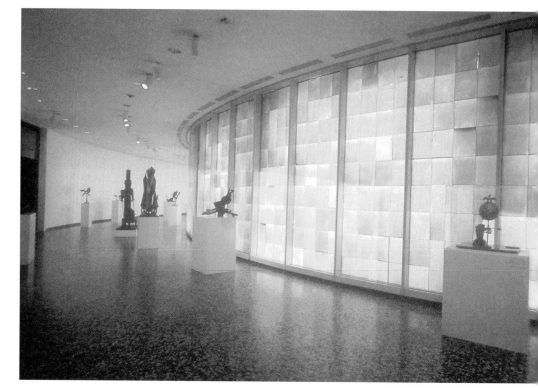

⚘ ANN HAMILTON / KATHRYN CLARK ⚘

VIEW

Installation at the Hirshhorn Museum and Sculpture garden, Washington, D.C.

1991

The installation involved placing translucent wax panels inscribed with the names of extinct animals and plants over the gallery windows. It used the visual interplay between the inside and outside of the museum building to express the irony of mankind's urge to collect and preserve inert natural specimens within an institution while at the same time participating in the destruction of the living world beyond its walls.

in the Grand Gallery of the Metropolitan Museum of Art, New York. Her label identified the materials of the object, 'brass, paint, canvas', and herself as the artist. Although this was removed shortly afterwards, she persisted in replacing it and also took a photograph of the fire-hose from which she produced a postcard edition. Bradshaw then went on to stock the postcard racks at the museum shop surreptitiously, and as a result her unofficial cards sold very well. As an ironic twist to this remarkable story, the Museum eventually acquired her original photograph from a collector and had it reproduced as the subject of its own 'official' postcard.

Andrea Fraser's authorized performance at the Philadelphia Museum of Art, *Museum Highlights: A Gallery Talk*, involved her masquerading as an official guide who offered tours of the museum. This was a work which infiltrated the museum's public services and incorporated both its site and its audience.[7] Artists have also created their own tours of museum collections using the medium of the audio guide as a more intimate form of private engagement with the visitor. This might involve the artist's own interpretations of specific objects which serve to stimulate the visitor's imagination within the museum space. Rather than seek to interpret objects on display in the manner of conventional museum audio guides, Janet Cardiff has created a number of 'audio walks' for museums which can totally change the visitor's mental perception of the gallery surroundings by mixing words, music and sound effects in a fantasy tour.[8]

For their collaborative installation called *View* at the Hirshhorn Museum, Washington (1991), the conscious merging the museum's architecture into their installation was central to Ann Hamilton and Kathryn Clark's working strategy: 'The challenge of the Hirshhorn "Works" project was to place work in or with a site that didn't isolate it but let it interact with the museum. Outside or tangential to our discussions about the site was a desire to create something that was emotional, as a contrast to our perception of the coldness of the building.'[9]

The Hirshhorn's circular form (suggestive of containment) and its close proximity to the Smithsonian Institution inspired the artists to examine the museum principle of collection and classification in the pursuit of knowledge. Taking advantage of the vast expanse of gallery windows, they covered the glass with several hundred translucent wax panels,

each embossed with the name of an extinct species of animal or plant. This had the effect of bathing the interior of the sculpture gallery with amber light. In their joint statement Ann Hamilton and Kathryn Clark wrote: 'Those aspects of culture that are designed as valuable for collection are often at odds with what is actually valuable in daily life ... If collecting is about the removal of objects to a hermetic context, then art that exists in the seams can introduce and remind us of all that cannot be preserved.'[10]

Site-specific intervention in art museums can also be used to alter the context and framing by using constructions and deconstructions of existing exhibition spaces. This process was adopted by Michael Asher in two separate projects that he created for Chicago museums in 1979.[11] At the Museum of Contemporary

Art, he made an installation that consisted of eighteen aluminium plates which he had removed from the cladding of the museum façade. He had them hung like paintings on an interior gallery wall that was visible from the street through the glazed frontage. Although ironically made out of elements of the fabric of the Museum building, Asher's installation was acquired to become part of the permanent collection. Using terms like 'situational aesthetics', Asher has described his work as '... the subtraction of materials from the site of both production and reception ...'.[12] Artists have also made site-specific works that both interact with and incorporate the museum both as an architectural and institutional entity. In *Une Enveloppe Peut en Cacher une Autre* (One Container May Hide Another) at the Musée Rath, Geneva (1989), Daniel Buren covered part of the façade and sides of the

DANIEL BUREN
UNE ENVELOPPE PEUT EN CACHER UNE AUTRE
Work *in situ*, at the Musée Rath, Geneva
1989

This project – literally, 'One Container May Hide Another' – which was conceived for the Centre d'Art Contemporain, Geneva, involved partially encasing a typical neoclassical museum building with Buren's own artwork. In disrupting the usual view of the façade and creating a new entrance, he was effectively appropriating the institution as part of his work, so challenging its traditional role in the containment and framing of art.

building with his characteristic striped 'paintings'. He was thus reversing the traditional situation of the edifice acting as the container for the artwork, so challenging and extending the physical confines of the institutional framework. Buren's installation functioned simultaneously as the shell and core, and – perhaps most significantly – contested the notion of the museum as the final resting place of the art object.

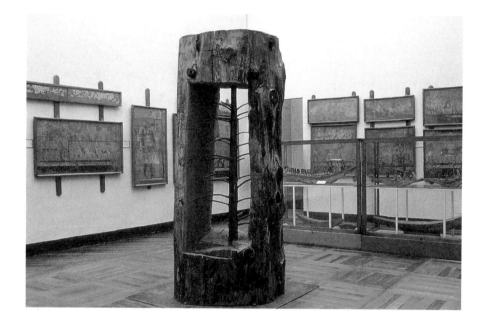

↩ **GIUSEPPE PENONE**
TREE DOOR

Installation view, from the exhibition 'Time machine: Antico Egitto e Arte Contemporanea'
Museo Egizio, Turin
1995–96

Penone's sculpture was carved from a colossal cedar tree-trunk, the same wood as had been used in antiquity for the coffins and other artifacts displayed in the upper gallery. His work involved carving out or 'resurrecting' a new tree from the dead trunk, a concept which had an appropriate link with the ancient Egyptian idea of rebirth. Penone was one of fourteen artists invited to instal work inspired by ancient Egypt amongst the museum's permanent display.

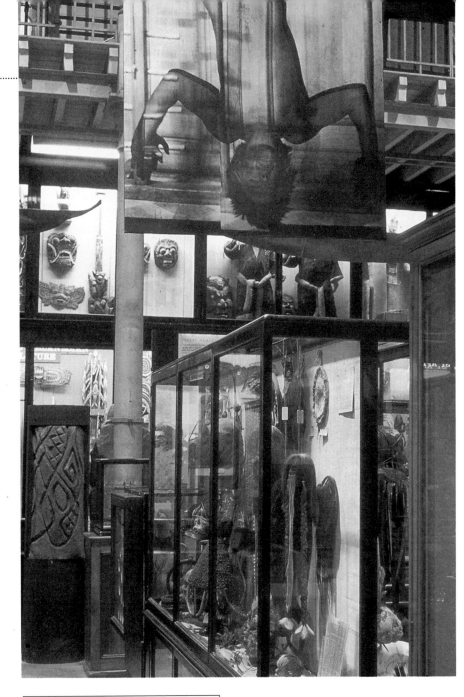

⚘ SARAH LUCAS
THE PLEASURE PRINCIPLE

Installation at the exhibition 'Beyond the Pleasure
Principle' at the Freud Museum, London
2000

Inspired by one of Sigmund Freud's writings of the
same title, Lucas made site-specific installations in
Freud's study, dining room and bedroom. Using
light-bulbs, a fluorescent strip and underwear
stretched over chairs, she created a highly sugges-
tive scene in which a couple may be imagined
under the 'gaze' of Freud, a photograph of whom
hangs on the wall.

⚘ TOM OTTERNESS
THE TABLES

Installation at Senckenberg Museum,
Frankfurt am Main
Detail
1992

This installation at the natural history museum was
part of an outreach project organized by Kasper
König as in his capacity as director of the Portikus
Museum of contemporary art, Frankfurt. The work
consisted of three large tables which were sited in
the midst of a display of dinosaur skeletons. Based
on wooden picnic tables, they presented an
arrangement of over a hundred small bronze sculp-
tures influenced by Greek, Roman, Christian, Indian
and Aztec elements. Otterness first began this
grandiose work in 1985 and it has been installed in
different venues including MoMA, New York.

⚘ DIVERS MEMORIES

Installation view. From an exhibition with the same
title at the Pitt Rivers Museum, Oxford
1994

Between 1987 and 1994 Chris Dorsett organized a
series of five exhibitions at the Pitt Rivers Museum,
collectively called 'Divers Memories'. They featured
works (by artists, photographers, film makers,
poets, actors and musicians) which had no accom-
panying labels because they were intended to be
'submerged' within the existing museum
display. The large photograph of the artist Roger
Andersson hanging upside down was suspended
from an outrigger canoe. Dorsett's project has also
been sited at other venues as far afield as Hong
Kong (Museum of Site, Yeuen Long, New Territo-
ries); at the Pielisen Museum, Lieksa, Finland, it had
as many as 125 participants.

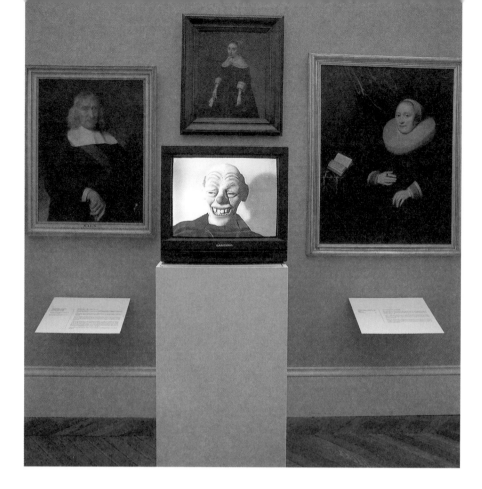

IGOR KOPYSTIANSKY ⚲
ANTE REM, IN RE, POST REM

Installation at the Bodemuseum, Berlin
1992

After creating his own pastiches of historical paint-
ings, Kopystianski then deliberately damaged them
using a domestic washer/dryer. Spread out like
a carpet, his neglected and crumpled canvases
formed a stark contrast to the Museum's formal
display of historical paintings. This was part of a
series of interventions with the same title that Igor
and Svetlana Kopystiansky made for their exhibi-
tion 'Dialoge im Bodemuseum'.

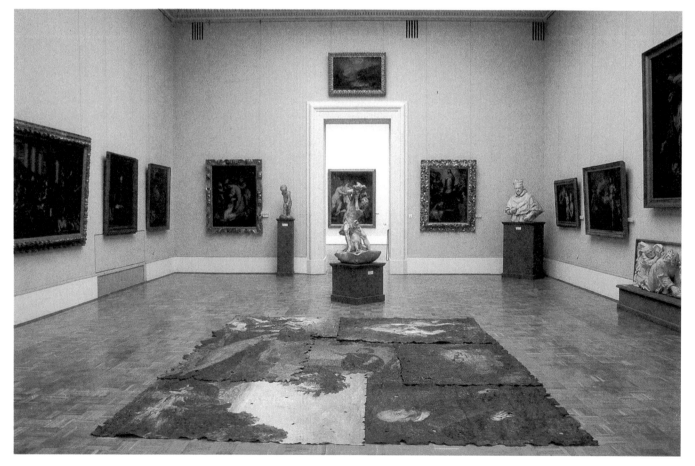

⊕ GILLIAN WEARING
CONFESS ALL ON VIDEO
DON'T WORRY YOU WILL BE IN
DISGUISE. INTRIGUED? CALL
GILLIAN ...

Video installation (1994), from the exhibition
'Private View' at the Bowes Museum, Barnard
Castle, County Durham
1996

An existing work by Wearing was installed specially
for a group exhibition in this museum housed in
a former stately home. Organized by the Henry
Moore Institute, Leeds, the show included over a
hundred contemporary works by thirty-five British
and German artists. Wearing's video featured a
broad cross-section of people, heavily disguised
in a variety of wigs and masks, confessing their
innermost secrets. Screened on a monitor, it was
juxtaposed with a group of the museum's portraits
featuring idealized, inscrutable expressions which
contrasted well with Wearing's masked contempo-
rary subjects.

KEN APTEKAR ⊕
FROM DARNELL HESTER

1997

From the exhibition 'Talking to the Pictures' at the
Corcoran Gallery of Art, Washington, D.C.
1997–98

Aptekar made his own painted copies of details
from some less well-known works in the Corcoran's
permanent collection. Each was covered with
a sheet of glass bearing a sandblasted text that
recorded an individual viewer's response to
the original painting which was exhibited next
to Aptekar's copy. His version of the School-of-
Rembrandt portrait, *An Elderly Man in an Armchair*,
c. 1630, is overlaid with a quotation from a
museum guard. In some cases he also used his
own words which related to specific childhood
memories or family history. These more personal
reflections contrasted with the museum's charac-
teristically impartial art-historical interpretations.

⊕ CLAUDIO PARMIGGIANI
SYNECDOCHE

1976

Installation at the Kunsthistorisches Museum, Vienna
1986

Juxtaposed with by an allegorical work by the 16th-
century painter Dosso Dossi, Parmiggiani created
his own work in progress. Displayed in context next
to the original painting hanging in the museum
gallery, his installation takes the unfinished work
out of its historical frame, placing it in the real time
space of the viewer.

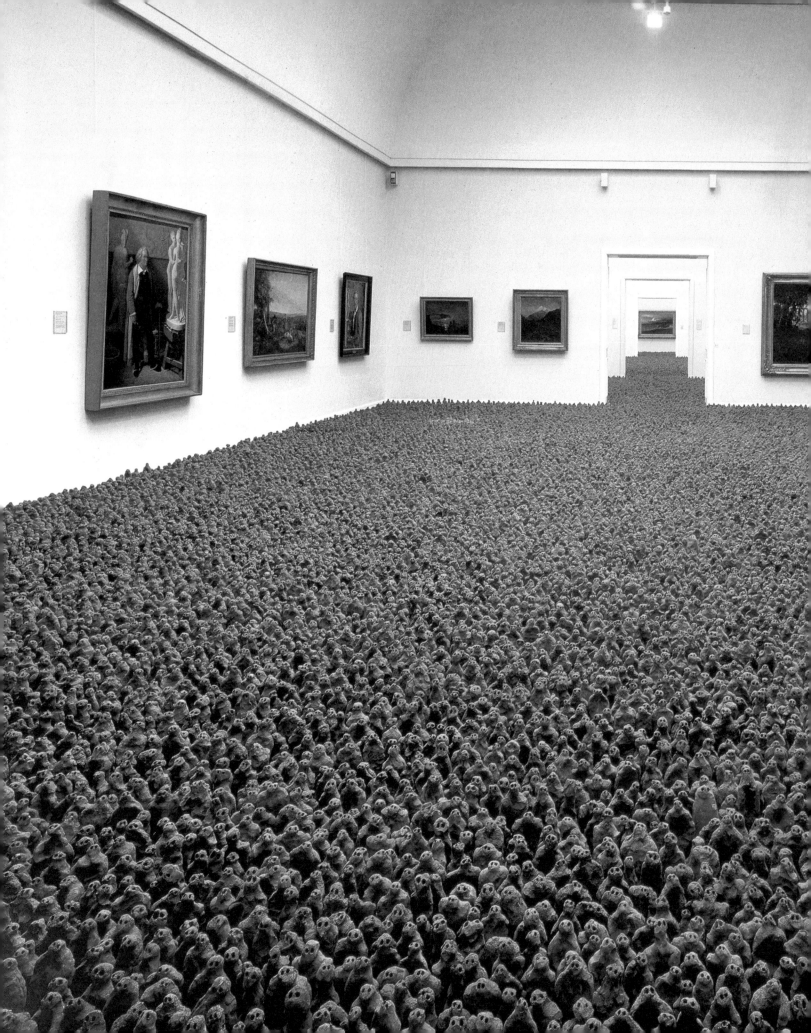

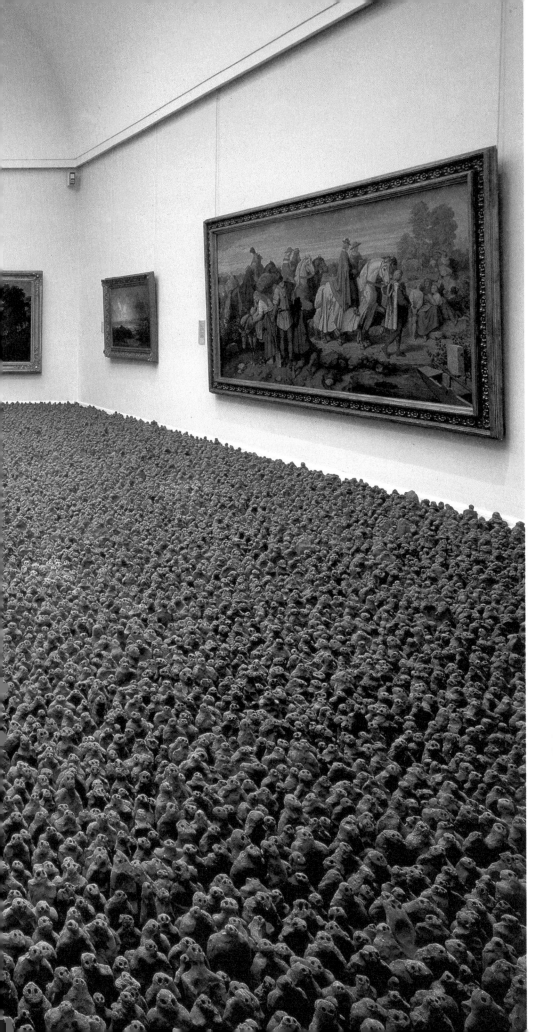

ANTONY GORMLEY
EUROPEAN FIELD

1993

Installation at the Kunsthalle zu Kiel der Christian-Albrechts Universität, Kiel, Germany

1997

Gormley's installation in a gallery devoted to the museum's historical collection of paintings consisted of 40,000 terracotta figures produced by children, their parents and grandparents. He also created a parallel work, *Host*, in the contemporary wing of the Kunsthalle; this involved flooding the three galleries with 43m³ of mud and 15,000 litres of sea water to the same height as the terracotta figures in *Field*.

FRED WILSON ⟳
MINING THE MUSEUM

Installation view at the Maryland Historical Society,
Baltimore
1992

In an existing museum display showing 'Modes of
Transport 1770–1910', Wilson placed a Ku Klux
Klan hood (taken from the reserve collection) in a
perambulator. This suggested a potentially disturb-
ing association between the white baby it once
carried and a black servant who may have pushed
it. This idea was reinforced by displaying a photo-
graph showing two black nannies with a similar
baby carriage.

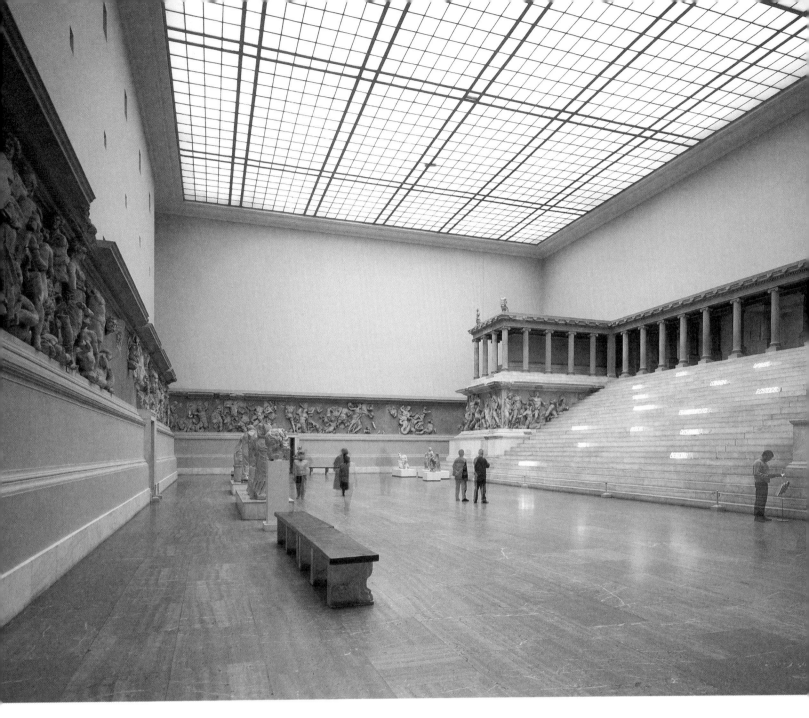

ALFREDO JAAR 🌿
**THE AESTHETICS OF
RESISTANCE**
Installation at the Pergamon Museum, Berlin
1992

In this work, the title of which paid homage to a
book by Peter Weiss, Jaar positioned neon-tubes
bearing the names of selected German cities where
attacks on immigrant 'aliens' had recently been
reported. The installation gained significance in
the ambience of the classical architecture, with its
notion of the high culture. Above the figures from
the altar's frieze, he arranged three rows of black-
and-white photo close-ups showing studies of
'skinhead' haircuts and boots which were inter-
woven with the reliefs of battle scenes.

RENÉE GREEN
BEQUEST

Installation view at the Worcester Art Museum,
Worcester, Massachusetts
1991–92

The title refers to a legacy from the Salisbury family.
Green installed portraits of male members from
three generations accompanied by personal
memorabilia and clapboard panelling intended to
refer to the typical New England architectural style.
Each slat was inscribed with sentences from works
by Edgar Allan Poe, Herman Melville, Nathaniel
Hawthorne, and W.E.B. DuBois. These were
intended as reflections on designations of white-
ness and blackness in American literature or Puritan
ideology and their traditional associations with
good and evil. The texts were chosen because they
had contributed to the American myth, while also
revealing the parallel and obscured histories of
African Americans.

B
b

A
a

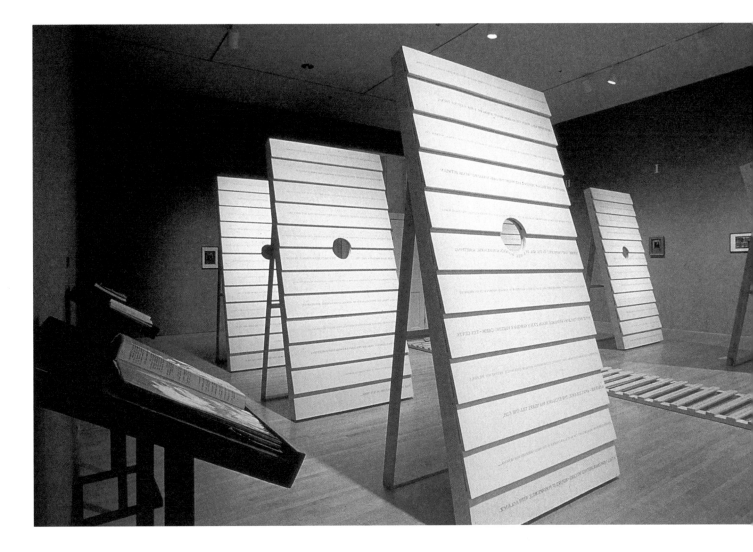

SIGLINDE KALLNBACH
PERFORMANCE AT THE
FRAUEN MUSEUM, BONN
6 December 1991

The work included an installation using seven large-format photographs, edited sequences of several Kallnbach performances shown on a TV monitor, together with a wall painting where she had used her own body to apply the paint. In the museum's upper galleries her work was integrated with art of the National Socialist era and her performance, for which she covered her body with tar, was intended to make a striking contrast with the idealized depiction of women by male artists. The title of the upstairs installation was 'Rollenbilder im Nationalsozialismus – Umgang mit dem Erbe' ('Role images in National Socialism – association with the heritage'). During the National Socialist era, such work would certainly have been regarded as 'degenerate'.

DOVE BRADSHAW
DO NOT TOUCH
Installed at the Museum of Modern Art, New York
1979

Bradshaw replicated an official 'Do Not Touch' sign from MoMA, New York, and also produced a museum label describing it. She then fixed it to the wall in one of the galleries; the label was subsequently removed by the security guards. This action was part of a performance work which resulted in Bradshaw claiming various museum 'non-art' objects as her own works.

ROBERT FILLIOU
POUSSIÈRE DE POUSSIÈRE
NO. 34/100
1977

In 1977, Filliou made a series of playful, unauthorized performances at major public museums in Paris, including the Louvre. Donning a white overall and taking a soft cloth, he dusted various oil paintings (in this example Max Ernst's *La plus belle*). Each cloth with a painting's 'precious' dust adhering to it was then placed in a cardboard archive box with a snapshot recording his action.

The Eternal Network presents:
ROBERT FILLIOU
POUSSIERE DE POUSSIERE
(à l'effet MAX ERNST (cha plus belle)

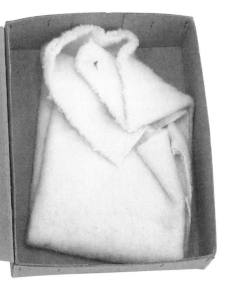

ANN EGGEBERT / JULIAN WALKER
MR & MRS WALKER HAVE MOVED

Performance, photography and video
Kettle's Yard, Cambridge
16–20 June 1998

For this work the artists, Anne Eggebert and Julian Walker, stayed at the museum for four days (one day overnight) with their two-year-old son. It was developed partly as a response to the founder's idea that 'art is better approached in the intimate surroundings of a home'. The couple tried to avoid the usual separation between art and life, and their activities were recorded as a continuous 'CCTV sur-veillance image'. The museum, with its fragile exhibits and security alarms, proved to be very difficult and uncomfortable as a domestic space, particularly with a young child.

HENRIK HÅKANSSON
10 SECONDS OF FOREVER (TODAY)

Installation view at the Natural History Museum, London
2000

This project was linked to a group exhibition at the Serpentine Gallery, London, called 'The Green House Effect', which was intended to stimulate the viewer's perception in distinguishing what is natural from what is artificial. With this in mind, Håkansson used a CCTV camera to convey a real-time surveillance of the Natural History Museum's Wildlife Garden, which was projected on a large screen. The comparative ordinariness of this real, 'living' British wildlife made an effective contrast with the exotic and theatrical museum dioramas featuring 'dead' specimens in artificial landscapes.

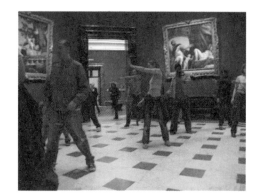
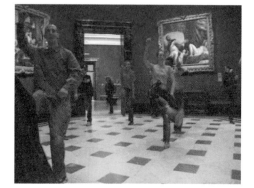
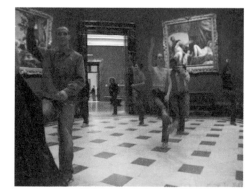

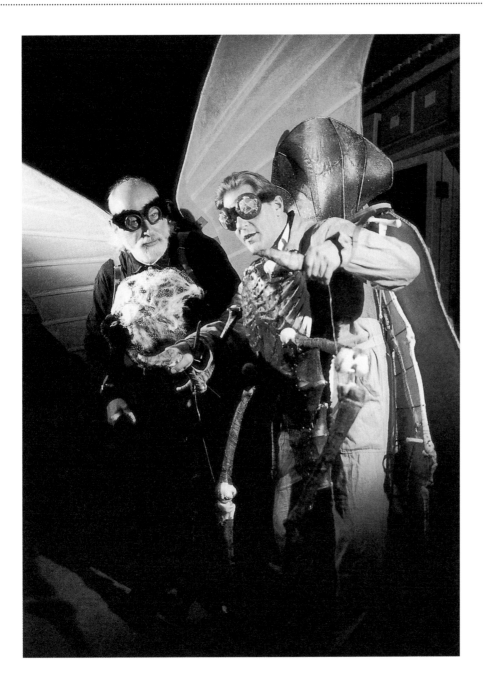

⊕ **JAN FABRE**
A CONSILIENCE

Video installation at the Natural History Museum,
London

2000

Screened in a central public area, this video record-
ing captured a dialogue between Fabre and the
museum's entomologists dressed in costumes of his
own creation. Fabre, who took the role of ambas-
sador of the beetle world, is seen in this still in
conversation with the Head of Entomology, Dick
Vane-Wright, who acts the part of a butterfly. This
project, organized jointly by the museum's arts
programme and the Arts Catalyst, had evolved
from an earlier collaboration between Fabre and
Ilya Kabakov.

**TWENTEENTH
CENTURY** ⚵
SYSTEM ADDICT

Dance performance at the National Gallery,
London

14 June 2000

This collective of twelve young artists formed
a temporary dance troupe specifically to make
a series of unauthorized performances in the
National Gallery, London. Besides carefully
practising their dance routine in advance, they
also worked out an effective strategy for dealing
with the security guards. Each time their perfor-
mance was cut short they would simply disperse
and merge with other visitors, only to regroup for a
fresh performance in another gallery. Their dance
routine, which lasted around a minute and a half,
aimed to introduce an element of mischievous
humour into normally restrained surroundings.

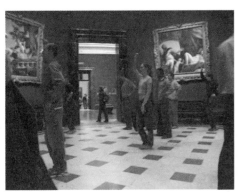
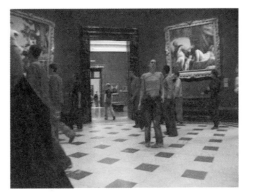
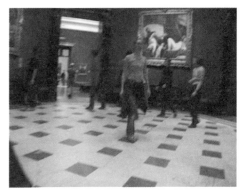

JOHANNES WOHNSEIFER

with

MARK GONZALES
BACKWORLDS/FORWARDS

Skate performance by Mark Gonzales;
ramp sculptures by Johannes Wohnseifer

Städtisches Museum Abteiberg,
Mönchengladbach

December 1998

Wohnseifer invited the skateboarder Mark Gonzales to make a display of his skill by skating through the museum's permanent collection. Although the artist produced some special sculptures for Gonzales to use as ramps, his performance was particularly intended to provide an interaction with the building itself, which is characterized by many different levels and stairs. Despite Gonzales' proficient skating, his activity was dangerous and shocking in the context of the more contemplative space of an art museum.

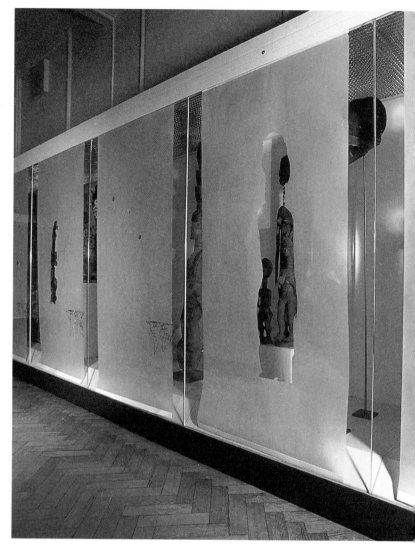

ANNE BRENNAN
IS IT REAL?

Sound work in the form of an audio guide to the
Australian War Memorial Museum, Canberra
1997

The title referred to what Brennan considered to
be a question commonly asked by the museum's
young visitors. Her audio guide to the First World
War galleries was concerned with alternative
ways of interpreting the objects. She constructed
a sound collage of excerpts from diaries, the voices
of a child visitor and various curators, to which she
added a personal speculative monologue. This
work was part of a Canberra Contemporary Art
Space project called 'Archives and the Everyday',
which brought together artists and collecting insti-
tutions in the area.

SONIA BOYCE
PEEP

Installation view, The Green Centre for
Non-Western Art and Culture, Brighton Museum
and Art Gallery, Sussex
1995

Boyce carefully traced the contours of shadows cast
by the ethnographic objects in the museum vitrines
and cut out the resulting shapes. She then covered
the inside of the glass with the opaque paper
shapes, partially obscuring the artifacts on display.
Thus, in order to see the objects properly, the
museum visitor was forced to move up close to the
glass and peer between these strangely shaped
silhouettes. This rather self-conscious and voyeuris-
tic action drew attention to the act of looking and
also alluded to less apparent, concealed histories of
the museum objects.

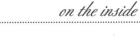

NEIL CUMMINGS / MARYSIA LEWANDOWSKA
ERRATA

From the exhibition 'Now, Here' at Louisiana Museum of Modern Art, Humlebaek, Denmark
1996

The booklet *Errata* was designed to be slipped inside the official guide to the permanent collection. Its content embraced all kinds of non-art objects which the visitor might encounter in a museum, and which would not feature in an official catalogue, for example signs, souvenirs, postcards, furniture and café crockery.

← TERRY SMITH
PERHAPS

Audio work, installation view from the exhibition 'Intervenciones en el espacio' at the Museo de Bellas Artes, Caracas, Venezuela
1995

Smith selected a portrait from the museum's collection to make an audio work which ran for fifteen minutes. This was a narrated sequence of different imaginary life stories of the sitter depicted in the portrait based on her facial expression and costume. His installation consisted of the original painting accompanied by personal stereos available for visitors to listen to his taped commentary like an official museum guide.

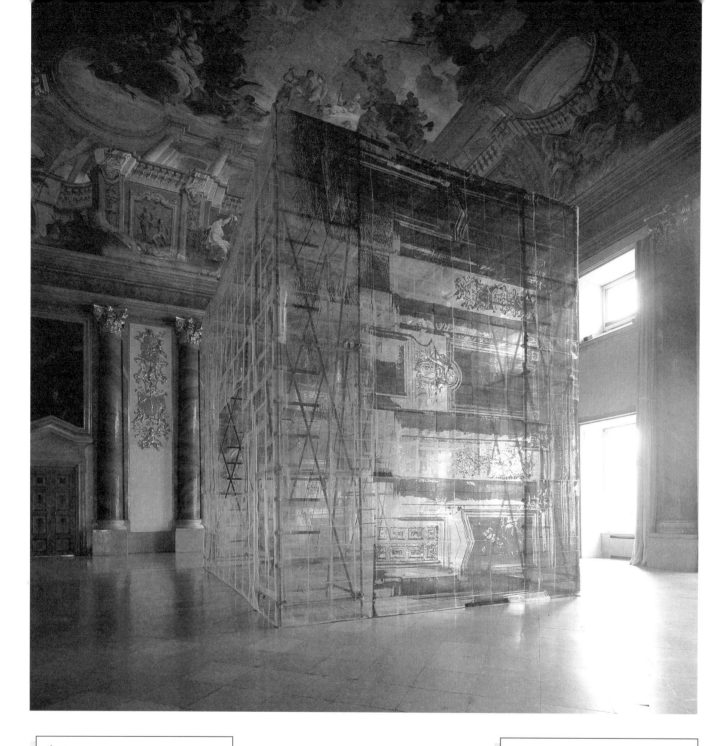

⚘ THOM BARTH
CUBE 3-87 COPY MARBLE ROOM

Installation at the Museum of Modern Art,
Palais Liechtenstein, Vienna
1987

In the Baroque music room of this former princely
palace, Barth installed a massive cube made from
hundreds of transparent sheets on which he had
applied images of the room. Each sheet revealed
only a vague and colourless version of the marble-
lined room with its frecoes and oil paintings by
Andrea Pozzo. Barth turned the cube through 90°
so that the ceiling painting was illuminated by light
passing through the front windows.

FRANZ WEST ⊕
COUCHES

Installation at the Kunsthistorisches Museum,
Vienna
1989–90

In a solo exhibition held at a museum which does
not normally show work by living artists, West dis-
tributed his metal sculptures throughout the
galleries, placing them next to the conventional
seating provided for visitors to contemplate the his-
toric paintings; visitors were invited to sit or recline
on his metal sculptures and thus, when relaxing in
this way, became an integral part of the work.

⟳ MARIE-JO LAFONTAINE

'WIR HABEN DIE KUNST DAMIT WIR NICHT AN DER WAHRHEIT ZUGRUNDE GEHEN'

Installation at the Glyptothek, Munich
1991

In the recessed sections of the neoclassical Glyptothek's dome, Lafontaine inset panels with photographic images of flames. By incorporating the inscription into the work, and appropriating its profound message as the title (a quotation from Friedrich Nietzsche meaning literally, 'We have art so that we are not destroyed by truth'), she was also able to heighten the installation's overall sense of drama thanks to the juxtaposition of the idea of 'destruction' with the flame images.

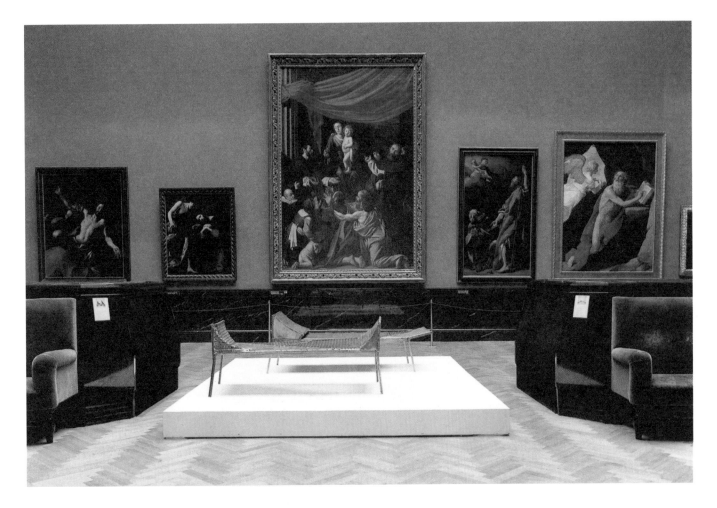

KAZUSHI KUSAKABE ⌖
210

Installation view of gallery 210
From the exhibition 'Future Recollections'
Kyoto Municipal Museum of Art, Kyoto
1997

Gallery 210 had recently been refurbished, but
Kusakabe reused its previous hessian wall-covering
as a means of rediscovering the former hanging
positions of works exhibited there, and then affixed
tiny labels to point out every mark and scratch on
the wall, the door frame and skirting boards.

⌖ TERRY SMITH
CAPITAL

Installation view
The British Museum, London
1995

Smith was invited to create a site-specific work in
one of the museum's major galleries which was
undergoing refurbishment, in the course of which
a vast expanse of wall would be replastered; this
prospect offered him the opportunity to create
an ephemeral relief drawing occupying the entire
length of the gallery. This task involved chipping
away the existing plaster surface with a chisel to
reveal the brickwork beneath, and Smith chose to
depict the Museum's principal architectural motif,
the Ionic capital. He also drew inspiration from
the fact that Karl Marx had written *Das Kapital*
(published in 1867) in the famous circular reading
room at the British Museum.

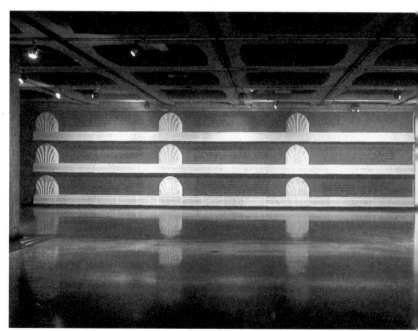

↵ GONZALO DIAZ
EL ESTADO DE DERECHO

From the exhibition 'Intervenciones en el Espacio'
at the Museo de Bellas Artes, Caracas, Venezuela
1995

Diaz reproduced the bas-relief palmettes from the
cornice on the museum façade and displayed them
in the exhibition gallery, arranging the mouldings
so as to incorporate texts from the 19th-century
constitution of Chile. By creating a contemporary
work around an architectural motif, he was indi-
rectly referring to the institution, both the past and
present. This work was part of a group exhibition
which included a number of architectural interven-
tions by internationally known artists intended to
examine the nature of the institution.

⚲ SHIRO MATSUI
THE WAY TO THE ARTWORK IS
THROUGH THE STOMACH

Installation view, from the exhibition 'Future
Recollections'
Kyoto Municipal Museum of Art, Kyoto
1997

As part of an exhibition which set out to examine
both the history and function of this art museum
(one of the oldest in Japan) as a critical space.
Matsui's work was made from painted canvas,
integrated into the building's entrance and interior
galleries. Matsui also participated in another group
exhibition, 'Reading the Art Museum; Hyoheikan
and Art of Today' (2001) at the Tokyo National
Museum (organized by the National Museum of
Modern Art, Tokyo); this examined the very exis-
tence of the museum as a container for artworks.

EPILOGUE

without walls

Speaking about the display and collection of contemporary art within a museum context, the art historian Sir Ernst Gombrich takes a sceptical view concerning the very existence of modern art museums, 'I think that a museum of modern art is a contradiction in terms. Museums used to exist to preserve the treasures of the past and to save them.'[1] As much as museums might try to convey some of the sense of immediacy of the art they display, they are limited by their adherence to the nineteenth-century model from which they evolved. By exhibiting works of art museums validate them as being worthy of preservation, conferring on them an 'official' seal of quality and authenticity. This practice of institutional validation naturally affects artists, who in turn drive and sustain the museum acquisition system which can lead to their works being preserved for posterity in the context and company of acknowledged masterpieces. The proliferation of new museums has led to an acceleration in the cycle from the completion of a work by an artist to its public display or acquisition. Museums continue to expand in order to display their growing collections of contemporary art, but face the long-term consequences of acquiring works that are potentially

problematic in terms of their scale or medium. It is important, however, to distinguish between those museums which also house historic collections and the newer ones such as *Kunsthallen* whose function is to serve as temporary exhibition spaces. In the case of established museums of modern art, a sense of power is conveyed through the fame of their holdings, whereas new museums often proclaim their status through their architecture.

There has been a growing tendency to view certain museum buildings as works of art in their own right which are as significant as the art they are intended to house. This idea has a worthy precedent in Frank Lloyd Wright's distinctive design for the Solomon R. Guggenheim Museum, New York (built 1956–59). Thomas Krens, who became its director in 1988, initiated a concept for a series of museums to be designed by world-famous architects which followed on from Peggy Guggenheim's original vision of a global network of museums controlled by the New York foundation. This idea, criticized by some as a form of cultural imperialism, has led in recent years to the construction of the Guggenheim Museum in Bilbao, Spain, opened in 1997. The extravagant forms

of Frank O. Gehry's design relate to his unusual choice of titanium for the cladding material, and his use of a computer software program intended for the aerospace industry. This approach enabled him to combine structural analysis with a fluid design to produce architecture as a sculptural form. Since the 1960s Gehry has used his designs for art installations as a means of experimenting with ideas that he later applied to architecture. His friendship and collaboration with many international artists have also influenced his museum designs, and he has acknowledged the significance that his conversations with them have had: 'They made me realize that the stature of a building in the community could make it equally as important as other buildings, therefore it should not be a neutral box.'[2] The inaugural exhibition of the new museum in Bilbao, 'The Guggenheim and the Art of This Century', included three contemporary sculptures of colossal dimensions by Robert Morris, Claes Oldenburg and Richard Serra respectively. Thus the dynamics and scale of some new museum architecture can offer a powerful catalyst for artists to produce impressive responses to site-specific commissions.

JEFFREY SHAW
THE VIRTUAL MUSEUM
1991

Installation at Ars Electronica, Brucknerhaus,
Linz, Austria, in 1992

The viewer interactively controls the journey
through Shaw's *Virtual Museum*, which consists of
five rooms, each having the same appearance as
the real room in which the installation is located.
Each virtual room contains its own specific exhibits
composed of alphabetic and textual forms. A
motorized rotating platform enables the chair to
move in conjunction with the video monitor, thus
establishing a link between the real and the virtual.

In proposing different kinds of spaces
for the exhibition of art, some artists have
created their own architectural models.
In 1992 and 1997, Frank Stella produced
a number of distinctive models for
museums in support of real proposals,
none of which have so far been realized.[3]
Alternatively, artists may be inspired to
create models of fictional, utopian
museums, such as Katharina Fritsch's
Museum Model 1:10, presented at the
1995 Venice Biennale. This work, with its
sense of absolute uniformity which extends
to the surrounding trees, is as much a
sculpture as an architectural model.

According to Fritsch, 'There is no
"neutral" arrangement of space (I think
it is an illusion anyway); there is only a
sculptural concept of a building. I want
to make a stand that is beyond "design",
which is the greatest weakness of most
museums. I think that a subjective, spe-
cific choice of form is easier for an artist
to respond to than a museum in which
more or less disinterested postmodern
quotations of style are lined up with
"sophisticated artistry".'[4]

Dissatisfaction with the way museums
display work has prompted some artists

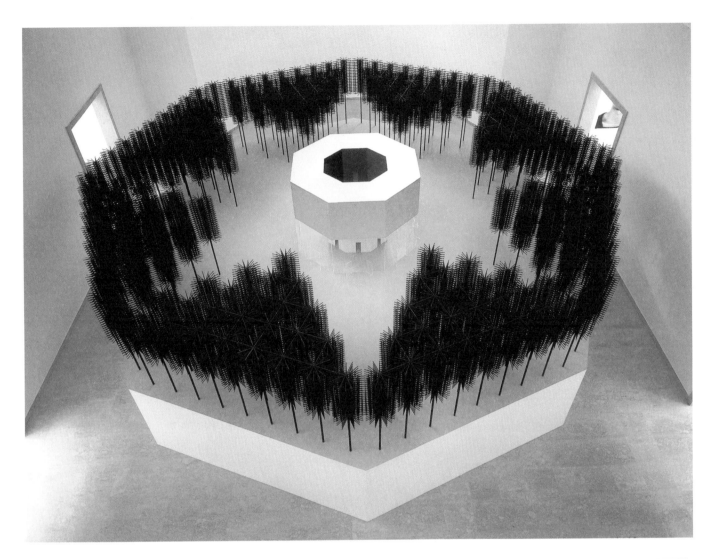

to create their own alternative exhibition spaces. Frustrated by the impermanence of museum exhibitions and the insensitive handling and installation of his work, Donald Judd went on to realize his ideal museum in the small town of Marfa, Texas. He was disturbed by museums' habit of divorcing art from life; it meant 'having culture without culture having any effect', which served 'to make art fake'.[5] Highly critical of museums, Judd resented the fact of a curator having control over the display of an artist's work and maintained that the only way to ensure that his sculpture was exhibited

to his satisfaction was to instal it personally. In 1973, he purchased aircraft hangars, barracks and other former military buildings in Marfa and by the late 1980s he had begun to buy up much of the town, where he established the Chinati Foundation. In addition to showing his own art and collection, he displayed works by other artists such as Dan Flavin, John Chamberlain, Claes Oldenburg and Ilya Kabakov. The overall aesthetic experience of visiting Marfa was aptly described by Kabakov in an interview in 1995: 'When I first went to Marfa, my biggest impression was the unbelievable combination

KATHARINA FRITSCH
MUSEUM MODEL 1:10
Installation at the XLVI Venice Biennale
1995

Rather than being a conventional architectural model, this 'Museum' is conceived as an idealized exhibition space. According to Fritsch, the contemporary art on view should consist of works designed specifically for the museum, with sculpture displayed on the lower level and paintings on the upper floor. There is no permanent collection and the work is intended to remain in place for a maximum of two years. As a sculptural form it embodies the geometric shapes of the octagon in the buildings and a star in the layout of the trees.

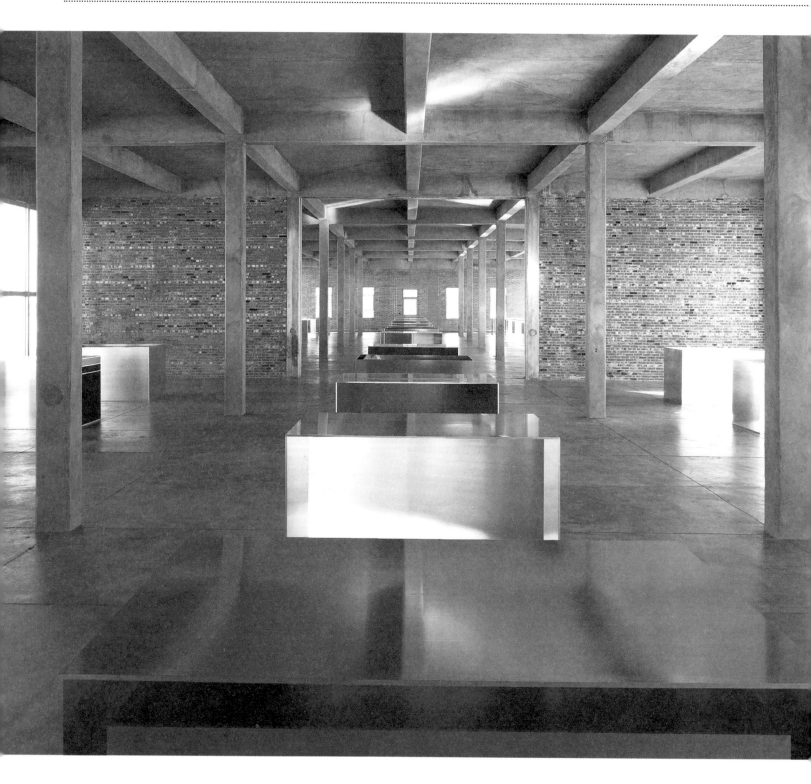

⇦ **DONALD JUDD**
100 UNTITLED WORKS IN MILL
ALUMINUM
Detail of a permanent installation at the Chinati
Foundation, Marfa, Texas
1982–86

Judd's dissatisfaction with museum displays of his
work led him to create his own exhibition space for
his finely crafted aluminium sculptures, which are
particularly sensitive to placement, light and
handling. He adapted two former military sheds for
the installation of this work (48 sculptures are in
one shed, 52 in the other). The effect of opening
up the sides of each building with continuous,
square windows from floor to ceiling, is to make
the sculptures equally visible from the outside.

MUSEUM OF JURASSIC
TECHNOLOGY ⇦
THE HORN OF MARY DAVIS
OF SAUGHALL
1989

Founded in Los Angeles by the artist and film-
maker David Wilson, this institution exemplifies
the notion of the museum as an art form in its
own right. It includes a series of evocative,
dimly lit installations with finely crafted vitrines,
dioramas, optical devices and complex slide
projections accompanied by audio narratives.
Wilson's unique form of presentation, involving
a mix of fact with myth and art with science,
creates an aura of wonder in the same way as
early cabinets of curiosity did. This permanent
installation relates to a 17th-century legend about
a woman who grew a horn.

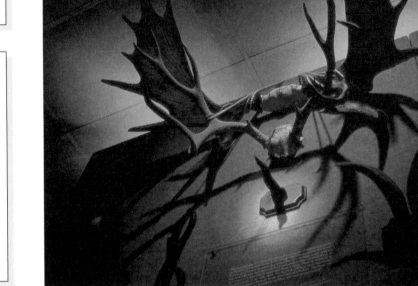

of estrangement, similar to a holy place, and at the same time of attention to the life of the works there. For me it was like some sort of Tibetan monastery; there were not material things at all, none of the hub-bub of our everyday lives. It was a world devoid of all trivial and banal existence – a world for art.'6

Just as the role of the artist has sometimes become assimilated with that of the curator, broader collective definitions of 'art' and 'museum' are becoming increasingly interwoven. Following precedents created by artists like Marcel Broodthaers, a number of artists and art organizations have adopted the term 'museum' to refer to both their practice and activities. The Museum of Jurassic Technology in Los Angeles, created by David Wilson, is a hybrid institution which is simultaneously art and museum. It shares the early museum's possibilities to cross the boundaries between art and science, to stimulate thought, wonder, astonishment and fascination. Its most significant feature is its refusal to be classified, slipping easily between each fixed definition. Wilson himself has noted: 'The way people see it tends to reflect where their area of endeavor comes from. People in the museum world oftentimes will look at our museum as a critique of museums. People from the art world call it a performance art or Art. People from the scientific community will understand it as a critique of science, or some way a critique of scientific principles or scientific theory. And you know, we're happy with that. It's great that people think all of it'.7 Wilson has created a smaller site-specific version of his museum in Germany at the Karl Ernst Osthaus-Museum, Hagen. Since 1988 this institution has under-taken an ongoing project called 'Museum of Museums', in which artists are com-missioned by it to create permanent installations which relate specifically to museological concepts. The project includes Johan van Geluwe's installation entitled *Curator's Gallery* (1991) and the

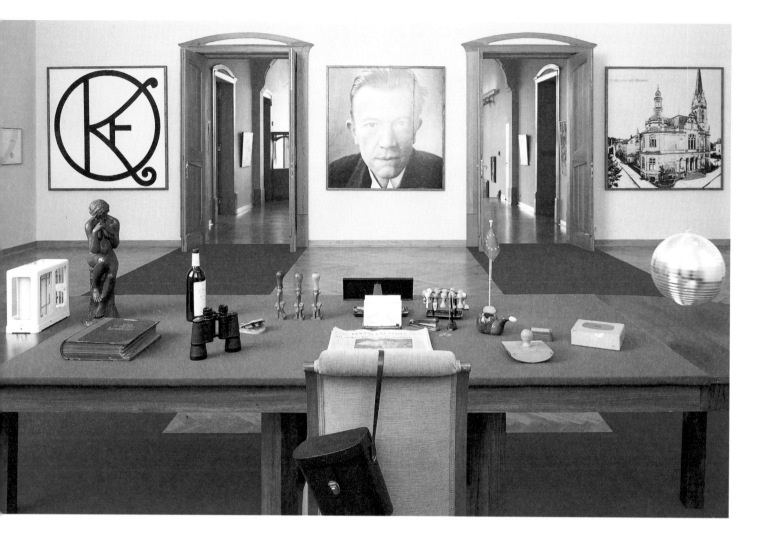

**JOHAN VAN GELUWE
CURATOR'S GALLERY**

Installation at the Karl Ernst Osthaus-Museum,
Hagen, Germany
1991

This work is an ironic commentary on the admin-
istrative role of the museum curator. It is part of a
series of permanent exhibits commissioned from
artists on the theme of museums. The numerous
items on the desk-top suggest the object fetishism
and bourgeois complacency of an outdated type of
curator. On the wall opposite is hung a large
photograph of the museum's founder, which
serves as a constant reminder of its adherence to
a tradition of experimental museology.

museum in Hagen also houses Geluwe's
conceptual work also called *Museum of
Museums*, an ongoing archive that he
has been accumulating since 1975,
consisting mainly of artists' books and
documents which relate to real and
imaginary museums.

Contemporary art has become too broad
a concept to be contained within the walls
of a museum, and there is a growing
interest in creating an alternative to the
static nature of an institution by linking a
wider network of urban sites. A number of
art organizations have deliberately appro-
priated the term 'museum' as a gesture of

defiance against the limitations imposed
by the framing and connoisseurship of
art within traditional institutions. The
Museum in Progress, Vienna, organizes
exhibitions that span a wide range of media
in unconventional sites such as bus-stops,
billboards, newspapers and television.
'It has defined its aims as the conquest
of the media as a vehicle for art (that is
the mass media in their most common
forms which are by far the most dominant
factor in social life today) and the devel-
opment of an adequate concept of the
museum appropriate to the age of mass
communication.'[8]

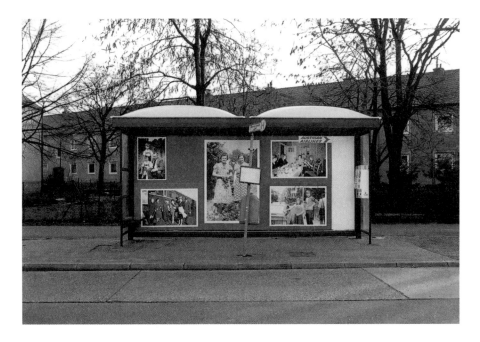

Some museums have also recognized this a need to develop off-site projects and reunite art with the everyday by distributing its collections and exhibitions from one centre to numerous peripheral sites. This practice was pioneered in Belgium as early as 1986 by the Museum van Hedendaagse Kunst, Ghent, with the exhibition '*Chambres d'Amis'* (Guest rooms), in which fifty-eight local families agreed to allow fifty artists to create and exhibit work in their homes. This bid to engage a wider public audience more directly with the work of contemporary artists is also reflected in the Experimental Programs section of The Museum of Contemporary Art, Los Angeles, where the exhibition 'Uncommon Sense' (1997) included a number of unlikely museum events such as a live rodeo, drawing classes with nude models, theatre productions on a local bus, collaborations with the City Fire Department and sanitation workers, and even a link-up with a popular television soap opera.

In 1995, the Museum of Fine Arts, Boston, staged an exhibition called 'The Label Show' for which artists, visitors, critics and other staff members were invited to compose the descriptive labels and wall texts. In the accompanying leaflet, Trevor Fairbrother (then a curator at the museum) wrote: 'The world of contemporary art is a good place to examine the language of museums. This experimental exhibition addresses the complicated and sometimes paradoxical contributions of contemporary art to an encyclopaedic art museum.'[9]

Effective models have emerged from collaborations between artists and curators, providing the opportunity to reflect and rethink what a museum is and how it best functions. This approach often involves artists being invited to reinterpret and rehang existing collections and to assist by acting as consultants and designers in planning museum architectural projects.

One of the most radical examples of this type of project was at the Museum für angewandte Kunst (Museum of Applied Arts) in Vienna where, in 1990, seven artists including Barbara Bloom, Jenny Holzer and Donald Judd were invited to collaborate with the collection curators in both the reinstallation of the permanent collection and the redesign of the gallery spaces. Collaborations between artists and museums displaying historical and non-art collections have frequently resulted from the personal initiative of individuals rather than being part of a premeditated overall museum strategy.

In the early 1990s, special exhibitions and interventions represented the fruits of a dialogue between artists and likeminded museum curators or of outside proposals put forward by practising artists or contemporary art institutions. Such exhibitions have subsequently become part of a wider range of official museum public programmes, with

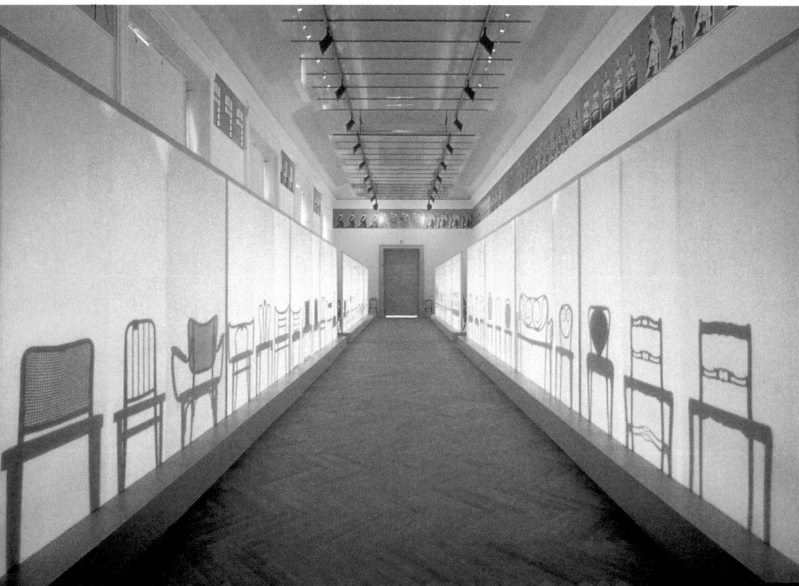

BARBARA BLOOM
HISTORICISM ART NOUVEAU

Collection arranged by Barbara Bloom
Museum für angewandte Kunst, Vienna
1993

Bloom's special arrangement of the museum's Art Nouveau furniture was part of a programme in which contemporary artists were invited to redesign its permanent displays. She created an installation consisting of an 'avenue' of chairs behind fabric screens where their silhouettes emphasize their linear elegance. This method of presentation enables the visitor to view and appreciate the chairs in terms of their design, while the frieze above the gallery places the exhibits in a historical context.

special departments being set up in order to plan and co-ordinate projects.

In common with other museums, the National Gallery, London, has for many years run artist residency programmes, in which individual artists produce their own direct response to works in its collection. In 2000, the Gallery extended this idea to produce a major exhibition called 'Encounters' which included works by twenty-four established contemporary artists, each of whom was invited to create a new work inspired by a specific painting. As part of a new contemporary art programme, the Science Museum, London, incorporated a series of commissioned works into the permanent displays in the new Wellcome Wing galleries which opened in 2000. The works, executed in various media, are integral with the overall exhibition design and relate to some of its themes. In the introduction to the contemporary art programme the Museum states: 'The works gently challenge any notions we may have that scientific or technolog-

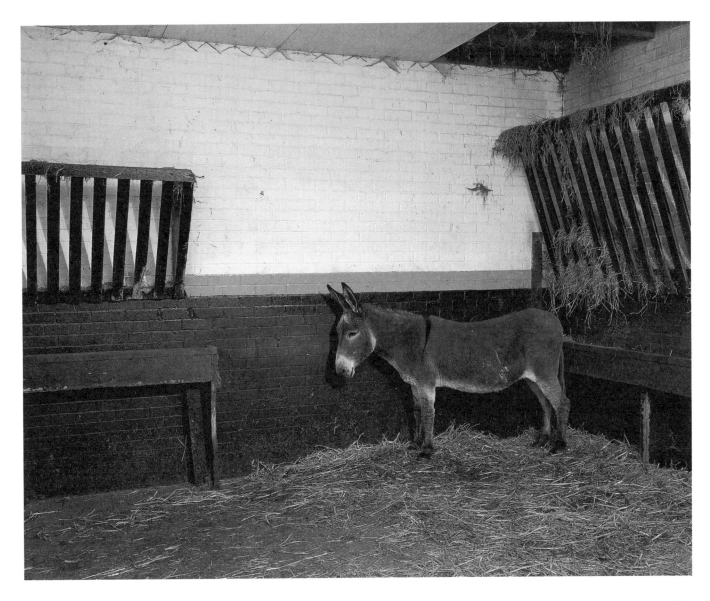

ical facts can be looked at from only one point of view. They also reinforce the fact that scientific and artistic activities do not exist in isolation from one another. Both transform and shape the culture and society we live in.' In contrast, the British Museum's Contemporary Arts and Cultures Programme is not intended to generate new works for the museum's collection, through a commission or exhibition, but to provide a valuable exchange mechanism between artist, museum and audience. By matching the contemporary

sensibility of artists with the creative inspiration offered by the artifacts and the Museum's specialist curatorial resources, mutually beneficial projects are developed through the artist/museum dialogue.[10]

Since the 1960s museums of modern art have struggled with collecting interdisciplinary art, such as video, performance and site-specific installation, that could no longer be classified within the traditional categories of painting, sculpture, photography etc. Such works can be continuously

JEFF WALL
A DONKEY IN BLACKPOOL
Transparency in light-box
From the exhibition 'Encounters' at the National Gallery, London
2000

Each of the artists invited to contribute to 'Encounters' was asked to create a new work inspired by an existing painting of their own choosing. A small reproduction of the source of inspiration was placed next to each new work. The painting chosen by Wall was *Whistlejacket* (1762), a life-size, dynamic depiction by George Stubbs of a famous racehorse owned by the 2nd Marquess of Rockingham; his response to this aristocratic equestrian portrait was to show an image of a humble yet dignified donkey used for children's seaside rides, presented as a large back-lit transparency viewed in a wall-mounted light-box.

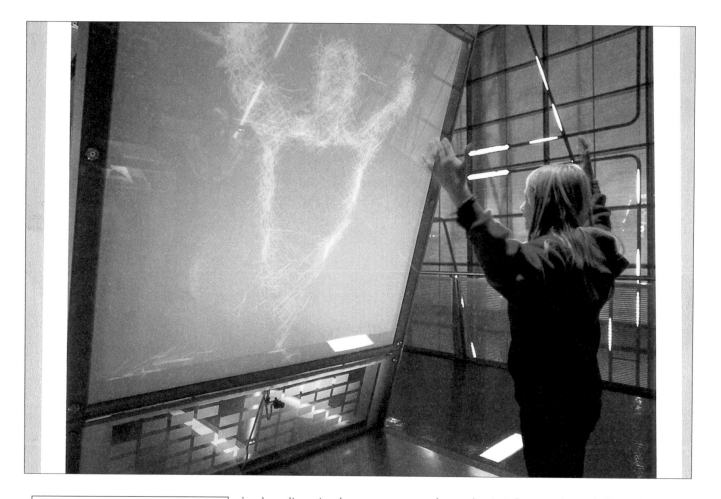

CHRISTIAN MÖLLER
PARTICLES

Interactive media installation from the Sounds
Digital section at the Science Museum, London
(Wellcome Wing)
2000

Using specially written software combined with
technology originally developed for cinematic
special effects, Möller created an interactive work
as part of the museum's permanent display called
'Digitopolis'. The visitor's image on the screen
appears as a swarm of glowing, animated particles
generated in response to their movement which is
synchronized with an audio soundtrack of digitally
generated acoustic effects.

copied or are ephemeral by nature and
therefore challenge the traditional role of
the museum as collector, appraiser and pre-
server of significant and valuable objects.

Jeffrey Shaw's *Virtual Museum* (1991)
demonstrates a method of presenting a
three-dimensional computer-generated
museum constituted by immaterial rooms
and exhibits. It consists of a round rotating
platform with a large video projection
monitor, a computer and a chair. Seated in
the chair, the viewer can control his or her
movement through the virtual museum
where forward and backward movement
and the rotation of the chair combine to
interact with the images on the screen.
Thus the viewer moves and is moved in
both virtual and real space. According to
Shaw, '… a virtual museum should be
more broadly understood as any shared
device or environment, real and/or virtual,
that enables a digitally structured organi-
zation of audiovisual data to be locally and
or remotely engaged by a large public.'[11]

Artist's own websites challenge the author-
ity of the art museum since they offer
Internet users art that cannot be confined
in one place, as well as works created exclu-
sively for digital media so as to allow digital
collecting, saving and archiving; in this
way the works can never be exclusively
possessed by any individual or institution.[12]
The Internet can convey 'original' art
in the medium for which it was created
and with the use of special software,
viewers can even alter and adopt a work
of art. This freedom challenges both the
authority and the limitations of the
traditional art museum and embraces
André Malraux's visionary idea of a
'Museum without Walls' – a museum
of endless possibilities.[13]

BEN KINMONT
WE BOTH BELONG
On-line project at adaweb,
http://www.adaweb.com/influx/kinmont/bkl.html
1995–96

For his interactive web project, Kinmont sought
photographs of people washing dishes, and in
return he offered participants their own photo
framed and paired with a photo of himself
engaged in the same activity. He then uploaded
the various images to his website, along with the
letters that accompanied them and notes about
the project, including the expenses he incurred. In
this way he was able to distribute his particular art-
making process to the broadest possible audience.

The dialogue between artists and museums provides a simultaneous engagement with and reflection on present-day society and culture. Yet the museum and the art that it houses still depend on an audience, without which an institution's true cultural significance is lost. This idea is expressed by Georges Bataille in *Museum*: 'We must realize that the halls and art objects are but the container, whose content is formed by visitors. It is the content that distinguishes a museum from a private collection.'[14] Collaborations with artists have offered individual museums an opportunity to take an objective look at their traditional approaches to the display and presentation of their collections and thus to learn more about themselves and their audiences. Institutions increasingly respond to the flexibility provided by working with living artists, allowing them to adopt procedures which would never be possible within the confines of an inflexible system. The ongoing relationship between artists and museums is a classic relationship in that it is dependent on two very opposite forces interacting with and feeding off each other. It provides a mechanism for counter-balancing the traditional museum's sense of constancy and institutional rigidity with the artist's free spirit and enquiring mind – a dialogue which effects a vital link in mankind's ever-evolving cultural history.

NOTES ON THE TEXT

Introduction
OPEN THE BOX

1 One of the few *Wunderkammer* collections which has sur- vived partially intact is preserved at Ambras Castle, Innsbruck. This is divided into the traditional three categories (*naturalia*, *artificialla* and *mirabilia*), with the objects displayed against differently coloured backgrounds in twenty vast cabinets. The *Wunderkammer* collections were greatly affected by the growth of exploration and the urgent need to accumulate exotic new specimens. As collections outgrew their cabinets, it became clear that they could no longer be kept for exclusive use by a small number of *dilettanti* and some were dispersed, while others were redeployed to become the core of public museums. Other terms for such collections were *studiolo*, curiosity cabinet or *cabinet de curiosité*.

2 Adalgisa Lugli, *Wunderkammer* (catalogue for the XLII Venice Biennale), 1986. This exhibition discussed the parallels between the *Wunderkammer* and the Arte Povera movement.

3 Walter Benjamin, *Das Passagen-Werk*, vol. 1 (ed. Rolf Tiedermann), Frankfurt am Main, 1982, in vol.V of *Gesammelte Schriften* (eds. Rolf Tiedermann and Hermann Schweppenhauser), p. 280.

4 Oldenburg and Williams, 'Store Days; Documents from The Store' (1961) and 'Ray Gun Theatre' (1962), New York, 1967, p. 39.

5 Though Arman suggested 'filling-up' the void created by Klein in the exhibition *Le Vide* ('The Void'), it took him two years to convince the gallery owner that it was acceptable to fill the same rooms with rubbish. Although the original idea for *Le Plein* ('Full-up') had been to empty the contents of refuse trucks directly into the gallery, the eventual compro- mise was to collect discarded items from Paris streets.

6 Jeremy Bentham's *Auto-Icon*, the clothed skeleton of the eighteenth-century philosopher, with replacement wax head, is permanently preserved in accordance with the terms of Bentham's will.

7 Piero Manzoni's first version of this device was the 1959 work *Artist's Breath*, which harked back to Duchamp's phial of Paris air. This was followed by *Artist's Blood* and the series *Merda d'artista*, both of 1961. These questioned the value of art works and cast doubt on the idea of authenticity.

8 One work from this series *The Crystal Cage (Portrait of Bernice)* is unique among Cornell's 'dossiers' for being con- tained in a suitcase; it thus has parallels with Duchamp's *Boîte-en-valise*.

9 Joseph Cornell's *Duchamp Dossier* was acquired by the Philadelphia Museum of Art in 1990. Its outer cover is one of the prototype boxes for Duchamp's series of multiple *Boîtes- en-valise*. Its contents of 117 items includes many souvenirs acquired by Cornell in the course of their collaboration on the project;. cf. exhibition catalogue *Joseph Cornell/Marcel Duchamp … In resonance*, Menil Collection, Houston, 1999.

10 Pat Hackett (ed.), *The Andy Warhol Diaries*, New York, 1989, p. 577.

11 David Bourdon, 'Andy's Dish', from the exhibition cata- logue *Raid the Icebox I with Andy Warhol* at the Museum of Art, Rhode Island School of Design, 1969, p. 17. This exhibition was staged at three venues, the Institute for the Arts, Rice University, Houston (October 1969–January 1970), The Isaac Delgado Museum, New Orleans (January–February1970) and the Museum of Art, Rhode Island School of Design, Providence (April–June 1970).

12 Daniel Robbins, 'Confessions of a Museum Director', from the exhibition catalogue *Raid the Icebox I with Andy Warhol* (op. cit.), p. 15.

13 Carl Linnaeus (1707–78) was a Swedish botanist who developed the universal system of classification called taxon- omy, which was adopted by many museums by the end of the eighteenth century. The first great natural history museums pioneered these laws of the classification of organ- isms based on hierarchies, a symbolic 'chain of being' where

man is placed at the apex of the natural pyramid, beneath which are the lower animals (vertebrates, invertebrates etc.).

14 Quoted from *Marcel Broodthaers* (catalogue of exhibition at the Walker Art Center, Minneapolis), New York,1989, p. 71.

15 Marcel Broodthaers quoted in Birgit Pelzer, 'Recourse to the letter', *October* 42, Fall 1987, p. 166.

16 Marcel Broodthaers, 'Methode' from the exhibition cata- logue *Der Adler vom Oligozän bis Heute* ('The Eagle from the Oligocene to the Present'), Städtische Kunsthalle, Düsseldorf, 1972, vol. 1, pp. 11–15.

17 The *Musée Sentimental* was staged in Paris (1977), Cologne (1979), Berlin (1981) and Basel (1989).

18 Filippo Tommaso Marinetti, 'The Founding and Manifesto of Futurism' (1909), in R.W. Flint (ed.), *Marinetti: Selected Writings*, translated by R.W. Flint and Arthur A. Coppotelli, New York, 1971, pp. 41–3. First published in *Le Figaro*, Paris, 20 February 1909.

19 Kasimir Malevich, 'On the Museum', English translation in *Essays on Art* (New York, 1971), pp. 68–72.

20 Alexander Rodchenko, 'Declaration on Museum Manage- ment' (1919), in Selim Omarovich Khan-Magomedov, *Rodchenko: The Complete Work*, with introduction by Vieri Quilici (translated by Huw Evans), Cambridge, Mass., 1987, p. 288. First published in *Izobrazitel 'noe iskusstvo* (*Figurative Art*), no. 1 (1919), p. 85.

21 From André Breton, *Surrealism and Painting*, 1927.

22 Hal Foster, 'What's Neo about the Neo-Avant-Garde?', *October* 70, Fall 1994, pp. 5–32.

23 Daniel Buren, Oliver Mosset, Michel Parmentier and Niele Toroni, 'Statement', English translation published in Michel Claura, 'Paris Commentary', *Studio International*, vol. 177, no. 907, London, January 1969, p. 47.

24 Robert Smithson, 'Some Void thoughts on Museums', *Arts Magazine* 41, no. 4 (February 1967).

25 As documented in Lucy Lippard, *Six Years: The Dematerial- ization of the Art Object from 1966–72*. This was the period conventionally associated with conceptual art and was a listing of the principal artists, events and works of those years.

26 From statistics quoted in *New York Times* article, 10 January 1999, 'The State of the Art Museum, Ever Changing', by Glenn D. Lowry, Director, MoMA.

27 Its first exhibition, held in 1818, was a retrospective of the work of Jacques-Louis David, but in the case of the major museums like the Louvre, only works by artists already deceased were collected.

28 Alfred H. Barr, 'Present status and future direction of The Museum of Modern Art', p. 2. Source, MoMA Archives: AHB Papers (AAA:3266;122), 1933.

29 Hans Haacke, 'Museums, Managers of Consciousness', *Art in America* 72, no. 2 (February 1984), pp. 9–17.

30 Quoted in *Hans Haacke: Unfinished Business* (exhibition catalogue, ed. Brian Wallis, The New Museum of Contem- porary Art, New York), Cambridge, Mass., 1986, p. 96.

31 Daniel Buren, 'Function of the Museum' (1970), in A.A. Bronson and Peggy Gale (eds.), *Museums by Artists* (translation by Laurent Sauerwein), Toronto, 1983, pp. 57–74 (first published in *Daniel Buren*, Oxford: Museum of Modern Art, 1973, n.p.).

32 Examples of such involvement are the 'Artist's Eye' at the National Gallery, London, 'Artist's Choice' at MoMA, New York, and 'Connections' at the Museum of Fine Arts, Boston.

Chapter I
THE MUSEUM EFFECT

1 Extract from 'Unsettled Objects', 1968–9, Pitt Rivers Museum, Oxford. Quoted from the exhibition catalogue *Museum as Muse*, MoMA, New York, 1999, p. 94.

2 Mark Dion in conversation with Miwon Kwon, *Mark Dion*, London, 1997, p. 17.

3 Taxonomy (see Introduction, note 13), was supplemented by the geographical system in which everything is classified according to region.

4 Mark Dion in conversation with Miwon Kwon, op. cit., p. 18.

5 A facsimile of Christian Boltanski' s original letter of request sent out to museums is included in *Reconstitution*, a boxed set of publications to accompany his retrospective exhibitions held in 1990–1 at the Whitechapel Gallery, London, the Stedelijk Van Abbemeseun, Eindhoven, and the Musée de Grenoble.

Chapter II
ART OR ARTIFACT

1 Peter Blake, 'A Cabinet of Curiosities From the Collections of Peter Blake, Morley Gallery, London, 1999, p. 11 (the artist discusses collecting with Andrew Lambirth).

2 Barbara Bloom, *The Reign of Narcissism* (guide book), Württembergischer Kunstverein, Stuttgart/Kunsthalle Zürich/Serpentine Gallery, London, 1990.

3 In 1973–74 exhibitions on the theme of 'Spurensicherung' in art and anthropology were staged at the Ludwig Museum in Aachen, and in Hamburg and Munich; these included works by Anne and Patrick Poirier and Claudio Costa.

4 Between 1986 and 1991 Nikolaus Lang developed a project concerned both with the disappearance of the culture of the Australian Aborigines and with the oppression of indigenous peoples by European settlers; this also included native fauna, flora and geological specimens. This work was later presented in the form of a touring exhibition entitled 'Nunga and Goonya', shown in Munich, Bremen, Stuttgart, Vienna and Dublin.

5 Nikolaus Lang's project *For the Götte Brothers and Sisters* (1973–74) researched the surviving traces of human contact with nature through his examination and presentation of artifacts found in the ruins of three remote huts. Claudio Costa's project *The Museum of Monteghifo* (1975) involved the transformation of a deserted farmhouse, in a Ligurian mountain village, into an anthropological museum. The existing building and its contents were used to illustrate the decline of traditional peasant culture which had resulted from the growth of tourism and industrialization in Italy.

6 In 1992 Susan Hiller was invited by Bookworks and the Freud Museum to create a work for exhibition and future publication.

7 Susan Hiller, quoted from the Tate Gallery's audio guide, 2000.

8 Susan Hiller quoted from *Museum as Muse* (op.cit.), p. 93.

9 Mark Dion, 'The Natural History Box: Preservation, Categ- orization and Display 1995'; see *Artist's Writings: Mark Dion*, London, 1997, p.135.

10 See Adalgisa Lugli, *Wunderkammer* (catalogue for the XLII Venice Biennale), 1986.

11 Rosamond W Purcell, *Special Cases, Natural Anomalies and Historical Monsters*, 1997; also an exhibition of the same title at The Getty Institute for the History of Art and Humanities, Santa Monica, California, 1994.

12 Joan Fontcuberta, quoted in 'Weird Science: Animal Quackers', Review of *Fauna* by David Cary Tuck in *Taxi* magazine, New York, May 1989.

13 Ilya Kabakov, 'The Man Who Never Threw Anything Away', c. 1977; see *Artist's Writings: Ilya Kabakov*, London, 1998, p. 99.

Chapter III
PUBLIC INQUIRY

1 From Ilya Kabakov, 'Total Installation', p. 273 (Frankfurt lectures 1992–93, published 1995).

2 Daniel Buren, 'Function of the Museum' (1970), op. cit. (see Introduction, note 31), pp. 57–74.
3 Mark Dion in Kynaston McShine (ed.), *The Museum as Muse*, MoMA exhibition catalogue, New York, 1999, p. 98.
4 Ibid.
5 From *Hans Haacke: 'Unfinished Business'*: 'Museums, Managers of Consciousness', The New Museum of Contemporary Art, New York (1986–7), Cambridge, Mass., p. 68.
6 Ibid.
7 Michael Asher, artist's statement in *The Museum as Muse*, op. cit., p. 156.
8 Neil Cummings and Marysia Lewandowska explore this concept in detail in *The Value of Things*, Basel, Boston and Berlin, 2000.
9 Andrea Fraser quoting the words of Alfred H. Barr, Jr. inscribed on a plaque in MoMA, New York.
10 Andrea Fraser, quoted from artist's statement in *The Museum as Muse*, op. cit., p. 162.
11 From 'Collected – A conversation with Fred Wilson', British Museum Education Service, 1997.
12 From Fred Wilson's statement for the Whitney Museum of American Art Biennial, New York, 1993.

Chapter IV
FRAMING THE FRAME

1 Roland Barthes, *Camera Lucida: Reflection on Photography*, New York, 1981.
2 Douglas Crimp, *On the Museum's Ruins* (with photographs by Louise Lawler), Cambridge, Mass., 1993.
3 Thomas Struth, quoted from the MoMA exhibition catalogue, *Museum as Muse*, p. 116. It could be said that 'showing situations about an intensity of viewing is preferable to me and should constitute a kind of counterexample … my photographs can offer a reflection about the very situation.'
4 Interview between Benjamin H. D. Buchloh and Thomas Struth, in *Portraits: Thomas Struth*, Marian Goodman Gallery, New York, pp. 39–40. Thomas Struth, ibid.
5 Quoted from an e-mail letter to Ron Wakkary, 1998, from Website exhibition, *Louise Lawler – Stadium*, with text by Ron Wakkary (www.stadiumweb.com), *About Without Moving/Without Stopping*, p. 3.
6 Quoted from an interview with Zoe Leonard in an article by Barbara MacAdam, 'Zoe Leonard', *Arts News*, vol. 97, no. 3, March 1998, p. 167.
7 Rosamond W. Purcell in an article, 'The Game of the Name', from *Art Bulletin*, vol. LXXVII, no. 2, June 1995, p. 180. They have a long exposure time … 'although the scenery is constantly moving, the minimum exposure time is a quarter, a half, or even a full second.'

Chapter V
CURATOR/CREATOR

1 Wilson refers to the exhibition held at the Maryland Historical Society, Baltimore; from Fred Wilson, 'The Silent Message of the Museum', in Jean Fisher (ed.), *Global Visions: Towards a new internationalism in the visual arts*, London, 1994. In a later interview with the author he reiterates this viewpoint: 'I feel that in this work with museums, I'm using every aspect of my training as an artist so I don't have a problem calling this my art.' (From 'Collected – A conversation with Fred Wilson', British Museum Education Service, 1997).
2 Joseph Kosuth quoted from an interview by Randall Short, first published in *Newsday*, New York, 15 October 1990.
3 The exhibition opening coincided by chance with the court proceedings in Cincinnati concerning Robert Mapplethorpe's allegedly obscene photographs of nude children and of men in sadomasochistic poses. The court was faced with the dilemma that, although in terms of the law the photographs could be classed as pornography, several museum directors pronounced (nominated) them to be art and so swayed the jury against bringing in a guilty verdict.

4 The full title of the exhibition was 'Lost Magic Kingdoms and Six Paper Moons from Nahuatl'. First staged at the British Museum (Museum of Mankind) in 1987, the exhibition subsequently toured, first at the South Bank Centre, London (1988–9) and then at venues in Swansea, Birmingham, Sheffield, York, Bolton and Leeds. 'Six Paper Moons' is a metaphor for the way the Aztecs looked at the moon.
5 Quoted from Eduardo Paolozzi's introduction in the leaflet accompanying the South Bank Centre's touring exhibition, 1988.
6 Eduardo Paolozzi, *Lost Magic Kingdoms and Six Paper Moons from Nahuatl*, British Museum Publications, 1987, p. 7.
7 Ibid.
8 Although this show had been planned prior to Cage's death in 1992, it was staged posthumously a year later. Following its presentation at MOCA, Los Angeles, in 1993, 'Rolywholyover A Circus' toured to other venues during 1994 and 1995: The Menil Collection, Houston, Texas; Guggenheim Museum, New York; Art Tower Mito Contemporary Art Center, Japan; and Philadelphia Museum of Art. An earlier version of this project was staged in 1991 at the Neue Pinakotek, Munich, using a whole range of objects loaned from various Munich museums. 'Rolywholyover' is a word coined by James Joyce in *Finnegan's Wake* suggesting revolution and dynamic movement, while 'Circus' describes a consistent motif, previously used by Cage in music, which involves a number of events happening simultaneously.
9 John Cage quoted from exhibition leaflet, MOCA, Los Angeles, p. 1.
10 Peter Greenaway quoted from his introduction to the exhibition catalogue *100 Objects to Represent the World*, Stuttgart, 1992.
11 Peter Greenaway, quoted from the exhibition catalogue *The Stairs, Geneva, The Location*, London, 1994, p. 13.
12 Peter Greenaway, quoted from the exhibition catalogue *Some Organizing Principles*, The Glynn Vivian Art Gallery, Swansea, Wales, 1993, p. 4.
13 'Give & Take', 30 January–1 April 2001: Serpentine Gallery – Hans Haacke, 'Mixed Messages' (objects selected from the V & A collections); Victoria and Albert Museum – works by fifteen contemporary artists.
14 The 'Thinking Aloud' exhibition toured the U.K. during 1998–9: Kettle's Yard, Cambridge; Cornerhouse, Manchester; and Camden Arts Centre, London.
15 Richard Wentworth quoted from 'Thoughts on Paper – Richard Wentworth, prompted and transcribed by Roger Malbert', *Richard Wentworth's Thinking Aloud*, National Touring Exhibitions, 1998, p. 8.
16 Cornelia Parker quoted from 'A conversation between Cornelia Parker and Stuart Cameron – *Avoided Object*, Cardiff, 1996, p. 56.
17 Cornelia Parker, ibid., p. 56.
18 Quoted from an interview with the members of Group Material.
19 Group Material interview, ibid.
20 Group Material interview, ibid.

Chapter VI
ON THE INSIDE

1 Mark Dion in conversation with Carel van Tuyll van Serooskerken, *Sonsbeek 93*, p. 213.
2 Joseph Kosuth quoted from an interview by Randall Short, originally published in *Newsday*, New York, 15 October 1990.
3 Fred Wilson, 'The Silent Message of the Museum', in Jean Fisher (ed.), *Global Visions: Towards a new internationalism in the visual arts*, London, 1994.
4 Lisa G. Corrin (ed.), *Fred Wilson – Mining the Museum* (published by The Contemporary Baltimore in co-operation with the New Press, New York), 1994.
5 Renée Green quoted from an interview conducted by Donna Harkavy on 29 July 1991 published in the Worcester exhibition leaflet for *Bequest* entitled 'Insights: Renée Green', p. 4.

6 'Time Machine: Ancient Egypt and Contemporary Art', 1 December 1994–26 February 1995. At that time the British Museum's annual visitor figures were officially estimated at over six million.
7 For Andrea Fraser's *Museum Highlights: A Gallery Talk* see description and illustrations above (pp. 98–9).
8 An example this type of work by Janet Cardiff is *Chiaroscuro* (1997), which was first created for the exhibition 'Present Tense: Nine Artists in the Nineties', at San Francisco Museum of Modern Art, 1997–8.
9 From Ann Hamilton and Kathryn Clark's joint artists' statement published in the exhibition leaflet for *View* which was part of the series of 'Works' projects, at the Hirshhorn Museum and Sculpture Garden, Washington, D.C.
10 From Ann Hamilton and Kathryn Clark, ibid.
11 His other project in 1979 was staged at the Art Institute of Chicago as part of a group show, the '73rd American Exhibition'; this involved the resiting of a bronze statue from outside the museum to a gallery interior (see pp. 29–30).
12 Michael Asher defined 'situational aesthetics … as an aesthetic system that juxtaposes predetermined elements occurring within the institutional framework' and which 'incorporates different historical styles and elements of iconography into one manifestation.' Michael Asher, 'Writings, 1973–1983, on Works 1969–1979' (1983), pp. 81, 209.

Epilogue
WITHOUT WALLS

1 Sir Ernst Gombrich, in an interview with James Putnam, published under the title 'Images of the Soul', in *La Repubblica of the Arts*, 13 March 1999.
2 Frank O. Gehry quoted from Victoria Newhouse, *Towards a New Museum*, New York, 1998, p. 252.
3 Frank Stella's architectural models relate to proposals for the Groninger Museum, Groningen, The Netherlands (1992), The Desert Museum, Israel (1992), Kunsthalle Complex, Herzogin Garden, Dresden, Germany (1992), MCI, Private Museum for 20th-Century Latin American Art, Buenos Aires, Argentina (1997).
4 Katharina Fritsch, 'Museum', Venice Biennale, 1995, p. 10.
5 Donald Judd, 'Nie wieder Krieg' in *Architektur* (exhibition catalogue, Museum für angewandte Kunst, Vienna), 1991, p. 13.
6 Ilya Kabakov in conversation with Robert Storr, from *Art in America*, January 1995, pp. 68–69.
7 'The Museum of Jurassic Technology – An Interview with Director David Wilson', by F. Haas and M. Schmidt, *Finger* 2 (newsletter for contemporary cultural phenomena), Frankfurt, July 1998.
8 Robert Fleck, 'Museum and Concept Art', 1992, published in *Museum in Progress, 1991–1997*, 1997, p. 4.
9 From the accompanying leaflet, 'The Label Show – Contemporary Art and the Museum', The Department of Contemporary Art, Boston MFA.
10 The British Museum does, however, have an ongoing acquisition policy aimed at collecting contemporary art that reflects world cultures.
11 Jeffrey Shaw, quoted from an article published in *Tema Celeste*.
12 Yet museums still feel a need to acquire digital works. The San Francisco Museum of Modern Art purchased a whole collection of Web works called 'RSUB' from the digital-design shop Razorfish Studios in New York (1998).
13 André Malraux, *Museum Without Walls* (1947), proposed that all of human visual culture could be instantly and equally available via the reproduction.
14 *Museum*, 1930; quoted from *October* 36, Spring 1986, pp. 24–5.

BIBLIOGRAPHY

GENERAL

Adorno, Theodor W., 'Valéry Proust Museum', in *Prisms*, Cambridge, Mass., 1967

Armstrong, Richard, *Carnegie International 1995*, The Carnegie Museum of Art, Pittsburgh, 1995

Balkema, Annette and Slager, Henk (eds), *Still, The Museum*, Still Foundation, Rotterdam, 1997

Bayley, Stephen, *Commerce and Culture – From Pre-Industrial Art to Post-Industrial Value*, Design Museum, London, 1989

Benjamin, Walter, *Das Passagen-Werk*, vol. 1 (ed. Rolf Tiedermann), Frankfurt am Main, 1982, in vol.V of *Gesammelte Schriften* (eds Rolf Tiedermann and Hermann Schweppenhauser), p. 280;

——, 'Unpacking My Library: A Talk about Book Collecting', in *Illuminations*, New York, 1969

Bennett, Tony, *The Birth of the Museum – History, Theory, Politics*, London, 1995

Brand, Jan *et al.*, *Sonsbeek 93*, Ghent, 1993

Bronson, A.A. and Gale, Peggy (eds), *Museums by Artists*, Toronto, 1983

Cooke, Lynne and Francis, Mark, *Carnegie International 1991*, The Carnegie Museum of Art, Pittsburgh, 1991

Cooke, Lynne and Wollen, Peter (eds), *Visual Display: Culture Beyond Appearances*, New York and Seattle, 1995

Crimp, Douglas, *On the Museum's Ruins*, Cambridge, Mass., and London, 1993

Davis, Douglas, *The Museum Transformed – Design and Culture in the Post-Pompidou Age*, New York, 1990

De Oliveira, Nicolas *et al.*, *Installation Art* (with texts by Michael Archer), London, 1994

Duro, Paul (ed.), *The Rhetoric of the Frame – Essays on the Boundaries of the Artwork*, Cambridge, 1996

Fehr, Michael, *Open Box – Künstlerische und wissenschaftliche Reflexionen des Museumsbegriffs*, Cologne, 1998

Foucault, Michel, 'Nietzsche, Genealogy, History', in *Language, Countermemory, Practice: Selected Essays and Interviews*, Ithaca and New York, 1977

Fuchs, Rudi (ed.), *Overture – Arte contemporanea*, Turin, 1985

Grasskamp, Walter, 'Reviewing the Museum – or: The Complexity of Things', *Nordisk Museologi* 1 (1994), pp. 65–74

Gudis, Catherine (ed.), *A Forest of Signs: Art in the Crisis of Representation* (Museum of Contemporary Art, Los Angeles), Cambridge, Mass., and London, 1989

Hall, Margaret, *On Display – A Design Grammar for Museum Exhibitions*, London, 1987

Hanhardt, John G. and Keenan, Thomas, *The End(s) of the Museum*, Fundació Antoni Tàpies, Barcelona, 1995

Harding, Anna (ed.), *Curating – The Contemporary Art Museum and Beyond*, London, 1997

Honnef, Klaus and Kaminski, Gisela, *Documenta 5, Befragung der Realität – Bildwelten heute* (3 vols.), Kassel, 1972

Karp, Ivan and Lavine, Steven D. (eds), *Exhibiting Cultures – The Politics and Policy of Museum Display*, Washington, D.C., and London, 1991

Kimmelmann, Michael, *Talking with Artists at the Met, the Modern and elsewhere*, New York, 1998

Kuspit, Donald, 'The Magic Kingdom of the Museum', *Artforum*, February 1992, pp. 58–63

Lumley, Robert (ed.), *The Museum Time Machine*, London and New York, 1988

McShine, Kynaston, *The Museum as Muse: Artists Reflect*, The Museum of Modern Art, New York, 1999

Malraux, André, *Museum Without Walls*, New York, 1967

Martin, Jean-Hubert, *Château d'Oiron*, Paris, 1993

Noble, Alexandra, *Worlds in a Box*, London, 1994

Pagé, Suzanne and Parent, Béatrice, *Histoires de Musée*, Musée d'Art Moderne de la Ville de Paris, 1989

Pointon, Marcia (ed.), *Art apart – Art Institutions and Ideology Across England and North America*, Manchester, 1994

Rugoff, Ralph, *Circus Americanus*, London, 1995

Sarnitz, August (ed.), *Museums Positionen – Buildings and Projects in Austria*, Salzburg and Vienna, 1992

Schaffner, Ingrid, 'Deep Storage – the art of archiving', *Frieze* 23, Summer 1995, pp. 58–61

Schaffner, Ingrid and Winzen, Matthias, *Deep Storage – Collecting, Storing, and Archiving in Art*, Munich and New York, 1998

Schubert, Karsten, *The Curator's Egg*, London, 2000

Serota, Nicholas, *Experience or Interpretation – The Dilemma of Museums of Modern Art*, London and New York, 1996

Sherman, Daniel J., and Rogoff, Irit (eds), *Museum Culture – Histories Discourses Spectacles*, Minneapolis and London, 1994

Staniszowski, Mary Anne, *The Power of Display – A History of Exhibition of Installations at the Museum of Modern Art*, Cambridge, Mass., and London, 1998

Storrie, Calum *et al.*, 'Collected', *Inventory*, vol. 2, no. 2, 1997

Szeeman, Harald, 'Museum of Obsessions', *Rivista trimestrale di architettura* 9, 1987, pp. 6–9

Tuchman, Maurice and Carol, Eliel S., *Parallel Visions – Modern Artists and Outsider Art*, Los Angeles and Princeton, N.J., 1993

Walentiny, Christine *et al.*, *Cabinets of Curiosity – an inspiration for contemporary art* (exhibition booklet, Essex University), Colchester, 1999

Yanni, Carla, *Nature's Museums*, London, 1999

Introduction
OPEN THE BOX

Altshuler, Bruce, *The Avant-Garde in Exhibition – New Art in the 20th Century*, New York, 1994

Angell, Callie *et al.*, *Andy Warhol Museum*, Andy Warhol Museum, Pittsburgh, 1994

Asher, Michael, *Writings 1973–1983 on Works 1969–1979* (ed. Benjamin H.D. Buchloh), The Nova Scotia College of Art and Design, Halifax, and Museum of Contemporary Art, Los Angeles, 1983

Becker, Jochen, 'Peter Greenaway, The Physical Self, Boymans Museum, Rotterdam', *Kunstforum International* 117, no. 2, 1991, pp. 394–5

Bois, Yves-Alain *et al.*, *El Lissitzky 1890–1941: Architect, Painter, Photographer, Typographer*, Eindhoven, London and New York, 1990

Bon, Gigi, 'Viaggio nella Wunderkammer tra il Manierismo ed il Barocco', *Lingabue* 31, Venice, 1997, pp. 54–85

Bonk, Ecke, *Marcel Duchamp – The Portable Museum*, London, 1989

Bruggen, Coosje van, *Claes Oldenburg: Mouse Museum/Ray Gun Wing*, Ludwig Museum, Cologne, 1979

Buchloh, Benjamin H.D. (ed.), *Marcel Broodthaers – Writings, Interviews, Photographs*, Cambridge, Mass., and London, 1988

Buren, Daniel, 'The Function of the Museum', *Artforum*, September 1973, p. 68;

——, *Photo-Souvenirs 1965–88*, Villeurbanne, 1988

Buskirk, Martha and Nixon, Mignon (eds), *The Duchamp Effect*, Cambridge, Mass., 1996

Castle, Ted, 'Accumulations by Arman', *Art in America* 71, December, 1983, pp. 136–42

Compton, Michael *et al.*, *Marcel Broodthaers*, Tate Gallery, London, 1980

Conketton, Sheryl and Carol Eliel S., *Annette Messager*, Los Angeles County Museum of Art and The Museum of Modern Art, New York, 1995

Corrin, Lisa G. (ed.), *Mining the Museum: An Installation by Fred Wilson*, New York, 1994

De Menil, Dominique, *Raid the Icebox I with Andy Warhol: an exhibition selected from the storage vaults of the Museum of Art, Rhode Island School of Design*, Providence, R.I., 1969

Dietrich, Dorothea, *The Collages of Kurt Schwitters*, Cambridge, 1993

Distel, Herbert, *The Museum of Drawers: Tentoonstellingen*, Internationaal Cultureel Centrum, Antwerp, 1976

Elderfield, John, *Kurt Schwitters*, London, 1987

Fehlau, Fred, 'Louise Lawler Doesn't Take Pictures', *Artscribe*, May 1990, pp. 62–3

Garb, Tamar and Kuspit, Donald, *Christian Boltanski*, London, 1997

Gintz, Claude, 'From Madness to Nomadness – Robert Filliou', *Art in America* 73, June 1985, pp. 130–5

Goldwater, Marge *et al.*, *Marcel Broodthaers*, Minneapolis and New York, 1989

Grasskamp, Walter, 'Künstler und andere Sammler', *Kunstforum International* 32, no. 2 (1979), pp. 31–105

Haase, Amine, 'Wie zeigt man Beuys nach Beuys?', *Kunstforum* 117, 1992, pp. 336–437

Harrison, Charles and Wood, Paul (eds), *Art in Theory, 1900 to 1990*, Oxford, 1992

Hobbs, Robert, *Robert Smithson: A Retrospective View*, Herbert F. Johnson Museum of Art, Cornell University, Ithaca, N.Y., 1982

Holeczek, Bernhardt, *Timm Ulrichs*, Brunswick, 1982

Honnef, Klaus and Kaminski, Gisela, *Documenta 5: Befragung der Realität – Bildwelten heute* (3 vols.), Kassel, 1972

Kaprow, Allan, *Assemblage, Environments and Happenings*, New York, 1966

Kellein, Thomas, *Fluxus*, London, 1995

König, Kaspar, *Mouse Museum: A Selection of Objects Collected by Claes Oldenburg*, Documenta 5 (supplement), Kassel, 1972

Kotik, Charlotta *et al.*, *The Play of the Unmentionable – An Installation by Joseph Kosuth at the Brooklyn Museum*, New York and London, 1992

Lippard, Lucy R., *Six Years: The Dematerialization of the Art Object from 1966 to 1972*, Berkeley, California, 1997

Lugli, Adalgisa, *Wunderkammer* (catalogue for the XLII Venice Biennale), Milan, 1986; ——, *Wunderkammer – La Stanza delle Meraviglie*, Turin, 1997

McEvilley, Thomas, 'Another Alphabet – The Art of Marcel Broodthaers', *Artforum*, November 1989, pp. 105–15

McShine, Kynaston (ed.), *Information*, The Museum of Modern Art, New York, 1970; ——, *Joseph Cornell*, The Museum of Modern Art, New York, 1990

Manzoni, Piero, *Milano mitologia, Piero Manzoni, Palazzo Reale, Milano*, Milan, 1997

Messager, Annette, *Annette Messager Collectionneuse, Annette Messager Artiste, Faire Parade 197- 95*, Musée d'Art Moderne de la Ville de Paris, 1995

Noble, Alexandra, *Worlds in a Box*, South Bank Centre, London, 1994

Obrist, Hans Ulrich and Wyn Evans, Cerith, *Retrace your steps: Remember Tomorrow – Artists at the Soane* (exhibitions leaflet), Sir John Soane's Museum, London, 1999

O'Doherty, Brian, *Inside the White Cube – The Ideology of the Gallery Space*, Santa Monica and San Francisco, 1986

Oldenburg, Claes, *Store Days*, New York, 1968

Olson, Eva M.*et al.*, *Collective Vision – Creating a Contemporary Art Museum*, Museum of Contemporary Art, Chicago, and University of Chicago Press, 1996

Parsy, Paul-Hervé and Brecht, Roland, *Robert Filliou*, Musée national d'art moderne, Centre Georges Pompidou, Paris, 1991

Raap, Jurgen, 'Timm Ulrichs', *Kunstforum* 126, May–June 1994, pp. 294–327

Rorimer, Anne, 'Up and Down, In and Out, Step by Step, a Sculpture, a Work by Daniel Buren', *Museum Studies* 11, no.2, Chicago, Spring 1985, pp. 140–55

Tisdall, Caroline, *Joseph Beuys* (exhibition catalogue), Solomon R. Guggenheim Museum, New York, 1979

Van der Marck, Jan, *Arman*, New York, 1984

Wenzel, Eva and Beuys, Jessyka, *Joseph Beuys – Block Beuys*, Munich, 1998

Zeiller, Michael, *Musée Sentimental – Oberfläche, Organisation, Obszönität (Daniel Spoerri)*, Tübingen, 1986

Chapter I

THE MUSEUM EFFECT

Akasaka, Hideto, *Wolfgang Stiller, 94–97*, Röntgen Kunstraum and Katsuya Ikeuchi Galerie AG, Tokyo, 1997

Amman, J.C. (ed.), *Rosemarie Trockel*, Kunsthalle Basel, 1988

Baumgarten, Lothar, *Unsettled Objects* (exhibition catalogue for 'America Invention'), Solomon R. Guggenheim Museum, New York, 1993

Brett, Guy, *Jac Leirner*, Galeria Millan, São Paulo, 1989

Bonami, Francesco, 'Damien Hirst – the exploded view of the artist', *Flash Art*, Summer 1996, pp. 112–16

Caldas, Walterico, *A Série Veneza*, Centro Cultural Light, Rio de Janeiro, 1998

Caldas, Walterico and Leirner, Jac, *XLVII Bienal de Veneza*, Fundaçao Bienal de São Paulo, 1997

Coles, Alex *et al.*, *Mark Dion: Archaeology*, London, 1999

Cooke, Lynne *et al.*, *Double: Collective Memory and Current Art Practice (Ann Hamilton – Tropos)*, Parkett, Zurich, in association with The South Bank Centre, London, 1992

Cotter, Holland, 'Haim Steinbach: Shelf Life', *Art in America* 76, May 1988, pp. 156–63

Damaged Goods: Desire and the Economy of the Object (Re. Jeff Koons and Haim Steinbach), The New Museum of Contemporary Art, New York, 1986

Ermen, Reinhard, 'Yuji Takeoka – Abstand und Nahe', *Kunstforum International* 127, July–September 1994, pp. 261–71

Gumpert, Lynn *et al.*, *Reconstitution – Christian Boltanski*, Whitechapel Gallery, London, Stedelijk Van Abbemuseum, Eindhoven, and Musée de Grenoble, 1990

Hall, Charles and Calle, Sophie, *Damien Hirst*, London, 1991

Hickey, Dave, 'James Lee Byars – Just Make me up', *Flash Art* 177, Summer 1994, pp. 86–90

Inboden, Gudrun *et al.* in *Rosemarie Trockel – Bodies of Work 1986–1998* (exhibition catalogue, ed. Fressen Birte), Whitechapel Gallery, London, Hamburger Kunsthalle and Staatsgalerie Stuttgart, 1999

Jackson, Tessa and Snoddy, Stephen, *Annette Messager – Telling Tale*, Arnolfini, Bristol, and Cornerhouse, Manchester, 1992

Kabakov, Ilya,*Ten Characters*, ICA, London, 1989; ——, *Total Installation*, Ostfildern, 1995; ——, *On the Roof*, Düsseldorf, 1997; ——, *Life and Creativity of Charles Rosenthal (1898–1933)*, Art Tower Mito, 1999

Kline, Katy and Posner, Helaine, 'Ann Hamilton', *Myein*, United States Pavilion, Venice Biennale, 1999

Laing, Carol and Carr-Harris, Ian, *Susan Schelle – a question of behavior*, The Power Plant, Toronto, 1994

Lang, Nikolaus, *Nikolaus Lang*, Kestner-Gesellschaft, Hanover, 1975

Magregor, Elizabeth *et al.*, *Mark Dion - Natural History and Other Fictions*, Ikon Gallery, Birmingham, Kunstverein, Hamburg and De Appel Foundation, Amsterdam, 1997

Marmer, Nancy, 'Boltanski: The Uses of Contradiction', pp. 63–4, *Art in America* 77, October 1989, pp. 169–81

Meschede, Friedrich, *Matt Mullican in der Neuen Nationalgalerie Berlin*, Berlin, 1997

Messler, Norbert, 'James Lee Byars, Konstruktionen des Erinnerns Transitorische Turbulenzen', *Kunstforum International* 127, July–September 1994, p. 365

Metken, Günter and Murphy, Bernice, *Nunga and Goonya (Nikolaus Lang)*, catalogue of travelling exhibition, Munich, Bremen, Stuttgart, Vienna and Dublin (1986–91)

Meyer, Eva, *Joseph Kosuth – A Grammatical Remark*, Ostfildern, 1989

Milroy, Lisa, *Lisa Milroy* (exhibition catalogue), Waddington Galleries, London, 1999

Muthesius, Angelika (ed.), *Jeff Koons*, Cologne, 1992

Ohrt, Roberto, *Kippenberger*, Cologne, 1997

Penalva, João, *The Ormsson Collection – presented by João Penalva*, Museu da Cidade, Lisbon, 1997

Quinn, Marc, *Incarnate*, London, 1998

Renton, Andrew (ed.), *João Penalva*, Centro Cultural de Belém, Portugal, 1999

Rogers, Sarah J. and Geldin, Sherri, *The body and the object – Ann Hamilton 1984–1996*, Wexner Center for the Arts, Ohio State University, Columbus, 1996

Schimmel, Paul, 'Haim Steinbach – This is not a readymade' in Sue Henger (ed.), *Objectives – the New Sculpture*, Newport Beach, California, 1990, pp. 154–63

Semin, Didier *et al.*, *Christian Boltanski*, London, 1997

Shioda, Junichi (ed.), *(Re. Arhamaiani) Art in Southeast Asia – Glimpses into the Future*, Museum of Contemporary Art, Tokyo, Hiroshima City Museum of Contemporary Art, The Japan Foundation Asia Center, 1997, pp. 106–9

Springfeld, Björn (ed.), *On Kawara – Continuity/Discontinuity 1963–1979*, Moderna Museet, Stockholm, 1980

Starr, Georgina, *Georgina Starr*, Ikon Gallery, Birmingham, 1997

Stewart, Susan, *Ann Hamilton*, San Diego Museum of Contemporary Art, La Jolla, California, 1991

Sultan, Terrie *et al.*, *Maurizio Pellegrin – Works from Private Collections 1986–1996*, Venice, 1997

Trockel, Rosemarie, *Rosemarie Trockel* (exhibition catalogue), The Museum of Modern Art, New York,1988; ——, *Rosemarie Trockel* (exhibition catalogue), Museo Nacional de Arte Reina Sofia, Madrid, 1992

Vatimo, Gianni and Castellani, Valentina (eds), *Parmiggiani*, Turin, 1998

Vettese, Angela *et al.*, *Haim Steinbach*, Milan, 2000

Wallis, Clarrie, *Mark Dion – Tate Thames Dig* (exhibition leaflet), *Art Now* 20, Tate Gallery, London, 1999

Chapter II

ART OR ARTIFACT

Bijl,Guillaume, *Installationen, Situationen und Kulturtourismus*, Kunsthalle Recklinghausen, 1998

Bloom, Barbara, *The Reign of Narcissism – Guide Book*, Württembergischer Kunstverein, Stuttgart, Kunsthalle Zürich, and Serpentine Gallery, London, 1990

Brett, Guy *et al.*, *The Muse My Sister: Susan Hiller 1973–1983*, Orchard Gallery, Londonderry, 1984

Bronson, A.A. and Gale, Peggy (eds), *Museums by Artists*, Toronto, 1983

Brown, Neil *et al.*, *Tracey Emin*, London, 1998

Calle, Sophie, *Double Game*, London, 1999

Clark, Vicky A., *Never Odd or Even* (exhibition leaflet), The Carnegie Museum of Art, Pittsburgh, 1992

Clegg, David, *To Collect or Exchange*, Govett-Brewster Art Gallery, New Plymouth (NZ), 1996

Costa, Claudio, *Claudio Costa – Lavori Africani*, Tauro Arte, Centro Scultura, Associazione Culturale, Turin, 1992; ——, *Préhistoire et Anthropologie*, Galerie 1900–2000, Paris, 2000

Costa, Claudio and Paradiso, Antonio, *Situazione Antropologica dall'Uomo al Paesaggio*, Milan 1977

Eccher, Danilo *et al.*, *Gilbert and George*, Gallerie d'Arte Moderna, Bologna, and Charta, Milan, 1996

Elliot, James, *The Perfect Thought – works by James Lee Byars*, University Art Museum, University of California, Berkeley, 1990

Fontcuberta, Joan and Formiguera, Pere, *Fauna*, Seville, 1999

Foray, Jean-Michel *et al.*, *Anne et Patrick Poirier*, Milan, 1994

Grasskamp, Walter, 'Künstler und andere Sammler', *Kunstforum International* 32, no. 2 (1979), pp. 31–105

Halle, Howard, 'Barbara Bloom – A Collection', *Grand Street* 47, 1993

Herbert, Lynn M., *et al.*, *The Art Guys – Think Twice*, Houston and New York, 1995

Hiller, Susan, *After the Freud Museum*, London, 1995

Kabakov, Ilya, *Incident at the Museum, or Water Music*, Museum of Contemporary Art, Chicago, 1993

Killeen, Richard, 'C.M. Beadnell – Objects and Images from the Cult of the Hook', *Papers of the Hook Museum*, vol. 38, no. 2, Auckland, 1996

Lambirth, Andrew, *A Cabinet of Curiosities from the collections of Peter Blake*, Morley Gallery, London, 1999

Lugli, Adalgisa, *Wunderkammer – La Stanza delle Meraviglie*, Turin, 1997

Mabe, Joni, *Joni Mabe's Museum Book*, Atlanta, Georgia, 1988

Morris, Frances, *Sophie Calle – The Birthday Ceremony* (exhibition leaflet), *Art Now* 14, Tate Gallery, London, 1998

Morris, Gay, 'Props On A Stage – James Lee Byars', *Art in America*, October 1990, pp. 197–9

Mullican, Matt, *Matt Mullican, Works 1972–1992*, Cologne, 1993

João Penalva, *The Ormsson Collection – presented by João Penalva*, Museu da Cidade, Lisbon, 1997

Pietrantonio, Giacinto di, *Leonid Sokov*, Prato, 1995

Pohlen, Annelie, 'That can hatch from an infinity of eggs (Wunderkammer, Venice Biennale)', *Artforum*, September 1986, pp. 121–3

Prudhon, François-Claire, 'Sophie Calle – Autobiography in Progress', *Flash Art*, Jan.–Feb. 1992, p. 127

Renton, Andrew (ed.), *João Penalva*, Centro Cultural de Belém, Portugal, 1999

Rimanelli, David, 'Barbara Bloom and her Art of Entertaining', *Artforum*, October 1989

Schwarzbauer, Georg F., *Wolfgang Stiller – Laboratorium (88–89)*, Werkbund-Archiv, Martin-Gropius-Bau, Berlin, 1989

Schwendenwien, Jude, 'Other Worlds – Barbara Bloom', *Contemporanea*, January 1990, pp. 46–51

Shapira, Sarit, 'Sophie Calle – Personal Museum', *Flash Art*, October 1996, p. 105

Sinclair, Ross, *Real Life*, Tramway, Glasgow, and Pier Arts Centre, Stromness, 1996

Vallance, Jeffrey, *The World of Jeffrey Vallance (Collected Writings 1978–1994)*, Los Angeles, 1994;

——, *Paranormal Diagrams / Heretical Theories*, New York, 1998

Vatimo, Gianni and Castellani, Valentina (eds), *Parmiggiani*, Turin, 1998

Wilson, Andrew, *Gavin Turk: Collected Work 1989–1993*, London, 1993

Chapter III

PUBLIC INQUIRY

Antoine, Jean-Philippe *et al.*, *Feux Pâles: Une Pièce à conviction*, CAPC, Musée d'art contempororain, Bordeaux, 1990

Asher, Michael, *Painting and Sculpture from The Museum of Modern Art – Catalog of Deaccessions 1929 through 1998*, The Museum of Modern Art, New York, 1999

Bauer, Uta Meta *et al.*, *Now Here, Louisiana* (vols. I & II), *Louisiana Revy* 36, Louisiana Museum of Modern Art, Humblebaek, 1996

Bois, Yve-Alain, Crimp, Douglas and Kraus, Rosalind, 'A Conversation with Hans Haacke', *October* 30, New York, 1984, pp. 23–48

Brett, Guy, *Rose Finn-Kelcey*, Chisenhale Gallery, London, and Ikon Gallery, Birmingham, 1994

Bricker Balken, Debra and Horrigan, Bill, *Muntadas, Between the Frames: The Forum*, MIT List Arts Center, Cambridge, Mass., and the Wexner Center for the Arts, Ohio State University, Columbus, 1994

Buchloh, Benjamin H.D., 'Hans Haacke: Memory and Instrumental Reason', *Art in America* 76, February 1988, pp. 96–159

Cohen, Michael, 'Michael Asher – Rethinking site-specific critique', *Flash Art*, Nov.–Dec. 1993, pp. 88–90

Collin-Thiébaut, Gérard, *Catalogue des Images de Gérard Collin-Thiébaut*, Vuillafans, 1993

Cruz, Amanda, *Directions – Jac Leirner*, Hirshhorn Museum, Washington, D.C., 1992

Cummings, Neil and Lewandowska, Marysia, *The Value of Things*, Basel, 2000

Dellbrügge/De Moll, 'Kunst Geschichte Kunst', *Kunstforum International* 121, 1991, p. 74;

——, *Ein Leben für die Kunst*, Museum für Neue Kunst, Freiburg, 1991;

——, *Museumsboutique*, Stadtgalerie Saarbrücken, 1991

Enwezor, Okwui, *Altered States: The Art of Kendell Geers*, http://e-race.future.easyspace.com/altered.htm

Fisher, Jean (ed.), *Global Visions: Towards a new internationalism in the visual arts. The Silent Message of the Museum*, Fred Wilson, London, 1994

Fraser, Andrea, 'In and Out of Place (Louise Lawler)', *Art in America* 73, June 1985, pp 122–9;

——, 'Museum Highlights: a Gallery Talk', *October* 57, Jan.–Feb. 1991, pp. 104–22

Geers, Kendell, *Secession – Kendell Geers*, Secession, Vienna, 1999

Geers, Kendell, 'Fuck Art: The Prose of a Con-Artist', National Sculpture Symposium, *Pretoria Technikon*, 4 July 1995

Haacke, Hans, 'Museums, Managers of Consciousness', *Art in America* 72, February 1984, pp. 9–17;

——, *Unfinished Business*, The New Museum of Contemporary Art, New York, and MIT Press, Cambridge, Mass., 1986;

——, *Obra Social* (MetroMobiltan), Fundació Antoni Tàpies, Barcelona, 1995

Hanru, Hou *et al.*, *Cream* (Kendell Geers), London, 1998, pp. 136–9

Harding, Anna (ed.), *Art & Design, Curating – The Contemporary Art Museum and Beyond*, London, 1997

Jaar, Alfredo, *It is Difficult – Ten years*, Barcelona, 1998

Kuspit, Donald B., 'Cecile Abish's Museum of the Absurd', *Art in America* 70, January 1982, pp. 110–15

Landry, Pierre and Bellavance, Guy, 'Muntadas – On Translation: Le Public', *Journal du Musée d'Art Contemporain de Montréal*, no. 2, 2000

Leirner, Jac and Caldas, Walterico, *XLVII Bienal de Veneza*, Fundaçao Bienal de São Paulo, 1997

Muntadas, *Between the Frames – Interview Transcript*, Wexner Center for the Arts, Ohio State University, Columbus, and Massachusetts Institute of Technology, Cambridge, Mass., 1994

Roberts, James, 'Last of England – Gavin Turk', *Frieze*, Nov.–Dec. 1993, pp. 28–31

Romer, Stefan, 'Guillaume Bijl', *Kunstforum* 135, Dec. 1996–Jan. 1997, p. 92

Rorimer, Anne, 'Michael Asher: Recent Work', *Artforum*, April 1980, pp. 46–50

Storr, Robert, 'Louise Lawler: Unpacking the White Cube', *Parkett* 22, December 1989, pp. 105–8

Thill, Robert, 'L.A. Angelmaker and Francis Cape Bad; "Pennies and Shutters": Momenta, Brooklyn, New York', *Historic Kiosk*, New York, 1998

Vine, Richard, 'Images of Inclusion – Alfredo Jaar', *Art in America* 81, July 1993, pp. 90–5

Chapter IV

FRAMING THE FRAME

Belting, Hans, *Thomas Struth: Museum Photographs*, Hamburger Kunsthalle, Hamburg, 1993

Bonomi, Francesco, 'Hiroshi Sugimoto – Zen Marxism', *Flash Art* 180, Jan.–Feb. 1995, pp. 71–3

Erwith, Elliot, *Museum Watching*, London, 1999

Fehlau, Fred, 'Louise Lawler Doesn't Take Pictures', *Artscribe*, May 1990, pp. 62–3

Höfer, Candida, *Photographie*, Munich, Paris, London, 1998;

——, *Orte Jahre – Photographien 1968–1999*, Munich, Paris, London, 1999

Iles, Chrissie and Russell Robert (eds), *In Visible Light: Photography and Classification in Art, Science and The Everyday* (exhibition catalogue), Museum of Modern Art, Oxford, 1997

Johnson, Ken, 'Candida Höfer at Nicole Klagsbrum', *Art in America* 78, December 1990, pp. 168–9

Kellein, Thomas, *Hiroshi Sugimoto: Time Exposed*, Stuttgart, London and New York, 1995

Koyanagi Atsuko, Introduction to exhibition catalogue *Photographs by Hiroshi Sugimoto: Dioramas, Theaters, Seascapes*, New York and Tokyo, 1988

Lanzardo, Dario (ed.), *The Iron Guest*, Turin, 1989

Lanzardo, Dario and Poli, Francesco, *Arca Naturae – Le Collezioni "Invisibili" del Museo Regionale di Scienze Naturali di Torino*, Milan, 1998

Lawler, Louise, 'Arrangements of Pictures', *October* 26, 1984, pp. 3–16

Leonardi, Nicoletta and Bertolino, Giorgina, *Marzia Migliora, sotto-vuoto*, Turin, 1999

Purcell, Rosamond W., *Special Cases – Natural Anomalies and Historical Monsters*, San Francisco, 1997

Purcell, Rosamond W. and Gould, Stephen J., *Finders, Keepers – Eight Collectors*, London, 1992

Ross, Richard and Mellow, David, *Museology*, Santa Barbara, California, 1989

Seward, Keith, 'Zoe Leonard', *Artforum*, October 1991, p.106

Slyce, John, 'I Spy (Christine Borland)', *Dazed and Confused* 36, November 1997, pp. 80–3

Soutif, Daniel, 'Pictures and an Exhibition – The Museum and the Photograph: Containers of Whatever', *Artforum*, March 1991, pp. 83–9

Stack, Trudy Wilner, *Art Museum – Pictures at an Exhibition*, Center for Creative Photography, University of Arizona, Tucson, 1995

Storr, Robert, 'Louise Lawler: Unpacking the White Cube', *Parkett* 22, December 1989, pp. 105–7

Chapter V

CURATOR/CREATOR

Berkson, Bill, 'Group Material, Aids Timeline', *Artforum*, March 1990

Brett, Guy *et al.*, *Cornelia Parker – Avoided Object*, Cardiff, 1996

Corrin, Lisa and Haacke, Hans, 'Give & Take (exhibition catalogue), Serpentine Gallery, London 2001

Costa, Vanina, 'Thomas appartient à tout le monde', *Beaux Arts*, February 1991

Dannatt, Adrian, 'Feux Pâles – Ready-Mades Belong to Everyone', *Flash Art* 158, May–June 1991, p. 128

Drobnick, 'Dialectical Group Material', *Parachute* 56, 1988, pp. 29–31

Greenaway, Peter, *A Hundred Objects to Represent the World*, Stuttgart, 1992;

——, *Some Organising Principles*, Glynn Vivian Art Gallery, Swansea / Wales Film Council, 1993;

——, *The Stairs – Geneva The Location*, London, 1994

Haacke, Hans, *Ansichts Sachen/Viewing Matters*, Düsseldorf, 1999

Hart, Claudia, 'Vanishing act: Philippe Thomas (Readymades Belong to Everyone)', *Artforum*, April 1988, pp. 108–10

Kotik, Charlotta *et al.*, *The Play of the Unmentionable – An Installation by Joseph Kosuth at the Brooklyn Museum*, New York and London, 1992

Lazar, Julie, 'John Cage Rolywholyover A Circus', *Art & Design – Profile* No. 33 (Parallel Structures – Art, Dance, Music), London, 1993

Lebovic, Elizabeth, 'Feux pâles, Capc Musée, Bordeaux', *Art Press* 155, February 1991, p. 88

Malbert, Roger, 'Artists as Curators', *Museums Journal*, May 1995, pp. 25–33

Paolozzi, Eduardo, *Lost Magic Kingdoms – and Six Paper Moons from Nahuatl*, London, 1986;

——, *Lost Magic Kingdoms – and Six Paper Moons* (exhibition booklet), The South Bank Centre and the Museum of Mankind, London, 1988

Sims, Patterson, *The Museum: Mixed Metaphors, Fred Wilson*, Seattle Art Museum, Seattle, 1993

Vettese, Angela *et al.*, *Haim Steinbach*, Milan 2000

Swed, Mark, 'The Exhibition – John Cage', *The Contemporary*, MOCA, Los Angeles, Aug.– Sept. 1993, pp. 9–10

Wentworth, Richard, *Thinking Aloud*, London, 1998

Chapter VI

ON THE INSIDE

Adams, Brooks, 'Interventions, The Museum as Studio', *Art in America* 77, October 1989, pp. 63–4

Barde, Bernd (ed.), *Marie-Jo Lafontaine*, Ostfildern, 1999

Boyce, Sonia, *Peep*, Institute of International Visual Arts, London, 1995

Brennan, Anne *et al.*, *Archives and the Everyday*, Canberra Contemporary Art Space, 1997

Bruce, Chris *et al.*, *Ann Hamilton*, Henry Art Gallery, University of Washington, Seattle, 1982

Bryson, Norman, 'The Viewer Speaks – Ken Aptekar', *Art in America* 87, February 1999, pp. 98–101

Calle, Sophie, *La Visite Guidée* (with music by Laurie Anderson), Museum Boijmans-Van Beuningen, Rotterdam, 1996;

——, *Appointment* (Freud Museum), London, 2001

Corrin, Lisa G. (ed.), *Mining the Museum: An Installation by Fred Wilson*, New York, 1994

Corrin, Lisa G. *et al.*, *Mark Dion*, London, 1997

Cummings, Neil and Lewandowska, Marysia, *Errata*, Louisiana Museum of Modern Art, Humlebaek, 1996

Deweer, Mark (ed.), *A Meeting, Jan Fabre and Ilya Kabakov*, Deweer Art Gallery, Otegem, 1998

De Salvo, Donna, *Past Imperfect – A Museum Looks at Itself*, New York, 1993

Diaz, Gonzalo (ed.), *Unidos en la Gloria y en la Muerte*, Museo Nacional de Bellas Artes, Santiago de Chile, 1997

Dimitrijevic, Braco, 'Leonardo und die Mistgabel', *Kunstforum International* 135, Oct. 1996–Jan. 1997, pp. 296–311

Eggebert, Anne and Walker, Julian, *Mr. and Mrs. Walker have moved – Notes on Live Art Project*, Kettle's Yard, Cambridge, 1998

Fabre, Jan, *Conductor of Coincidence*, Symposium, Tokyo Opera City Cultural Foundation, Tokyo, 1997

Fenz, Werner, *Argusauge (Marie-Jo Lafontaine)*, Munich, 1991

Fleck, Robert *et al.*, *Franz West*, London, 1999

Fuenmayor, Jesus, 'Intervenciones en el Espacio – Museo de Bellas Artes, Caracas', *Flash Art*, May–June 1996, p. 57

Gooding, Mel and Putnam, James, *Terry Smith – Site Unseen*, London, 1997

Green, Renée and Harkavy, Donna, *Bequest – Insights: Renée Green* (exhibition leaflet), Worcester Art Museum, Worcester, Mass., 1991

Grennan, Simon, *Kissing the Dust – Contemporary Artists working with Collections*, Oldham, Walsall and Huddersfield Art Galleries, 1997

Grosenick, Uta and Riemschneider (eds), *Art at the Turn of the Century*, Cologne, 2000, pp. 194–7 (Renée Green)

Grumpet, Lynn *et al.*, *Reconstruction – Christian Boltanski*, Whitechapel Gallery, London, Stedelijk Van Abbemuseum, Eindhoven, and Musée de Grenoble, 1990

Hansen, David and Wastell, David, *Michael Schlitz, Intervention 4*, Tasmanian Museum and Art Gallery, Hobart, 1997

Hentschel, Martin, *Aus den Netzen (Out of the Web) – Thom Barth, Works 1987–1992*, Ostfildern, 1993

Hopper, Robert *et al.*, *Private View*, The Henry Moore Institute, Leeds, 1996

Kallnbach, Siglinde, 'Pandora's Box', *Kunstforum International* 130, May–July 1995, pp. 327–31;

——, *Performance*, Cologne, 1996

Kirshner, Judith Russi, *The Tables – Tom Otterness*, Portikus, Senckenbergmuseum, Frankfurt am Main, 1991

Kopystiansky, Igor, *The Museum*, Kunsthalle Düsseldorf, 1994

Kuraya, Mika *et al.*, *Reading The Art Museum; Hyokeikan and Art of Today*, Tokyo, 2001

Leslie, John *et al.*, *Natural History and Other Fictions – An Exhibition by Mark Dion*, Ikon Gallery, Birmingham, 1997

Little, Stewart W., 'Guerrilla Artist at the Met. (Dove Bradshaw)', *New York Gazette*, 5 February 1979

Myers, George Jr., 'Will mighty Met ever put out this fire? (Dove Bradshaw)', *The Columbus Dispatch*, 5 March 1995

Nakatani, Yoshihiro, *Future Recollections*, Kyoto Municipal Museum of Art, 1997

Putnam, James, *Beyond the Pleasure Principle – Sarah Lucas at the Freud Museum*

(exhibition leaflet), Sadie Coles HQ, London, 2000

Putnam, James (ed.), *Time Machine*, Museo Egizio, Turin, 1995

Putnam, James and Davies, Vivian (eds), *Time Machine*, British Museum, London, 1994

Raap, Jürgen, *Siglinde Kallnbach, Performance*, Cologne, 1995

Rian, Jeffrey, *Franz West – Possibilities*, The Institute for Contemporary Art, PS1, Long Island City, N.Y., 1989

Rifkin, Ned, *View – Ann Hamilton and Kathryn Clark* (exhibition leaflet), Hirshhorn Museum and Sculpture Garden, Smithsonian Institution, Washington, D.C., 1991

Rorimer, Anne, *The Art of Daniel Buren – Painting as Architecture – Architecture as Painting*, London, 1990

Schütz, Heinz, 'Svetlana und Igor Kopystiansky: Der Text und das Bild sind wirklich zerstört, sie sind versteckt', *Kunstforum International* 123, 1993, pp. 150–9

Sims, Patterson, *The Museum: Mixed Metaphors, Fred Wilson*, Seattle Art Museum, Seattle, 1993

Spector, Nancy, *Symptoms of Interference, Condition of Possibility-Negativity, Purity and the Clearness of Ambiguity – Ad Reinhardt, Joseph Kosuth and Felix Gonzalez-Torres*, 1994

Stein, Judith E., 'Sins of Omission – "Mining the Museum, Fred Wilson"', *Art in America* 81, October 1993, pp. 110–15

Sultan, Terrie *et al.*, *Ken Aptekar – Talking Pictures*, The Corcoran Gallery of Art, Washington, D.C., 1997

Theweleit, Klaus, *Antony Gormley*, Schleswig-Holsteinischer Kunstverein, Kunsthalle zu Kiel, 1999

Vallance, Jeffrey, 'Art Attacks, Exhibition by stealth', *Forteantimes* 99, June 1997

Wilson, Fred, 'Silent Messages', *Museums Journal*, May 1995, pp. 27–9

Epilogue

WITHOUT WALLS

Fairbrother, Trevor, *The Label Show*, The Museum of Fine Arts, Boston, Mass., 1994

Fleck, Robert and Ubl, Ralph, *Museum in Progress 1991–1997*, Museum in Progress, Vienna, 1994

Fritsch, Katharina, *Exhibition Catalogue*, San Francisco Museum of Modern Art and Museum für Gegenwartskunst, Basel, 1997;

——, *Museum – Venice Biennale, 1995*, Ostfildern, 1995

Geluwe, Johan van, *Art Museum Museum Art – Johan van Geluwe, The Museum of Museums*, De Vleeshal, Middelburg, 1986;

——, *Het Kabinet van de Conservator*, Karl Ernst Osthaus-Museum, Hagen, 1996

Goldberg, Vicki, 'Outreach, the Wandering Museum's Speciality', *The New York Times*, 10 January, 1997

Guidi, Benedetta Cestelli, 'New Tate Gallery of Modern Art – A discussion with Nicholas Serota', *Flash Art*, Jan.–Feb. 1998, pp. 57–8

Hanru, Hou *et al.*, *Cream* (Ben Kinmont), London, 1998

Heartney, Eleanor, 'The Museum: Lights On, Nobody Home?', *Art in America* 83, September 1995, pp. 39–43

Hoet, Jan, *Chambres d'Amis*, Museum van Hedendaagse Kunst, Ghent, 1986

Judd, Donald, *Selected Works, 1960–1991 – Donald Judd*, The Museum of Modern Art, Saitoma, and the Museum of Modern Art, Shiga, 1999

Kinmont, Ben, *We both belong, online project*, http://www.adaweb.com/influx/kinmont/bkl.html;

——, *Cream*, London, 2000

Lazar, Julie *et al.*, *Uncommon Sense*, The Museum of Contemporary Art, Los Angeles, 1997

Lowry, Glenn D., 'The State of the Art Museum, Ever Changing', *The New York Times*, 10 January 1999

Madoff, Steven Henry, 'Where the Venues Are Virtually Infinite', *The New York Times*, 10 January 1999

Morphet, Richard *et al.*, *Encounters – New Art from Old*, National Gallery, London, 2000

Newhouse, Victoria, *Towards a New Museum*, New York, 1998

Noever, Peter (ed.), *MAK – Austrian Museum of Applied Arts, Vienna*, Munich, 1995

Sarnitz, August (ed.), *Museums Positionen – Buildings and Projects in Austria*, Salzburg and Vienna, 1992

Serota, Nicholas, *Experience or Interpretation – The Dilemma of Museums of Modern Art*, London, 1996

Shaw, Jeffrey, *A User's Manual – From Expanded Cinema to Virtual Reality*, Karlsruhe and Ostfildern, 1997

Shaw, Jeffrey and Tijen, Tjebbe vaan, *An Imaginary Museum of Revolution*, Amsterdam, 1988

Solomon-Godeau, Abigail, '"The Label Show": Contemporary Art and the Museum', *Art in America* 84, December 1994, pp. 51–6

Tucker, Marcia, 'Museums experiment with new exhibition strategies', *The New York Times*, 10 January 1999

Tumlir, Jan, 'The Museum Museum – David Wilson and the Museum of Jurassic Technology', *Frieze*, March–April 1998, pp. 52–55

Wechsler, Lawrence, *Mr. Wilson's Cabinet of Wonder – Pronged Ants, Horned Humans, Mice on Toast, and Other Marvels of Jurassic Technology*, New York, 1995

LIST OF ILLUSTRATIONS AND SOURCES

Illustrations are identified by page numbers; whenever dimensions are noted, height precedes width and, if appropriate, depth.

2
Karsten Bott
One of Each on Shelves (detail), miscellaneous objects displayed at the Badisches Landesmuseum, Karlsruhe, 2000. Photo: Steffen Hauswirth (Landesbildstelle Baden, Karlruhe)

4
Jeffrey Vallance
The Travelling Nixon Museum, 1991 (see p. 71). Courtesy, the artist.

6
Richard Wentworth
Rims, lips, feet, glass, ceramics and epoxy, dimensions variable. Installation at the exhibition 'Private View', Bowes Museum, Barnard Castle, County Durham, 1996. Photo: J. Hardmann Jones. Courtesy, the artist and the Henry Moore Institute, Leeds

Introduction
OPEN THE BOX

9
Robert Filliou
The Frozen Exhibition, 1972. Bowler hat made of cardboard and felt with photos and texts. Photo: Kleinefenn. Courtesy Galerie Nelson, Paris

10
The *Wunderkammer* of Ferrante Imperato, Naples, from *Historia Naturale* by Ferrante Imperato, 1599

10
The Pitt Rivers Museum, Oxford. Courtesy, Pitt Rivers Museum, Oxford

11
Kurt Schwitters
Hanover Merzbau: View with Blue Window, 1933. Sprengel Museum Hannover, Kurt Schwitters Archiv. © DACS 2001

12
Joseph Cornell
Museum, c. 1944–48. Stained wood chest with photostats of type and typeset text, and twenty fabric-capped, cork-stoppered glass bottles housing various painted papers, objects, materials, 2¼ x 8⅜ in. (5.7 x 22.3 cm). Photo: Hicky-Robertson, Houston. The Menil Collection, Houston, Bequest of Jermayne MacAgy. Courtesy, Joseph and Robert Cornell Memorial Foundation, Florida

13
Arman
Le Plein (Full-up), detail of installation at the Galerie Iris Clert, Paris, 1960. Courtesy, the artist

14 left
Daniel Spoerri
Snare Picture, 1972. Courtesy, Galleria Massimo Valsecchi, Milan. © DACS 2001

14 right
Piero Manzoni
Merda d'Artista
No. 058, 1961, Metal can, diameter 4.8 x 6.5 cm. Photo: Orazio Bacci, Milan.

Courtesy, Archivio Opera Piero Manzoni, Milan. © DACS 2001

15 left
Auto-Icon of Jeremy Bentham with mummified head between the feet (in display cabinet). Courtesy, University College, London

15 right
Timm Ulrichs
The First Living Work of Art, 1961. Photograph on canvas, 100 x 80 cm, exhibited in Berlin, 1965. Collection: Heinz Holtzmann. Courtesy, the artist

16
Christian Boltanski
Vitrine de référence, 1971. Wood vitrine containing various objects, 60 x 120 x 12.5 cm. Courtesy, Galerie Ghislaine Hussenot, Paris. © ADAGP, Paris, and DACS, London 2001

17 above
Annette Messager
Album Collections, installation at Städtische Galerie im Lenbachhaus, Munich, 1973. © ADAGP, Paris, and DACS, London 2001

17 below
Joseph Beuys
Beuys Block, View of Room 3, 1970. Hessisches Landesmuseum, Darmstadt. Photo: Sina Althöfer. Courtesy, Hessisches Landesmuseum, Darmstadt. © DACS 2001

18
Andy Warhol
'Raid the Icebox I with Andy Warhol' exhibition, Museum of Art, Rhode Island School of Design, 1970. Courtesy, The Museum of Art, Rhode Island School of Design, Providence, R.I. © The Andy Warhol Foundation for the Visual Arts, Inc./ARS, New York, and DACS, London 2001

19 above
Marcel Duchamp
Boîte-en-valise (Portable Museum). Photo: Uwe Düttmann (for *Life* Magazine, 28 April 1942). © Succession Marcel Duchamp/ ADAGP, Paris, and DACS, London 2001

19 below
Sir John Soane's Museum, London. The rotunda, looking east. Photo: Professor Margaret Harker. Courtesy, The Trustees of Sir John Soane's Museum, London

20, 21
Herbert Distel
'Museum of Drawers', 1970–77, and detail of drawer no. 8. Chest of drawers containing miniature works by various artists, overall (approx.) 183 x 42 x 42 cm. Collection: Kunsthaus Zürich, donation of Herbert Distel and the Julius Bär Foundation. © Herbert Distel, Bern

22 left
Claes Oldenburg
'Mouse Museum', 1965–77 (detail), Museum Moderner Kunst, Stiftung Ludwig, Vienna. Enclosed structure of wood, corrugated aluminium and Plexiglas display cases containing 385 objects, 304 x 960 x 1030 cm. Photo: Martha Holmes. Courtesy, the artist

22 right
Claes Oldenburg
Poster for the 'Mouse Museum', 1972. Lithograph, 83.8 x 58.4 cm. Collection:

Claes Oldenburg and Coosje van Bruggen, New York. Photo: Ellen Page Wilson. Courtesy, the artist

23 left
Marcel Broodthaers
'Musée d'Art Moderne, Département des Aigles, Section XIXème Siècle', 1969. Photo courtesy, Maria Gilissen, Brussels

23 right
Marcel Broodthaers
Gold ingot, 'Musée d'Art Moderne, Département des Aigles, Section Financière', 1971. Photo courtesy, Maria Gilissen, Brussels

24
Daniel Spoerri
'Musée Sentimental', view of exhibition at the Kunstverein, Cologne, 1979. Courtesy, the artist

27
Daniel Buren
Photo-souvenir: 'Up and Down, in and out, step by step', work *in situ* (detail), Art Institute of Chicago, 1977. Photo: Rusty Culp. Courtesy, the artist

29
Hans Haacke
'MoMA-Poll', installation for visitor participation: two transparent acrylic ballet boxes, each 40 x 20 x 10 in. (101.6 x 50.8 x 25.4 cm), equipped with counting device able to record any piece of paper dropped through a slot in the top of the box. Installed as part of the international group exhibition 'Information' at the Museum of Modern Art, New York, 1970. Curator: Kynaston McShine. Director: John Hightower. Courtesy, the artist

30 top
Michael Asher, The Art Institute of Chicago, Gallery 219, installation view, 1979. Photo: Rusty Culp. Courtesy, the artist

30 below
Fred Wilson
'Metalwork 1793–1880', installation at the exhibition 'Mining the Museum' at the Maryland Historical Society, Baltimore, 1992. Photo courtesy, Metro Pictures, New York

31
Louise Lawler
Zeus and David, 1984. Black-and-white photo 14¾ x 12¼ in., mat 28 x 32 in. Courtesy, Metro Pictures, New York

32
Peter Greenaway
Seated Woman, from the exhibition 'The Physical Self' at the Museum Boijmans-Van Beuningen, Rotterdam, 1991. Photo: Jannes Linders. Courtesy, the artist

33
Joseph Kosuth
'Play of the Unmentionable', 1990. Installation view. the Brooklyn Museum, New York. Courtesy, the artist

Chapter I
THE MUSEUM EFFECT

35
Damien Hirst
Dead Ends Died Out, Explored, 1993,

Medium-density fibreboard (MDF), glass and cigarette butts, 153 x 243 x 12 cm. Photo: Stephen White. Courtesy, Jay Jopling, London

36
Jeff Koons
New Shelton Wet/Dry Tripledecker, 1981. Three vacuum cleaners, Plexiglas, fluorescent lights, 316 x 71 x 71 cm. © Jeff Koons. Courtesy, the artist

37
Marc Quinn
Eternal Spring (Sunflowers) I, 1998. Stainless steel, glass, frozen silicon, sunflowers and refrigeration equipment, 219.7 x 90 x 90 cm. Photo: Stephen White. Courtesy, Jay Jopling, London

38 above and below
Ann Hamilton
Between Taxonomy and Communion, 1990. Installation at the San Diego Museum of Contemporary Art, 1990. View of floor stained by the liquid leaching from the underbelly of the 18 ft long table and detail of surface with teeth laid out on a layer of iron oxide. Photos: Philipp Scholz Rittermann. Courtesy, the artist

39
Karsten Bott
One of Each, 1993. Installation at the Offenes Kunsthaus, Linz. Courtesy, the artist

40–41
Mark Dion
Tate Thames Dig, 1999–2000, Tate Gallery, London. Millbank and Bankside sites and detail of installation (vitrine). Photos: Mark Dion. Courtesy, American Fine Arts Co., New York, and Bonakar Jancov Gallery, New York

42
Martin Kippenberger
A Man and his Art, 'Frank Sinatra Series', 1994. Installation view. Courtesy, Galerie Gisela Capitain, Cologne, and Nolan/Eckman Gallery, New York

43
Christian Boltanski
The Archive of the Carnegie International 1896–1991, 1991. Installation in the Mattress Factory, Pittsburgh. Cardboard boxes and lamps; dimensions variable, here height 10 ft (3.05 m), depth 65 ft (19.80 m). Carnegie Museum of Art, Pittsburgh; Carnegie International 1991. Courtesy, Marian Goodman Gallery, New York, and Carnegie Museum of Art, Pittsburgh. © ADAGP, Paris, and DACS, London 2001

44
Waltercio Caldas
Venetian Series, 1997. Installation view. Steel, glass and Plexiglas. Private collection. Photo: Roberto Cecato. Courtesy, Galerie Lelong, New York, and the artist

45 above
Reinhard Mucha
Treysa, 1993. Wood, glass, felt and enamel, 85 x 173 x 40 cm. Courtesy, Anthony d'Offay Gallery, London

45 below
Yuji Takeoka
Schwebender Sockel (Floating Pedestal), 1992. 60 x 85 x 85 cm. Courtesy, Wako Works of Art, Tokyo

46
James Lee Byars
The Figure of Question, 1989. Marble, 40 x 8 x 8 cm. Courtesy, Galerie Michael Werner, Cologne
47 below
Amikam Toren, *Regulation Painting No. 10*, 1999. Vitrine and paint, 185 x 155 x 50 cm. Photo: Matthew Tickle. Courtesy, Richard Salmon Gallery, London
48 above
Susan Schelle, *Musée*, 1994. C-prints in specimen boxes, each 26 x 38 x 6 cm (installed: 57 x 166 x 6 cm). Collection of Christian Keesee, Oklahoma. Photo: Isaac Applebaum. Courtesy, Susan Hobb Gallery, Toronto
48 below
Gavin Turk
Gavin Turk Right Hand and Forearm, 1992. Silkscreen on paper, 34 x 27 in. (86.5 x 68.5 cm). Courtesy, Saatchi Gallery, London
49
Annette Messager
Le Repos des Pensionnaires (Boarders at Rest), 1971–72 (detail). Musée de Rochechouart (Haute-Vienne), 1990. Courtesy, the artist. © ADAGP, Paris, and DACS, London 2001
50
Joseph Kosuth
Taxonomy (re) applied, 1996. Cleveland Center for Contemporary Art, 1996. Courtesy, the artist
51
Maurizio Pellegrin
Segreto del 723 (Secret of 723), 1986–87. Padded canvas and acrylic paint, 400 x 500 cm. Courtesy, the artist
52
Lisa Milroy
Plates, 1992. Oil on canvas, 96 x 74 in. (243.8 x 188 cm). Courtesy, Waddington Galleries, London
53
Karsten Bott
Toothbrushes, 1991 (detail of installation). Galerie Hant, Frankfurt. Courtesy, the artist
54
Neil Cummings
The Collection Yellow, 1998 (detail). Plastic, found cardboard and bottles, Courtesy, the artist
55
Allan McCollum
Lost Objects, 1991. Installation view, Carnegie Museum of Art, Pittsburgh, from Carnegie International 1991. Enamel on cast concrete, 22 in. x 23 ft 9 in. x 72 ft (60 x 724 x 2200 cm). Courtesy, the artist and John Weber Gallery, New York. © Carnegie Museum of Art, Pittsburgh
56 above
Claudio Costa
L'ineffabile circolazione dell'umano (The ineffable circulation of humanity), 1981. Installation at the Galleria Massimo Valsecchi, Milan. Courtesy, Galleria Massimo Valsecchi, Milan
56 below
Siglinde Kallnbach
The Museum of Ashes, begun 1981. Detail of installation at the Frauenmuseum, Bonn, 1995. Photo: Siglinde Kallnbach. Courtesy, Galerie Thomas Zander, Cologne
57
Nikolaus Lang
For Mrs. G. Legacy – Food and Religious Hoard, Bayersoien, 1981–82. Complete installation 700 x 700 cm (23 x 23 ft

approx.). Collection: Nationalgalerie, Berlin. © Nikolaus Lang
58
Tim Head
State of the Art, 1984. Cibachrome print, 72 x 108 in. (183 x 275 cm). Arts Council Collection, The South Bank Centre, London. Courtesy, the artist
59 above
Haim Steinbach
stay with friends, 1986. Two plastic laminated wood shelves with Kellogg's and Telma cereal packets and pre-Christian pottery, maximum height 33¾ in. (85.7 cm). Photo courtesy, Speed Art Museum, Louisville, Kentucky. Courtesy, the artist
59 centre
Arhamaiani
Etalase, 1994 (detail). Display case containing photographs, icon, Coca-Cola bottle, Qur'an, fan, Pakwa mirror, dram, box of sand and pack of condoms. Overall 95 x 146.5 x 65.5 cm. Courtesy, the artist
59 below
Rosemarie Trockel
Balaclava Box, 1986. Woollen balaclavas and mannequin heads in vitrine, approx. 14 x 61 x 13 in. Collection: Joshua Gessel. Courtesy, Galerie Monika Sprüth, Cologne. © DACS 2001
60 above
Thomas Locher
Worten satze zahlen dinge – Tableaux, Fotografien, Bilder (Words, Sentences, Numbers, Things – Tableaux, Photographs, Pictures), 1993. Installation at Kunsthalle Zürich. Photo: Alex Troehler. Courtesy, the artist. © DACS 2001
60 below
On Kawara
One Million Years – Future, 1992 (detail). Ten volumes of loose-leaf binders in cardboard box; each volume contains 200 pages, 25.5 x 30.5 x 9 cm. Photo: Sue Ormerod, London. Courtesy, Lisson Gallery, London
61
Christian Boltanski
Inventory of the Man from Barcelona (detail). Installation at the Fundació Antoni Tàpies, Barcelona, 1995, from the exhibition 'The End(s) of the Museum'. Photo: Jordi Calafell. Courtesy, Fundació Antoni Tàpies, Barcelona. © ADAGP, Paris, and DACS, London 2001
62
Wolfgang Stiller
Versuch zu einer grundsätzlichen Neubewertung der Oberfläche (Attempt at a Fundamental New Assessment of the Surface), 1994–99. Installation view, Karl Ernst Osthaus-Museum, Hagen, 1999. Photo: Achim Kukulies. Courtesy, the artist
63
Readymades Belong to Everyone
Backstage, 1994. MAMCO Collection, Geneva. Courtesy, MAMCO, Geneva, and Galerie Claire Burrus, Paris
64
Imi Knoebel
Room 19, 1968. Installation at the Dia Art Foundation, New York, 1987. Photo: Nic Tenwiggenhorn. Courtesy, the artist
65
Christian Boltanski
Réserve du Musée des enfants (Children's Museum Storage Area), 1989. Installation from the exhibition 'Histoire de Musée', Musée d'Art Moderne de la Ville de Paris, 1989. Collection: Musée d'Art Moderne de la

Ville de Paris. Courtesy, Galerie Ghislaine Hussenot, Paris. © ADAGP, Paris, and DACS, London 2001

Chapter II
ART OR ARTIFACT

67
Claudio Costa
Museum of Man, 1974. Casts in display case, 260 x 410 x 78 cm. Courtesy, Galleria Massimo Valsecchi, Milan
68
Peter Blake
A Museum for Myself, 1977. Mixed media, 48 x 36 in. (122 x 91.5 cm). Photo: Miki Slingsby. Courtesy, Morley Gallery, London. © Peter Blake 2001. All Rights Reserved, DACS
69
Barbara Bloom
The Reign of Narcissism, 1989. Installation view at the exhibition 'A Forest of Signs', MOCA, Los Angeles, 1989. Courtesy, Gorney, Gravin + Lee, New York
70
Sophie Calle
The Birthday Ceremony 1991, 1997. Glass cabinet containing various objects, overall 170 x 86 x 49 cm. Photo: Stephen White. Courtesy, Jay Jopling, London
71 above
Guillaume Bijl
Documenta Wax Museum, 1992. Detail of installation at Documenta IX, Kassel, 1992. Courtesy, the artist
71 below
Jeffrey Vallance
The Travelling Nixon Museum, 1991. Mixed media, 20 x 22 x 7¼ in. (51 x 56 x 18.5 cm). Courtesy, the artist
72–73
Susan Hiller, *From the Freud Museum*, 1991–96. Detail of installation at the Freud Museum, London. Courtesy, the artist
74
Mark Dion
Cabinet of Curiosities for the Wexner Center for the Arts (Gallery D). Installation, 10 May–10 August 1997. Photo: Richard K. Loesch. Courtesy, American Fine Arts Co., New York
75
Anne and Patrick Poirier
Villa Médicis, 1970–72: *Quinze Hermes* (Fifteen Herms), installation at Villa Medici, Rome. Papier-mâché casts, wood, paper and glass, each 180 x 40 x 30 cm (approx.). 15 photographs of porcelain, 15 manuscript herbals. Courtesy, the artists. © ADAGP, Paris, and DACS, London 2001
76
Joan Fontcuberta/Pere Formiguera, *Fauna*, 1987–90. *Ceropithecus Icarocornu*, from the Archive of Professor Peter Ameisenhaufen c. 1940 (Expedition map/ field drawing/ Moment of the magic song over the totem of sacrifices). Courtesy, the artists. © DACS 2001
77
Ilya Kabakov
Incident at the Museum or Water Music, 1992. Ronald Feldman Fine Art, New York. Photo: Eric Landsberg. Courtesy, the artist
78
Ross Sinclair
Museum of Despair, 1994. Interior and exterior views, Royal Mile, Edinburgh. Courtesy, the artist

79 left
Gavin Turk
Pop, 1993. Waxwork displayed in vitrine of wood, glass and brass, 279 x 115 x 115 cm. Photo courtesy, Jay Jopling, London
79 above right
Tracey Emin, *Everyone I Have Ever Slept With 1963–1995*, 1995. Tent with applied decoration, mattress and light, 4 x 8 x 7 ft 6 in. (122 x 245 x 215 cm). Courtesy, Jay Jopling, London
79 below right
Gilbert and George
The Red Sculpture (Tape on Floor), 1976, photographed at Sonnabend Gallery, New York. Courtesy, Anthony d'Offay Gallery, London
80–81
Georgina Starr
The Nine Collections of the Seventh Museum: The Collection, 1994 (with annotated inventory diagram). Courtesy, the artist and Anthony Reynolds Gallery, London
82 left
Claudio Costa
Ontologia Antologica (Anthological Ontology), 1994. Filing cabinet with 45 drawers containing objects of the subconscious, 220 x 180 x 45 cm. Courtesy, Galleria Massimo Valsecchi, Milan
82 above right
The Art Guys
Appropriation #9, Peter Marzio, 11/12/ 92, 10:39 am, 1992. Coffee mug, black velvet and brass plaque in wood and glass vitrine. Collection Toni and Jeffrey Beauchamp, Houston, Texas. Courtesy, the artists
83 above
Karsten Bott
Trouser Pocket Collection, 1996. Courtesy, the artist
83 below
Nikolaus Lang, *To the Götte Brothers and Sisters*, Bayersoien, 1973–74, showing installation of open chest with the contents laid out (c. 400 x 600 cm). Collection: Städtische Galerie im Lenbachhaus, Munich. © Nikolaus Lang
84 above
Leonid Sokov
Stalin Meeting with Modern Sculpture, 1993. Bronze, lead, plaster, paint and fur, 170 x 240 x 340 cm (sculpture of Stalin 88 cm; 40 plaster sculptures approx. 7–10 cm). Courtesy, the artist
84 below
James Lee Byars
The Perfect Thought, University Art Museum, Berkeley, California, 18 April–24 June 1990. Courtesy, Galerie Michael Werner, Cologne
85 above
Matt Mullican
Untitled, 1990. Installation at the List Art Center, Cambridge, Mass. Courtesy, the artist
85 below
Guillume Bijl
Der Mensch überwindet Distanzen (Man Conquers Distances), 1993. Wiener Sezession, Vienna. Courtesy, the artist
86 above
Mario Merz
Coccodrillo del Niger (Niger Crocodile), 1972. Musée National d'Art Moderne, Centre Georges Pompidou, Paris. Courtesy, Christian Stein, Milan
86 below
Thomas Grünfeld
Three Misfits (detail), 1994. Taxidermy, wood

at the Pergamon Museum, Berlin. Neon lighting, black-and-white photographs, dimensions variable. This project was commissioned and curated by René Block and Frank Wagner for DAAD and NGBK, Berlin. Courtesy, the artist

170–171
Renée Green
Bequest, 1991–92. Installation details, Worcester Art Museum, Worcester, Massachusetts. Courtesy, Pat Hearn Gallery, New York

172 centre
Dove Bradshaw
Do Not Touch, 1979. The Museum of Modern Art, New York. 2½ x 11½ in. (6.3 x 29.2 cm). Courtesy, the artist

172 below
Siglinde Kallnbach
Performance at the Frauen Museum, Bonn, 6 December 1991. Photo: Freidhelm Schulz. Courtesy, the artist

173 above
Robert Filliou
Poussière de Poussière No. 34/100, 1997. Cardboard box, photograph and duster, 20.5 x 17.6 cm. Photo: Kleinefenn. Courtesy, Galerie Nelson, Paris

173 below
Jeffrey Vallance
Covert Wall Socket Exhibit at the Los Angeles County Art Museum (drawing after original work 'Wall Socket Plate Installation', Members' Room, Los Angeles County Museum of Art, 1977), 1998. Pencil, pen and collage on paper, 20 x 30 in. (55.8 x 76.2 cm). Courtesy, Lehmann Maupin, New York and the artist

174 top
Ann Eggebert & Julian Walker
Mr & Mrs Walker Have Moved, 16–20 June 1998, Kettle's Yard, Cambridge. Courtesy, the artists

174 centre
Henrik Håkansson
10 Seconds of Forever (Today), 2000. Installation at the Natural History Museum, London, associated with the group exhibition 'The Green House Effect', Serpentine Galley, London, 4 April–21 May 2000. CCTV camera, projector, monitors, timelapse for Multiplex video system, chairs, table. Photo: Stephen White. Courtesy, Serpentine Gallery, London

174–175 below
Twentieth Century
System Addict, 2000. Performance at the National Gallery, London, 14 June 2000. Courtesy, the artists

175 above
Jan Fabre
A Consilience, video installation at the Natural History Museum, London, 2000. Courtesy, The Natural History Museum, London. © DACS 2001

176–177
Johannes Wohnseifer with Mark Gonzales
Backworlds / Forwards. Skate performance by Mark Gonzales, ramp sculptures by Johannes Wohnseifer, 13 December 1998, Städtisches Museum Abteiberg, Mönchengladbach. Courtesy, Galerie Gisela Capitain, Cologne

178 left
Anne Brennan
Is it Real, 1997. Sound work in the form of an audio guide to the First World War Galleries of the Australian War Memorial Museum, Canberra, Australia (part of a Canberra Contemporary Art Space project 'Archives and the Everyday'). Curator: Trevor Smith. Co-ordination: Neil Roberts. Photo: Brenton McGeachie. Courtesy, the artist

178 right
Sonia Boyce
Peep, 1995. Installation view, The Green Centre for Non-Western Art and Culture, Brighton Museum and Art Gallery, Sussex. Commissioned by the Institute of International Visual Arts, London. Photo: David Catchpole, Courtesy, inIVA, London, and the artist

179 left
Terry Smith
Perhaps, 1995. Audio work, installation view from the exhibition 'Intervenciones en el espacio' at the Museo de Bellas Artes, Caracas. Courtesy, the artist

179 right
Neil Cummings / Marysia Lewandowska
Errata, 1996. Leaflet from the exhibition 'Now Here', Louisiana Museum of Modern Art, Humlebaek, Denmark, 1996. Courtesy, the artists

180
Thom Barth
Cube 3-87, Copy Marble Room, 1987. Installation at the Museum of Modern Art, Palais Liechtenstein, Vienna. 820 x 900 x 600 cm. Photo: Franz Schachinger, Vienna. Courtesy, the artist

181 above
Marie-Jo Lafontaine
'Wir haben die Kunst damit wir nicht an der Wahrheit zugrunde gehen' (We have art so that we are not destroyed by truth), temporary installation at the Glyptothek, Munich, 1991. Inscription and photographic panels. Courtesy, the artist

181 below
Franz West
Liegen (Couches), installation at the Kunsthistorisches Museum, Vienna, 1989. Each sculpture approx. 136 x 80 x 50 cm. Photo courtesy, Candida Höfer

182 left
Terry Smith
Capital, 1995. Installation view at the British Museum, London. Courtesy, the artist

182 top right
Kazushi Kusakabe
210, installation view of Gallery 210, from the exhibition 'Future Recollections' at the Kyoto Municipal Museum of Art, 1998. Photo: Hiromu Narita. Courtesy, Kyoto Municipal Museum of Art, Kyoto

182 centre right
Gonzalo Diaz
El Estado de Derecho (The State of Law), 1995, Room 1 from the exhibition 'Intervenciones en el espacio' at the Museo de Bellas Artes, Caracas, Venezuela. 9 palmettes and 3 mouldings cast in plaster and granite dust. Texts of the civil law of the Republic of Chile. Dimensions: 345 x 2255 x 15 cm. Courtesy, the artist.

183
Shiro Matsui
The Way to the Artwork is through the Stomach, 1997. Installation at the museum entrance, from the exhibition 'Future Recollections' at the Kyoto Municipal Museum of Art, 1998. Tarpaulin, steel, 6.50 x 6 x 16 m overall. Photo: Hiromu Narita. Courtesy, Kyoto Municipal Museum of Art, Kyoto

Epilogue
WITHOUT WALLS

185
Jeffrey Shaw
The Virtual Museum, 1991. Installation at Ars Electronica, Brucknerhaus, Linz, Austria, 1992. Interactive computer graphics software: Gideon May. Hardware: Huib Neissen and Bas Bossinade. produced under the auspices of the Städelsche Institut für Neue Moden, Frankfurt-am-Main. Collection: ZKM / Museum für Gegenwartskunst, Karlsruhe, 1991. Photo courtesy, the artist

186
Frank O. Gehry & Associates
The Guggenheim Museum, Bilbao, 1997. View of the northern river front. Photo: Erika Barahona Ede. © FMGB Guggenheim Bilbao Museo, Bilbao, Spain

187
Katharina Fritsch
Museum Model 1:10, 1995, installation at XLVI Venice Biennale, 1995. Photo: Nic Tenwiggenhorn, Düsseldorf. Courtesy, the artist

188
Donald Judd
100 Untitled Works in Mill Aluminum, 1982–86. Detail of a permanent installation, Chinati Foundation, Marfa, Texas, 1996. Photo: Todd Eberle. Courtesy, Chinati Foundation, Marfa, Texas

189
Museum of Jurassic Technology
The Horn of Mary Davis of Saughall, 1989. Installation view. Courtesy, Museum of Jurassic Technology, Los Angeles

190
Johan van Geluwe
The Curator's Gallery, 1991. Installation at the Karl Ernst Osthaus-Museum, Hagen, Germany. Courtesy, Karl Ernst Osthaus-Museum, Hagen

191
Hans-Peter Feldmann
Family Photos, 1994–95. Billboard project by the Museum in Progress, Vienna. Photo courtesy, the Museum in Progress, Vienna. © DACS 2001

192
Barbara Bloom
Historicism Art Nouveau, collection arranged by Barbara Bloom. Museum für angewandte Kunst (MAK), Vienna, 1993. Courtesy, Gorney, Bravin + Lee, New York

193
Jeff Wall
A Donkey in Blackpool, 1999, from the exhibition 'Encounters' at the National Gallery, London. Transparency in light-box, image size 76 x 96⅞ in. (193 x 246 cm). Courtesy, Anthony d'Offay Gallery, London

194
Christian Möller
Particles, 2000, interactive media installation from the Sounds Digital section at The Science Museum (Wellcome Wing), London. Courtesy, Science Museum, London

195
Ben Kinmont
We Both Belong, 1995–96, on-line project at adaweb (Wadsworth Atheneum, Hartford, Connecticut):(http://www.adaweb.com/influx/kinmont/bkl.html). Courtesy, the artist

INDEX

MUSEUMS, EXHIBITING ORGANIZATIONS ETC.